crochet SO FINE

EXQUISITE DESIGNS with FINE YARNS

KRISTIN OMDAHL

INTERWEAVE.
interweave.com

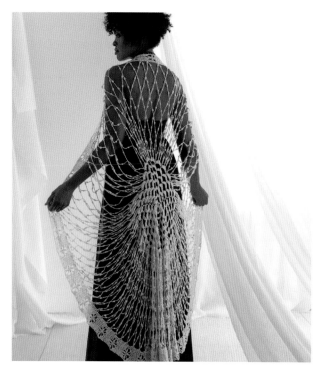

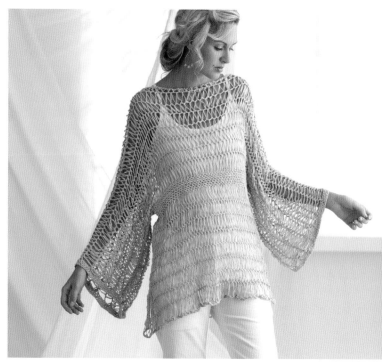

Editor Katrina Loving
Technical Editor Karen Manthey
Cover and Interior Design Karla Baker
Glossary Illustration Ann Swanson
Photography Joe Hancock
Stylist Carol Beaver
Hair and Makeup Kathy MacKay
Production Katherine Jackson

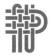

Interweave
A division of F+W Media, Inc.
201 East Fourth Street
Loveland, CO 80537
interweave.com

Manufactured in China by RR Donnelley Shenzhen.

Library of Congress Cataloging-in-Publication Data

Omdahl, Kristin.
Crochet so fine : exquisite designs with fine yarns / Kristin Omdahl.
 p. cm.
Includes bibliographical references and index.
ISBN 978-1-59668-198-9 (pbk.)
ISBN 978-1-59668-431-7 (PDF)
1. Crocheting--Patterns. 2. Shawls. 3. Hats. 4. Sweaters. I. Title.
TT825.O438 2010
746.43'4--dc22
 2009052248

10 9 8 7

Acknowledgments

This book represents the talents and hard work of many people. The photography is breathtaking, and I wish to thank photographer Joe Hancock, as well as stylists Carol Beaver (wardrobe) and Kathy MacKay (hair and makeup), for their incredible talent. I wish to thank everyone at Interweave, especially Tricia Waddell for believing in my ideas, Katrina Loving for incredible attention to detail, and Jaime Guthals for enthusiasm and positive energy! Finally, thank you to Shiri Mor and Karen Manthey for their impeccable technical skills!

To Marlon, my inspiration.
I love you with all my
heart and soul.

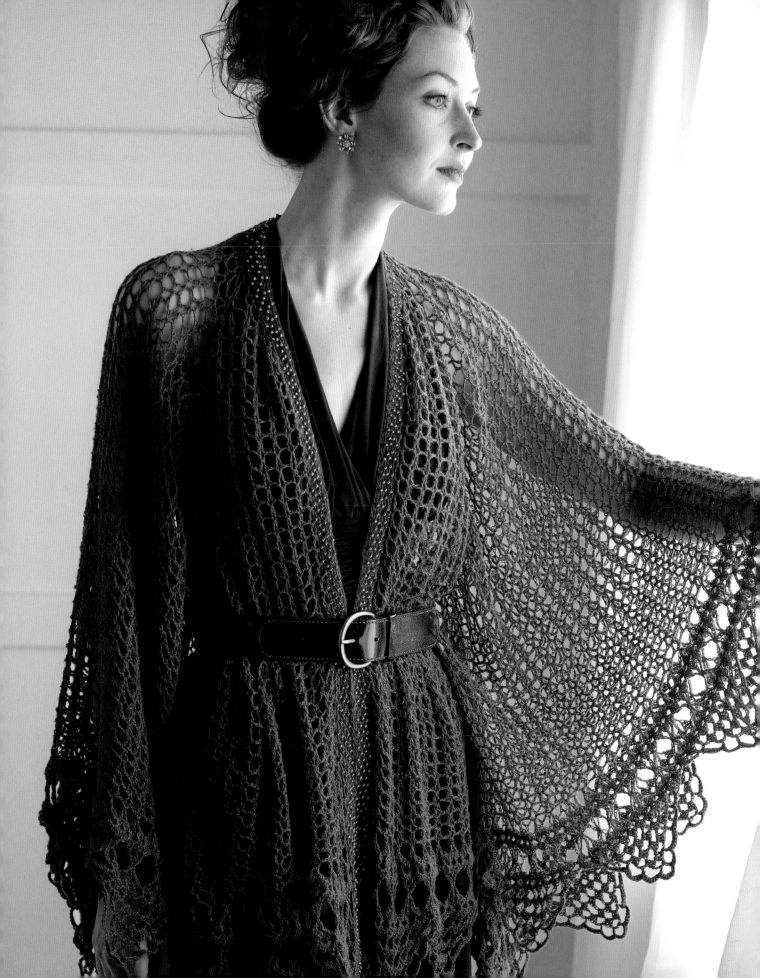

Contents

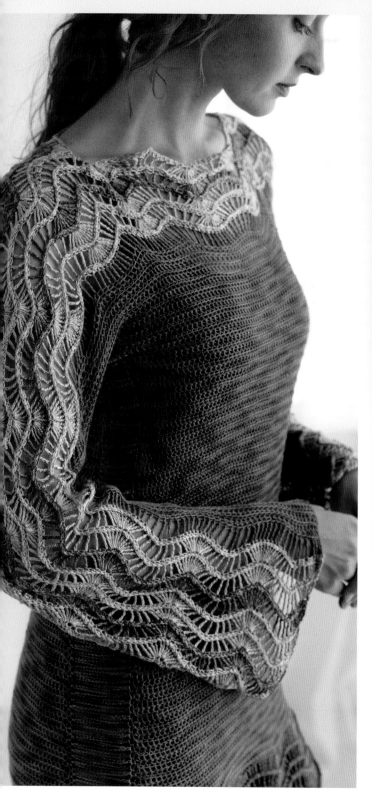
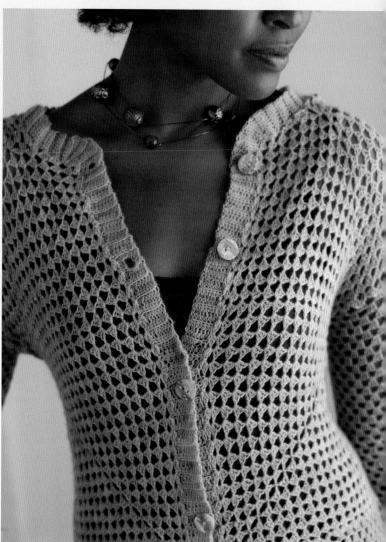

Crochet is all about having *fun*

Crochet stitchwork, by nature, tends to create bulkier fabric than its knitted counterpart. *Crochet So Fine* is a collection of garments and accessories that focuses on lightweight yarns to create fine, airy garments that will complement a variety of body types. A lightweight, loose fabric with good drape can often be more flattering than a fitted sweater crocheted in a heavier yarn. Therefore, in this book you will find delicate-looking lacey wraps and shawls; soft, drapey sweaters; and a variety of lovely lightweight accessories.

I moved to Florida just before beginning *Crochet So Fine*, so I had the amazing opportunity to be inspired by my new surroundings while creating this collection. The pieces showcase many tropical, natural influences, including the orchids in my garden, the ripples in the Imperial River, the spirals in the waves at the beach, and the beautiful purple dragonflies in my yard.

Creating beautiful things with my hands is such an important part of my life. I am constantly searching for new techniques and ideas in crochet, and I love to learn and experiment as often as I can. My goal in writing this book is to share my enthusiasm for crochet with you. I hope I can encourage you to try something new. It may take a couple of attempts to become comfortable with new techniques and a variety of yarns; just relax, breathe, and, most importantly, have fun.

kristin

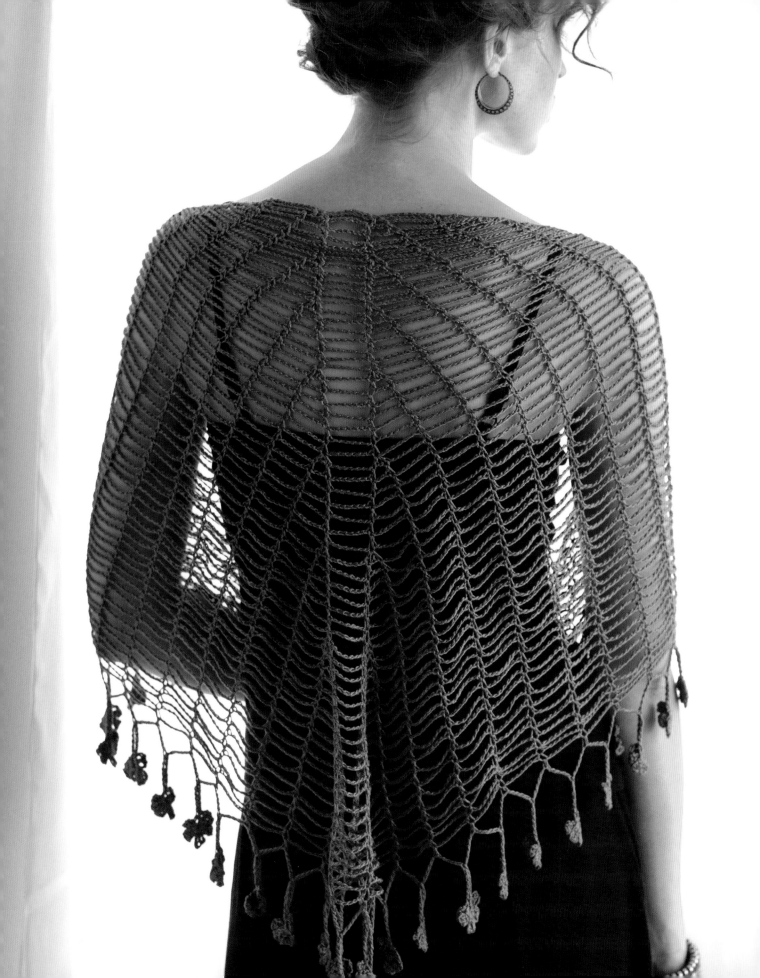

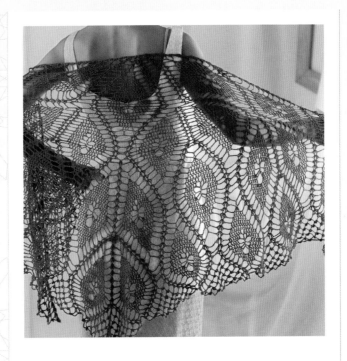

shawls and wraps

Shawls were my first crochet love, and they are still my favorite handmade garment to wear. There are so many options for making a unique shawl or wrap, with a multitude of different shapes, styles, sizes, and techniques. Each new shawl or wrap is a canvas on which I can create a story. For the stories in this chapter, I drew inspiration from many of the natural elements of my surroundings, such as orchids, dragonflies, and even the boundless sea.

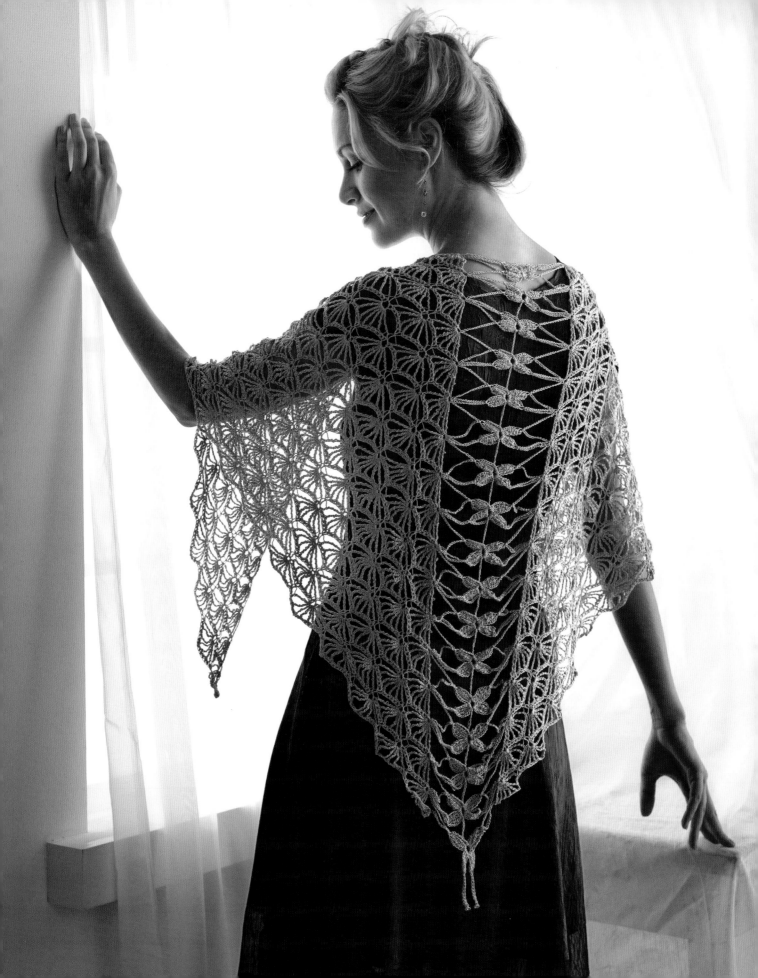

dragonfly SHAWL

My son and I helped save the life of a three-winged dragonfly that was drowning in my aunt's pool a few summers ago. We scooped him out of the pool and gently blew on his wings until they dried. When he finally took flight, we were overjoyed. I've had a special fondness for dragonflies ever since, and I've always wanted to re-create one in crochet. This triangular shawl is worked in three pieces: two side triangles of a beautiful easy-to-increase lace stitch pattern and a center dragonfly gusset that is worked in one long row and joined to both side triangles with long chain spaces as you go. No seaming required!

YARN

Crochet thread (Size 10); 1,050 yd (960 m).

shown: Coats & Clark, Aunt Lydia's Classic Crochet Thread (100% mercerized cotton; 350 yd [320 m]/3 oz [85 g]): 495 wood violet, 3 balls.

HOOK

E/4 (3.5mm) or size needed to obtain gauge.

NOTIONS

Tapstry needle.

GAUGE

First 6 rows of Triangle = 4½" x 4½" x 6½" (11.5 x 11.5 x 16.5 cm).

FINISHED SIZE

60" wide x 30" long (152.5 x 76 cm).

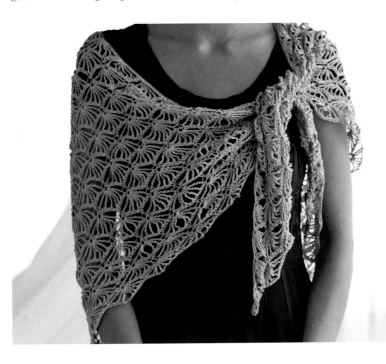

note

- ◦ Shawl is made in 3 pieces: a Right and Left Triangle (Right and Left Triangles are identical, just flipped so that WS is facing on Right Triangle) and a Center Gusset that joins everything together.

special stitches

Triple Treble Crochet (ttr) p. 158.

3 double-treble crochet cluster (3-dtr cl) p. 157.

4 double-treble crochet cluster (4-dtr cl) p. 157.

Shell ([ttr, ch 1] 6 times, ttr) in same st.

Dragonfly Shawl

See stitch diagram at right for a reduced sample of the pattern.

Triangle (make 2)

ROW 1: Ch 7 (counts as ttr, ch 1), ([ttr, ch 1] 5 times, ttr) in 7th ch from hook, turn—1 shell.

ROW 2: Ch 1, sl st in each st and ch across, turn.

ROW 3: Ch 7 (counts as ttr, ch 1), ([ttr, ch 1] 5 times, ttr) in 7th ch from hook, skip first 3 ttr from Row 1, sc in next ttr, skip next 2 ttr from Row 1, shell in last ttr—2 shells.

ROW 4: Rep Row 2.

ROW 5: Ch 7 (counts as ttr, ch 1), ([ttr, ch 1] 5 times, ttr) in 7th ch from hook, skip first 3 ttr from Row 3, sc in next ttr, skip next 3 ttr from Row 3, shell in next st, skip next 3 ttr from Row 3, sc in next ttr, skip next 2 ttr, shell in last ttr—3 shells.

ROW 6: Rep Row 2.

ROW 7: Ch 7 (counts as ttr, ch 1), ([ttr, ch 1] 5 times, ttr) in 7th ch from hook, skip first 3 ttr 2 rows below, sc in next ttr, *skip next 3 ttr 2 rows below, shell in next st, skip next 3 ttr 2 rows below, sc in next ttr, rep from * once, skip next 2 ttr 2 rows below, shell in last ttr—4 shells.

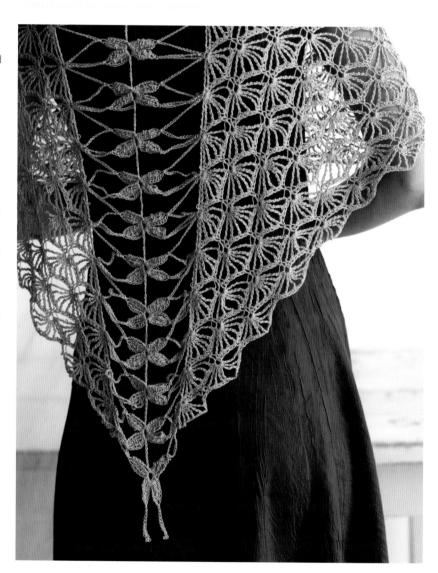

ROW 8: Rep Row 2.

ROWS 9–34: Rep Rows 7 and 8, except work one more rep every odd-numbered row—17 shells at end of Row 33. Fasten off.

Center Gusset

Note: The first row of the center will look like a long chain with 4-petal flowers before joining. The dragonfly shapes are formed by working Joining Rows.

ROW 1: Ch 5, [3-dtr cluster, ch 5, sl st] in 5th ch from hook, *ch 5, 3-dtr cluster in same, (original) ch, ch 13, sl st in 3rd ch from hook, sl st in each of next 10 ch (for antenna), ch 5, sl st in same original ch, rep from * once, (ch 5, 3-dtr cluster, ch 5, sl st) in same original ch (first dragonfly made), **ch 12, [3-dtr cluster, ch 5, sl st] 4 times in 5th ch from hook, rep from ** 15 times, ch 12, [3-dtr cluster, ch 5, sl st] 3 times in 5th ch from hook, 4-dtr cluster in same original ch. Do not fasten off.

Note: You are at the top of the Center Gusset now. Line up the gusset with side B of the Right Triangle (with WS of Row 1 facing; see construction diagram on p. 14 for correct position and orientation).

First Joining Row: Ch 10, sl st into center of base of shell on Row 1 of Triangle, ch 10, sl st into next 3-dtr cluster on Center Gusset, ch 10, sl st into center of base of shell on Row 3 of Triangle, ch 10, sl st into next 3-dtr cluster on Center Gusset, ch 10, sl st into same shell base on Row 3 of Triangle, ch 10, sl st into next 3-dtr cluster on Center Gusset, *ch 10, sl st into shell base on Row 5 of Triangle, ch 10, sl st into next 3-dtr cluster on Center Gusset, ch 10, sl st into same shell base on Row 5, ch 10, sl st into next 3-dtr cluster on Center Gusset, rep from * 14 times, (working into each cluster once and each shell base twice), ch 10, sl st into base of Row 33, ch 10, sl st into next 3-dtr cluster on last dragonfly, ch 10, sl st on top of last ttr of Row 33. Fasten off, leaving last cluster of last dragonfly unjoined.

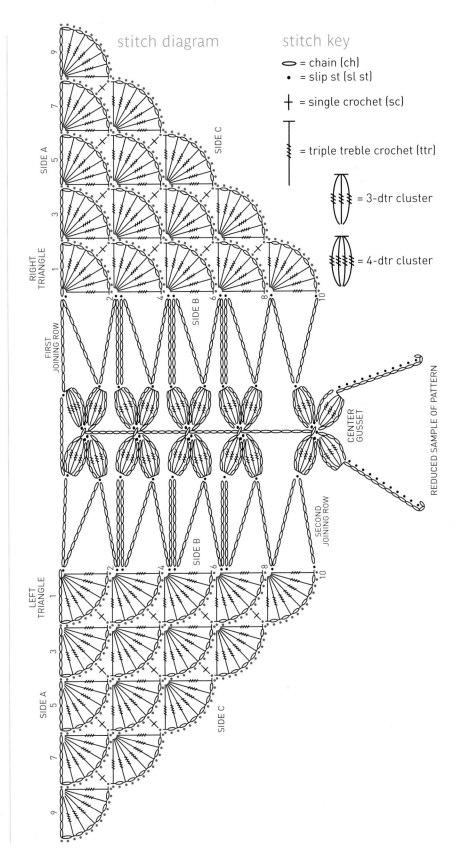

stitch diagram

stitch key

⬯ = chain (ch)

• = slip st (sl st)

✝ = single crochet (sc)

| = triple treble crochet (ttr)

⬭ = 3-dtr cluster

⬭ = 4-dtr cluster

construction diagram

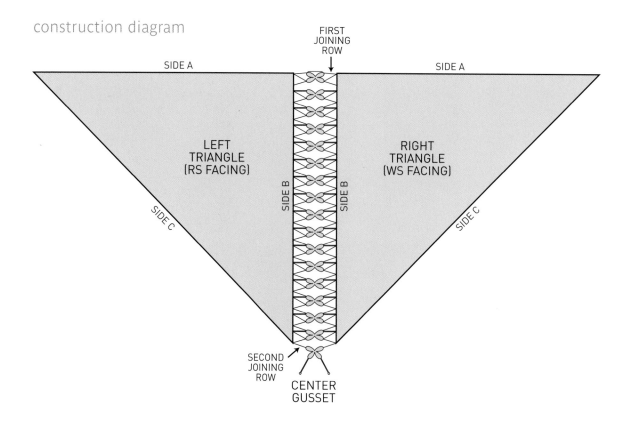

FIRST JOINING ROW

SIDE A

SIDE A

LEFT TRIANGLE (RS FACING)

RIGHT TRIANGLE (WS FACING)

SIDE B

SIDE B

SIDE C

SIDE C

SECOND JOINING ROW

CENTER GUSSET

Note: Now you will join the Center Gusset to side B of Left Triangle (with RS of Row 1 facing) starting with bottom of Center Gusset and corner of facing shell on Row 33 of the Right Triangle.

Second Joining Row: With RS facing, join yarn in top of first ttr at end of Row 33 on Left Triangle, ch 10, skip first 3-dtr cluster on first dragonfly (with antenna), sl st into next 3-dtr cluster on Center Gusset, ch 10, sl st into base of shell on Row 33 of Left Triangle, ch 10, sl st into next 3-dtr cluster on Center Gusset, *ch 10, sl st into base of shell on Row 31, ch 10, sl st into next 3-dtr cluster on Center Gusset, ch 10, sl st into same base shell on Row 31, ch 10, sl st into next 3-dtr cluster on Center Gusset, rep from * 14 times (working into each cluster once and each shell base twice), ch 10, sl st into base of shell on Row 1, ch 10, sl st into next 3-dtr cluster on last dragonfly, ch 10, working across top of last dragonfly, sl st in next 3-dtr cluster. Fasten off.

Wet or steam block to finished measurements. Weave in loose ends with a tapestry needle.

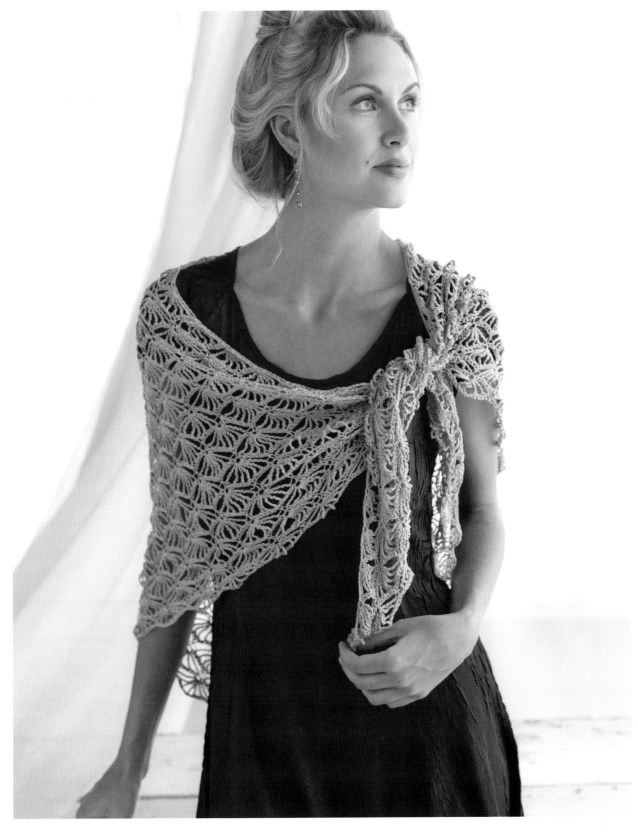

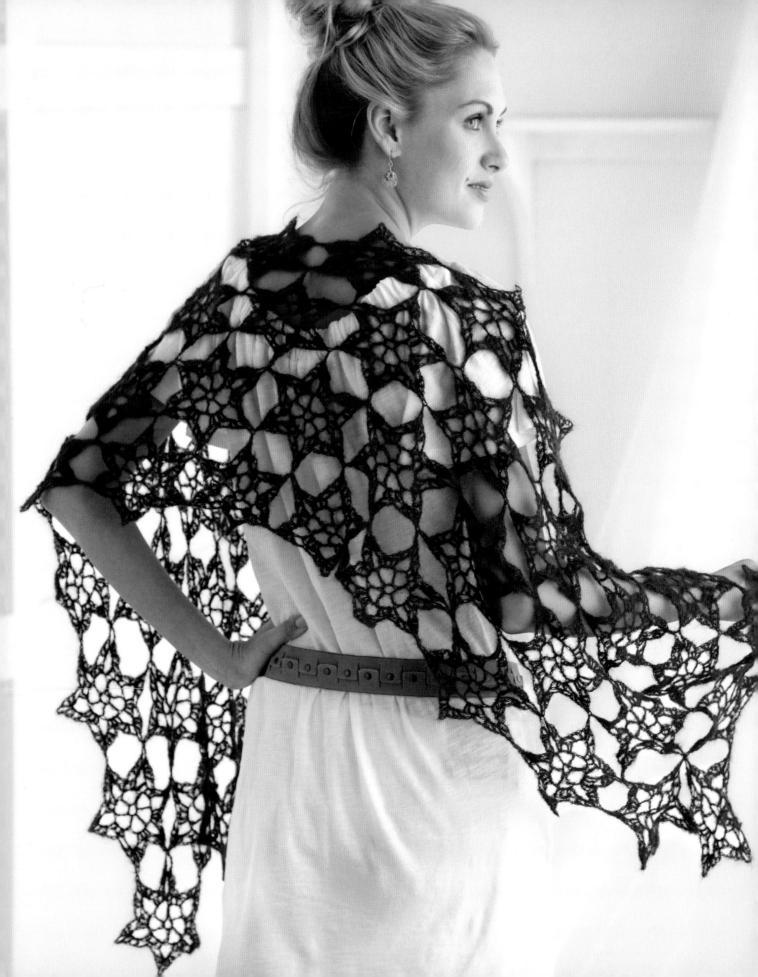

starry night WRAP

Imagine wearing this light wrap for a bit of warmth while leisurely strolling with the one you love on a cool and starry night. The dark midnight blue brushed-alpaca laceweight yarn inspired the entire project. The beautiful star-shaped, three-round motifs are joined as you go, and the entire wrap can be worked up quickly. Perhaps the most surprising aspect of this nicely sized wrap is that it is a one-skein project!

YARN

Laceweight (#0 Lace); 514 yd (470 m).

shown: Alpaca Yarn Company, Halo (100% brushed suri alpaca; 514 yd [470 m]/1.75 oz [50 g]): #7426 soar (blue), 1 skein.

HOOK

G/6 (4mm) or size needed to obtain gauge.

NOTIONS

Tapestry needle.

GAUGE

1 motif = 5" (12.5 cm) square

FINISHED SIZE

18" long x 64" wide (46 x 162.5 cm).

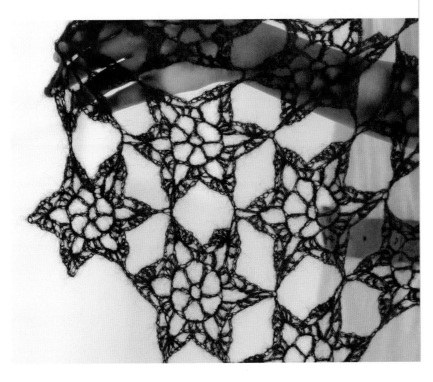

Starry Night Wrap

See stitch diagram at right for assistance.

First Motif

Ch 6, join with sl st to form ring.

RND 1: Ch 7 (counts as tr, ch 3), *tr in ring, ch 3, rep from *4 times, join with sl st to top of ch-4 at beg of rnd—6 ch-3 sps.

RND 2: Sl st in next ch-3 sp, ch 3 (counts as dc), 3 dc in ch-3 sp, ch 4, *4 dc in next ch-3 sp, ch 4, rep from * 3 times, 4 dc in next ch-3 sp, ch 2, hdc in top of ch-3 at beg of rnd instead of last ch-4 sp—6 ch-4 sps.

RND 3: Ch 4 (counts as dc, ch 1), (dc, ch 1, dc) in first ch-sp, ch 2, skip next 2 dc, sc in sp before next dc, ch 2, *(dc, ch 1, dc, ch 1, dc, ch 3, dc, ch 1, dc, ch 1, dc) in next ch-4 sp, ch 2, skip next 2 dc, sc in sp before next dc, ch 2, rep from * 4 times, (dc, ch 1, dc, ch 1, dc, ch 3) in last ch-sp (holding first half shell), join with sl st to 3rd ch at beg of rnd—6 ch-3 sps. Fasten off.

Second Motif
(2-Point Joining)

Ch 6, join with sl st to form ring.

RNDS 1–2: Rep Rnds 1–2 of First Motif.

RND 3: Ch 4, (counts as dc, ch 1), sl st in ch-3 sp on adjacent motif, ch 1, (dc, ch 1, dc, ch 1, dc) in same ch-4 sp on current motif, ch 2, skip next 2 dc, sc in sp before next dc, ch 2, (dc, ch 1) 3 times in next ch-4 sp, sl st into middle of next ch-3 sp on adjacent motif, ch 1, (dc, ch 1, dc, ch 1, dc) into same ch-4 sp on current motif, *ch 2, skip 2 dc, sc in sp before next dc, ch 2, (dc, ch 1, dc, ch 1, dc, ch 3, dc, ch 1, dc, ch 1, dc) in next ch-4 sp, rep from * 3 times, ch 2, skip next 2 dc, sc in sp before next dc, (dc, ch 1, dc, ch 1) in last ch-sp (holding first half shell), join with sl st to top of ch-4 at beg of rnd—4 ch-3 sps.

3-Point Joining

Ch 6, join with sl st to form ring.

RNDS 1–2: Rep Rnds 1–2 of First Motif.

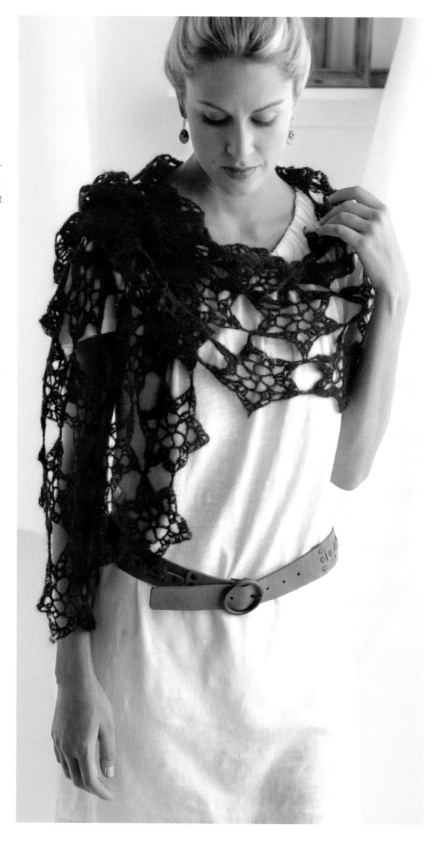

stitch diagram

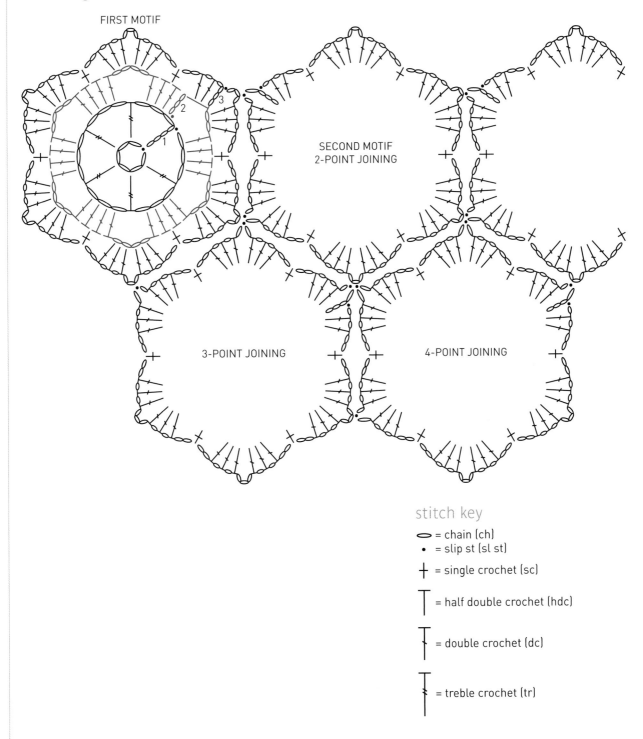

FIRST MOTIF

SECOND MOTIF
2-POINT JOINING

3-POINT JOINING

4-POINT JOINING

stitch key

◯ = chain (ch)

• = slip st (sl st)

+ = single crochet (sc)

T = half double crochet (hdc)

† = double crochet (dc)

‡ = treble crochet (tr)

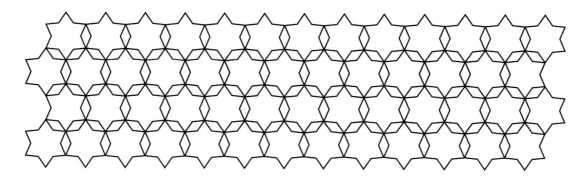

RND 3: Ch 4, (counts as dc, ch 1), sl st in ch-3 sp on adjacent motif, ch 1, (dc, ch 1, dc, ch 1, dc) in same ch-4 sp on current motif, *ch 2, skip next 2 dc, sc in sp before next dc, ch 2, [dc, ch 1] 3 times in next ch-4 sp, sl st into middle of next ch-3 sp on adjacent motif, ch 1, (dc, ch 1, dc, ch 1, dc) into same ch-4 sp on current motif, rep from * once, **ch 2, skip 2 dc, sc in sp before next dc, ch 2, [dc, ch 1, dc, ch 1, dc, ch 3, dc, ch 1, dc, ch 1, dc] in next ch-4 sp, rep from ** twice, ch 2, skip next 2 dc, sc in sp before next dc, (dc, ch 1, dc, ch 1) in last ch-sp (holding first half shell), join with sl st to top of ch-4 at beg of rnd—3 ch-3 sps.

4-Point Joining Motif

Ch 6, join with sl st to form ring.

RNDS 1–2: Rep Rnds 1–2 of First Motif.

RND 3: Ch 4, (counts as dc, ch 1), sl st in ch-3 sp on adjacent motif, ch 1, (dc,

ch 1, dc, ch 1, dc) in same ch-4 sp on current motif, *ch 2, skip next 2 dc, sc in sp before next dc, ch 2, [dc, ch 1] 3 times in next ch-4 sp, sl st into middle of next ch-3 sp on adjacent motif, ch 1, (dc, ch 1, dc, ch 1, dc) into same ch-4 sp on current motif, rep from * twice, **ch 2, skip 2 dc, sc in sp before next dc, ch 2, (dc, ch 1, dc, ch 1, dc, ch 3, dc, ch 1, dc, ch 1, dc) in next ch-4 sp, rep from ** once, ch 2, skip next 2 dc, sc in sp before next dc, (dc, ch 1, dc, ch 1) in last ch-sp (holding first half shell), join with sl st to top of ch-4 at beg of rnd—2 ch-3 sps.

Follow construction diagram above for motif placement of remaining motifs. Cont to join 13 motifs per strip. At the end of 4 strips of 13 motifs, the shawl is complete, with a total of 52 motifs.

Wet block (with cold water) to finished measurements. Weave in loose ends with a tapestry needle.

orchid CIRCULAR SHAWL

I have a beautiful orchid garden in my backyard that I enjoy every day. I especially like to watch the buds grow and grow until they burst open with spectacular blossoms. This shawl was inspired by a stem of multiple orchid buds from my yard. The middle ring of long rounds of chains and clone knots was developed to mimic the long stems of orchid blossoms before they bloom. Wear the shawl as a wrap over your shoulders; slip your arms through the holes to wear it as a vest; or fold it in half, drape it over your shoulders, cinch with a belt, and let the remainder flow as large sleeves.

YARN

Fingering weight (#1 Super Fine); 1,281 yd (1,171 m).

shown: Alpaca Yarn Company, Glimmer (97% Baby Alpaca/3% Polyester; 183 yd (167.3 m)/1.7 oz (50 g)): #100 white house, 7 balls.

HOOK

E/4 (3.5mm) or size needed to obtain gauge.

NOTIONS

Split-ring stitch marker; tapestry needle.

GAUGE

First 4 rnds = 4" (10 cm) in diameter. 18 sts x 8 rows = 4" (10 cm) in dc border edging.

FINISHED SIZE

54" (137 cm) in diameter.

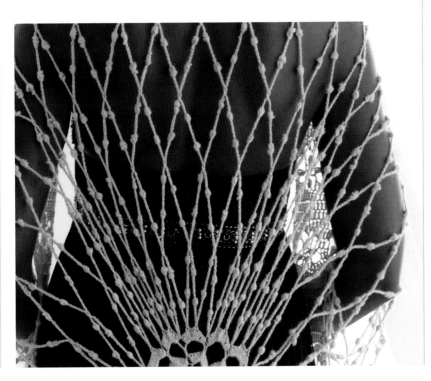

special stitches

Clones Knot

Draw up a ½" (1.3 cm) chain. Holding the chain in place, yarn over hook (figure 1), *bring the hook toward the front and under the loop to the back, yarn over hook and bring the hook back under the loop toward the front (3 loops on hook, 1 wrap completed; figure 2). Repeat from * twice (7 loops on hook, 3 wraps completed). Yarn over hook (figure 3), draw yarn through all loops on hook. Secure knot by working ch 1 tightly (figure 4).

note: The length of the initial chain indicates the size of the Clones Knot. To make a larger Clones Knot, draw up a longer chain and repeat from * in the above instructions to wrap the yarn around the chain until it is completely covered.

Foundation double crochet (fdc) p. 157.

2 double crochet cluster (2-dc cl) p. 157.

3 double crochet cluster (3-dc cl) p. 157.

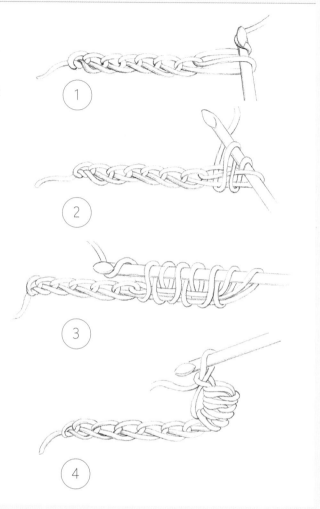

note

- The floral edging is worked sideways and joined to the circular shawl on every 4th row for a finished shawl with no seams.

Orchid Circular Shawl

Refer to stitch diagram A on p. 26 for assistance.

Ch 4, join with sl st to form ring.

RND 1: Ch 1, [sc, ch 5] 3 times in ring, join with sl st in first sc at beg of rnd—3 ch-5 sps.

RND 2: Ch 1, sc in first sc, (sl st, ch 3 [counts as dc now and throughout], 7 dc, ch 3 [counts as dc now and throughout], sl st) in next ch-5 sp, sc in next sc, *(sl st, ch 3, 7 dc, ch 3, sl st) in next ch-5 sp, sc in next sc, rep from * once more, join with sl st in first sc at beg of rnd—3 petals.

RND 3: Ch 1, sc in first sc, *ch 7, skip next 4 dc, sc in next dc, ch 7, skip next 4 dc, sc in next sc, rep from * twice, omitting last sc, join with sl st in first sc at beg of rnd—6 ch-7 sps.

RND 4: Ch 1, sc in first sc, (sl st, ch 3, 7 dc, ch 3, sl st) in next ch-7 sp, *sc in next sc, (sl st, ch 3, 7 dc, ch 3, sl st) in next ch-7 sp, rep from * around, join with sl st in first sc at beg of rnd—6 petals.

RND 5: Ch 1, sc in first sc, *ch 7, skip next 4 dc, sc in next dc, ch 7, skip next 4 dc, sc in next sc, rep from * 5 times, omitting last sc, join with sl st in first sc at beg of rnd—12 ch-7 sps.

RND 6: Ch 1, sc in first sc, (sl st, ch 3, 7 dc, ch 3, sl st) in next ch-7 sp, *sc in next sc, (sl st, ch 3, 7 dc, ch 3, sl st) in next ch-7 sp, rep from * around, join with sl st in first sc at beg of rnd—12 petals.

RND 7: Ch 1, sc in first sc, *ch 7, skip next 4 dc, sc in next dc, ch 7, skip next 9 sts, sc in next dc, ch 7, skip next 4 dc, sc in next sc, rep from * 5 times, omitting last sc, join with sl st in first sc at beg of rnd—18 ch-7 sps.

RND 8: Rep Rnd 6—18 petals.

RND 9: Ch 1, sc in first sc, *ch 7, skip next 4 dc, sc in next dc, [ch 7, skip next 9 sts, sc in next dc] twice, ch 7, skip next 4 dc, sc in next sc, rep from * 5 times, omitting last sc, join with sl st in first sc at beg of rnd—24 ch-7 sps.

RND 10: Rep Rnd 6—24 petals.

RND 11: Ch 1, sc in first sc, *ch 7, skip next 4 dc, sc in next dc, [ch 7, skip next 9 sts, sc in next dc] 3 times, ch 7, skip next 4 dc, sc in next sc, rep from * 5

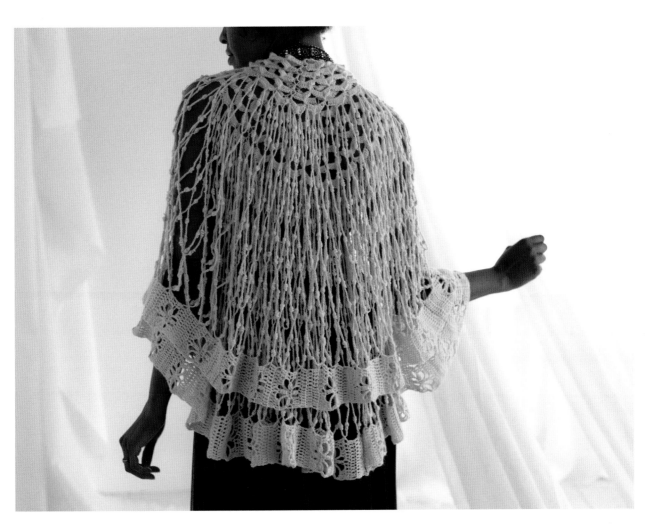

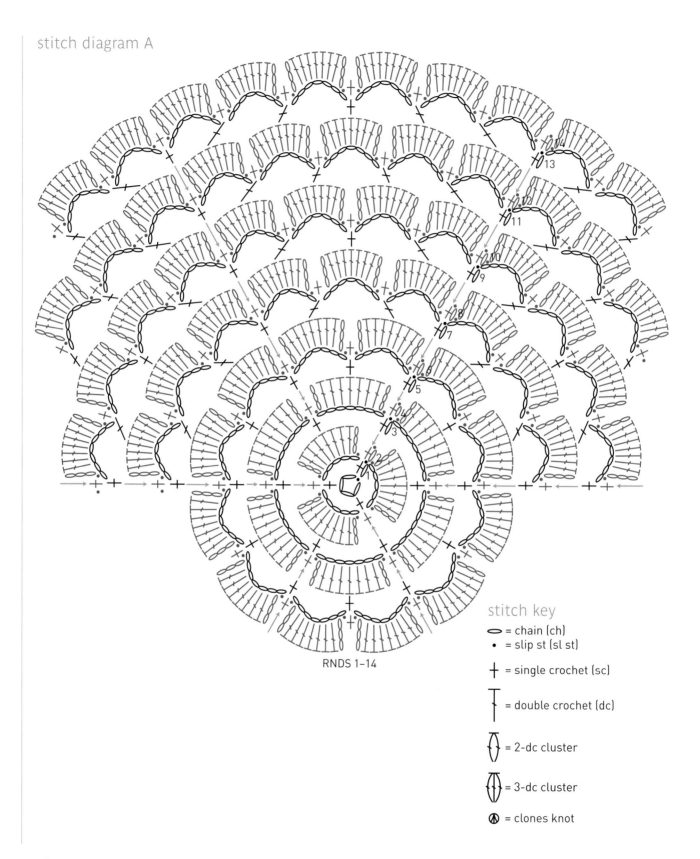

RNDS 1–14

stitch key

⬭ = chain (ch)

• = slip st (sl st)

✛ = single crochet (sc)

┬ = double crochet (dc)

⬭ = 2-dc cluster

⬭ = 3-dc cluster

⊛ = clones knot

times, omitting last sc, join with sl st in first sc at beg of rnd—30 ch-7 sps.

RND 12: Rep Rnd 6—30 petals.

RND 13: Ch 1, sc in first sc, *ch 7, skip next 4 dc, sc in next dc, [ch 7, skip next 9 sts, sc in next dc] 4 times, ch 7, skip next 4 dc, sc in next sc, rep from * 5 times, omitting last sc, join with sl st in first sc at beg of rnd—36 ch-7 sps.

RND 14: Rep Rnd 6—36 petals.

Refer to stitch diagram B, on p. 28, for assistance with the next two rows.

RND 15: Ch 1, sc in first sc, ** *[ch 5, work clones knot] 4 times, ch 5, skip next 2 sts, sc in the next st, rep from * once, [ch 5, work clones knot] 4 times, ch 5, skip next 3 sts, sc in the next st, rep from ** around—108 giant loops. Fasten off.

RND 16: With RS facing, join yarn with sl st to center of any giant lp from Rnd 15, ch 1, sc in same sp, *[ch 5, work clones knot] 4 times, ch 5, sc in center of next giant loop—108 giant loops. Fasten off.

RNDS 17–19: Rep Rnd 16. Fasten off.

Edging

Note: Edging is worked around perimeter of shawl. At the end of every 4th row, edging is joined to the next adjacent giant lp from Rnd 19.

Refer to stitch diagram C on p. 28 for assistance.

ROW 1: Work 14 fdc.

ROWS 2–4: Ch 3 (counts as dc now and throughout), dc in each dc across, turn. At the end of Row 4, sl st to center of next giant lp from Rnd 19.

ROW 5: Ch 3, dc in each of next 5 dc, ch 3, skip next dc, 3-dc cl in next st, ch 3, skip next dc, dc in each of next 5 sts, turn.

ROW 6: Ch 3, dc in next dc, ch 3, 2-dc cl around the post of last dc worked, sc in next ch-3 sp, sc in next 3-dc cl, sc in next ch-3 sp, ch 3, 2-dc cl around post of

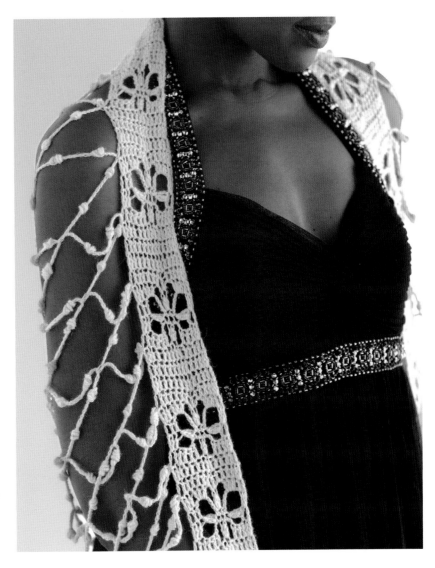

last sc worked, skip next 3 dc, dc in each of last 3 sts, turn.

ROW 7: Ch 3, dc in each of next 2 dc, ch 7, sc in each of next 3 sc, ch 7, dc in each of last 2 dc, turn.

ROW 8: Ch 3, dc in next dc, 3 dc cl in next ch-7 sp, ch 3, skip next sc, 3-dc in next sc, skip next sc, ch 3, 3 dc in next ch-7 sp, dc in each of last 3 sts, sl st in center of next giant lp from Rnd 19.

ROW 9: Ch 3, dc in each of next 5 dc, dc in next ch-3 sp, dc in next 3-dc cl, dc in next ch-3 sp, dc in each of last 5 dc, turn.

Rep Rows 2–9 until Edging is joined to every giant lp around. Whipstitch last row of Edging to first row of Edging to create a circular border.

Wet or steam block to finished measurements. Weave in loose ends with a tapestry needle.

stitch diagram B

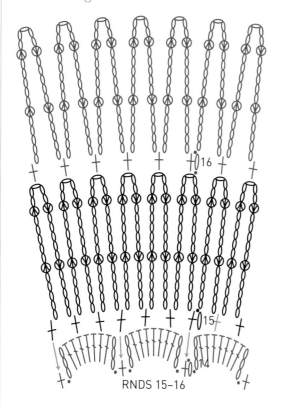

RNDS 15–16

stitch diagram C

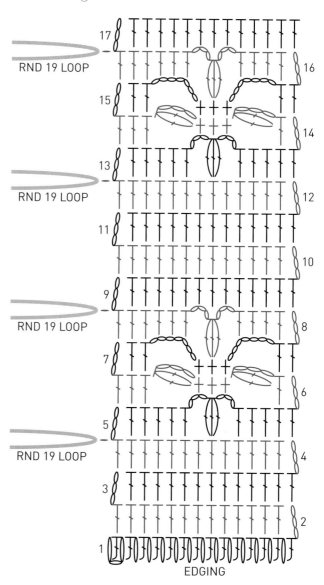

17
RND 19 LOOP
16
15
14
13
RND 19 LOOP
12
11
10
9
RND 19 LOOP
8
7
6
5
RND 19 LOOP
4
3
2
1

EDGING

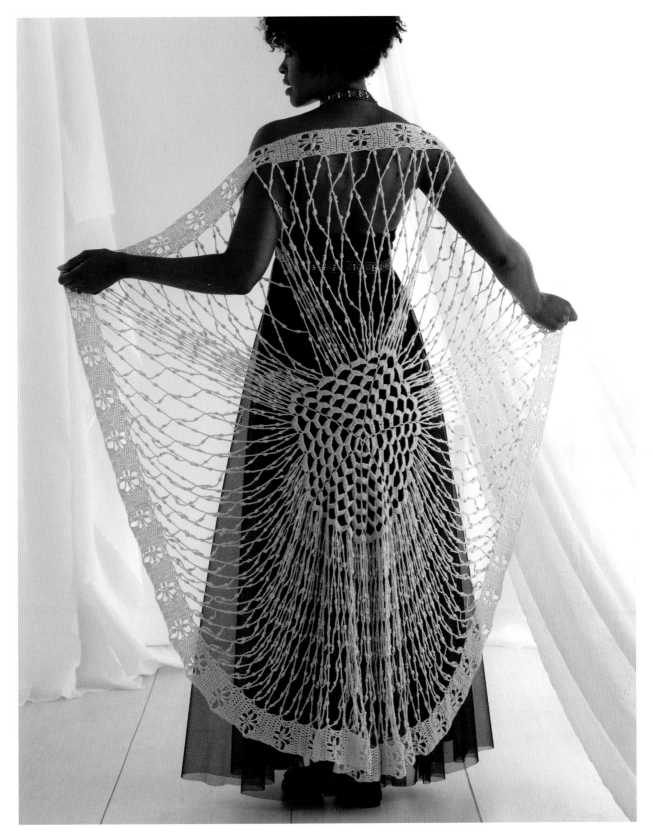

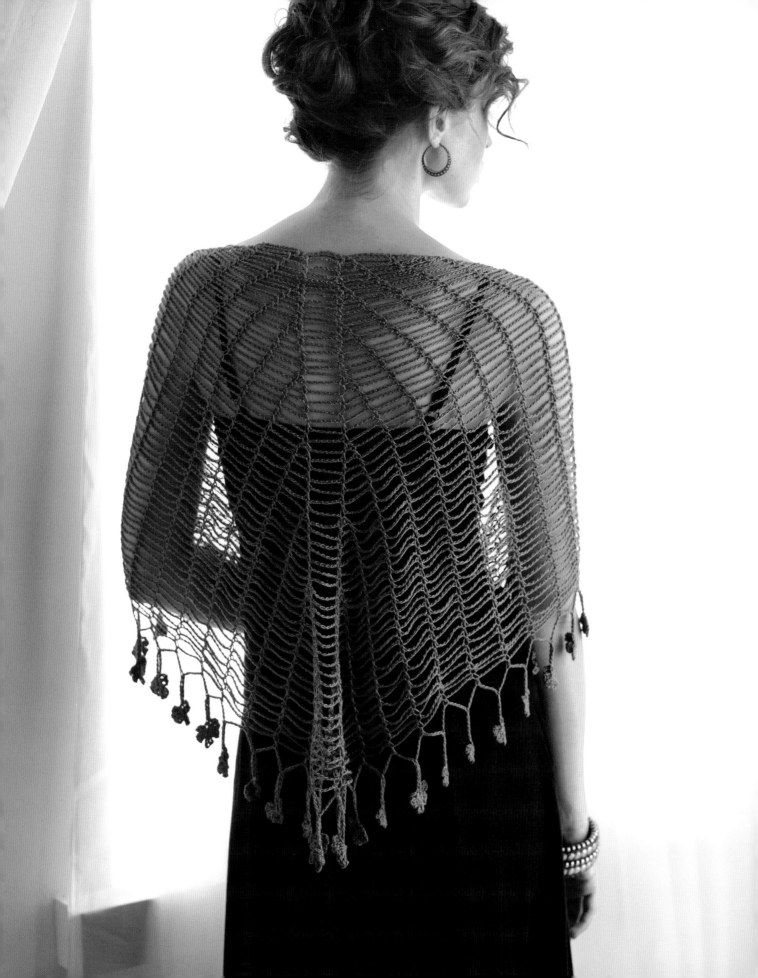

sprout CHAINS SHAWLETTE

The long chain and solo single crochet stitch pattern featured in this shawl is easy to memorize and relaxing to crochet. The flower fringe border makes me smile every time. It's incredibly easy to make because the flowers are worked right into the one-row border, even though they look like they were separately crocheted motifs! This sweet little shawlette adds just the right touch when draped around the shoulders of a pretty dress or wrapped around the neck as an eye-catching scarf.

YARN

DK weight (#3 Light); 360 yd (329 m).

shown: Stitch Diva Studios, Studio Silk (100% plied silk yarn; 120 yd [110 m]/1¾ oz [50 g]): snakeskin, 3 skeins.

HOOK

E/4 (3.5mm) or size needed to obtain gauge.

NOTIONS

Split-ring stitch marker; tapestry needle.

GAUGE

1 rep in patt (sc, ch 7) and 5 rows sc = 1½" (3.8 cm).

FINISHED SIZE

54" wide x 24" long (137 x 61 cm) including flower fringe.

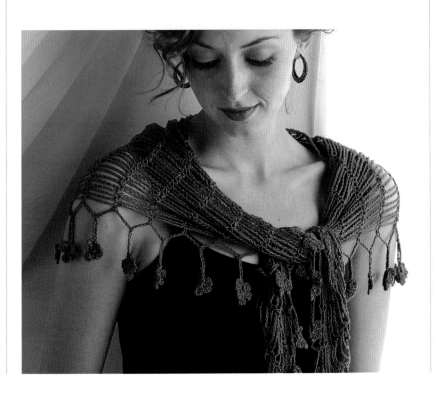

note

- Shawl begins at the top center and is worked down in V-shaped rows. The shawl and flower fringe are worked in one piece.

Sprout Chains Shawlette

Shawl Body

Refer to stitch diagram A at right for assistance with the Shawl Body.

ROW 1: Ch 26, sc in 2nd ch from hook, [ch 7, skip next 7 ch, sc in next ch] 3 times, turn.

ROW 2: Ch 1, (sc, ch 2, sc) in first sc, *ch 7, (sc, ch 2, sc) in next sc, rep from * twice, turn.

ROW 3: Ch 1, sc in first sc, ch 3, sc in next sc, *ch 7, sc in next sc, ch 3, sc in next sc, rep from * twice, turn.

ROW 4: Ch 1, sc in first sc, ch 4, sc in next sc, *ch 7, sc in next sc, ch 4, sc in next sc, rep from * twice, turn.

ROW 5: Ch 1, sc in first sc, ch 5, sc in next sc, *ch 7, sc in next sc, ch 5, sc in next sc, rep from * twice, turn.

ROW 6: Ch 1, sc in first sc, ch 6, sc in next sc, *ch 7, sc in next sc, ch 6, sc in next sc, rep from * twice, turn.

ROW 7: Ch 1, sc in first sc, *ch 7, sc in next sc, rep from * across, turn.

ROW 8: Rep Row 7.

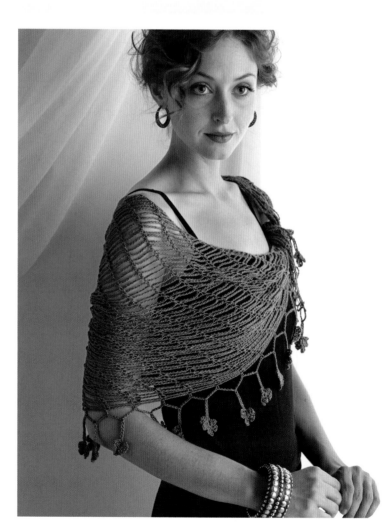

ROW 9: Ch 1, (sc, ch 2, sc) in first sc, *[ch 7, sc in next sc]* 3 times, (ch 2, sc) in same sc, ch 7, (sc, ch 2, sc) in next sc, *[ch 7, sc in next sc]* 3 times, (ch 2, sc) in same sc, turn.

ROW 10: Ch 1, sc in first sc, ch 3, sc in next sc, *[ch 7, sc in next sc]* 3 times, ch 3, sc in next sc, ch 7, sc in next sc, ch 3, sc in next sc, *[ch 7, sc in next sc]* 3 times, ch 3, sc in next sc, turn.

ROW 11: Ch 1, sc in first sc, ch 4, sc in next sc, *[ch 7, sc in next sc]* 3 times, ch 4, sc in next sc, ch 7, sc in next sc, ch 4, sc in next sc, *[ch 7, sc in next sc]* 3 times, ch 4, sc in next sc, turn.

ROW 12: Ch 1, sc in first sc, ch 5, sc in next sc, *[ch 7, sc in next sc]* 3 times, ch 5, sc in next sc, ch 7, sc in next sc, ch 5, sc in next sc, *[ch 7, sc in next sc]* 3 times, ch 5, sc in next sc, turn.

ROW 13: Ch 1, sc in first sc, ch 6, sc in next sc, *[ch 7, sc in next sc]* 3 times, ch 6, sc in next sc, ch 7, sc in next sc, ch 6, sc in next sc, *[ch 7, sc in next sc]* 3 times, ch 6, sc in next sc, turn.

ROW 14: Ch 1, sc in first sc, (ch 7, sc in next sc) in each sc across, turn.

ROW 15: Rep Row 14.

ROWS 16–22: Rep Rows 9–15, working from * to * 5 times.

ROWS 23–29: Rep Rows 9–15, working from * to * 7 times.

ROWS 30–36: Rep Rows 9–15, working from * to * 9 times.

ROWS 37–43: Rep Rows 9–15, working from * to * 11 times.

ROWS 44–50: Rep Rows 9–15, working from * to * 13 times.

ROWS 51–57: Rep Rows 9–15, working from * to * 15 times.

stitch diagram A

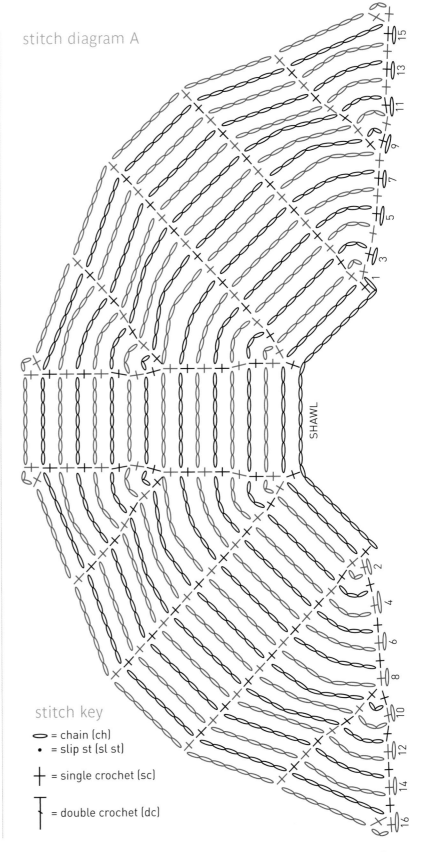

stitch key

\bigcirc = chain (ch)

• = slip st (sl st)

$+$ = single crochet (sc)

\top = double crochet (dc)

stitch diagram B

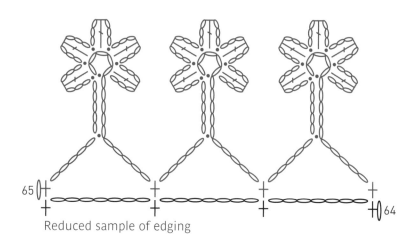

Reduced sample of edging

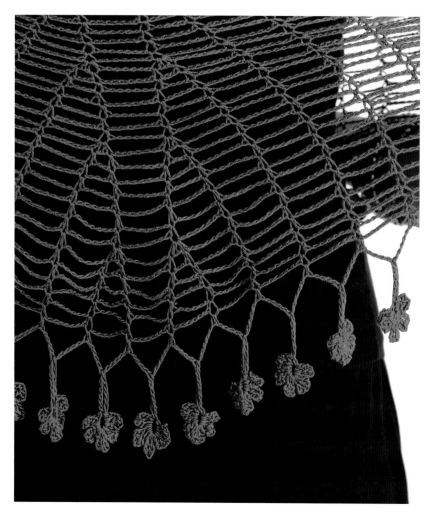

ROWS 58–64: Rep Rows 9–15, working from * to * 17 times.

Do not fasten off.

Edging
Refer to stitch diagram B above for a reduced sample of the Edging.

ROW 65: *Ch 15, sl st in 5th ch from hook to form ring, [ch 3, dc, ch 3, sl st in ring] 5 times, ch 5, sl st in 10th ch from original ch-15, ch 5, skip next ch-7 sp, sc in next sc, rep from * across—39 flower fringes.

Wet or steam block to finished measurements. Weave in loose ends with a tapestry needle.

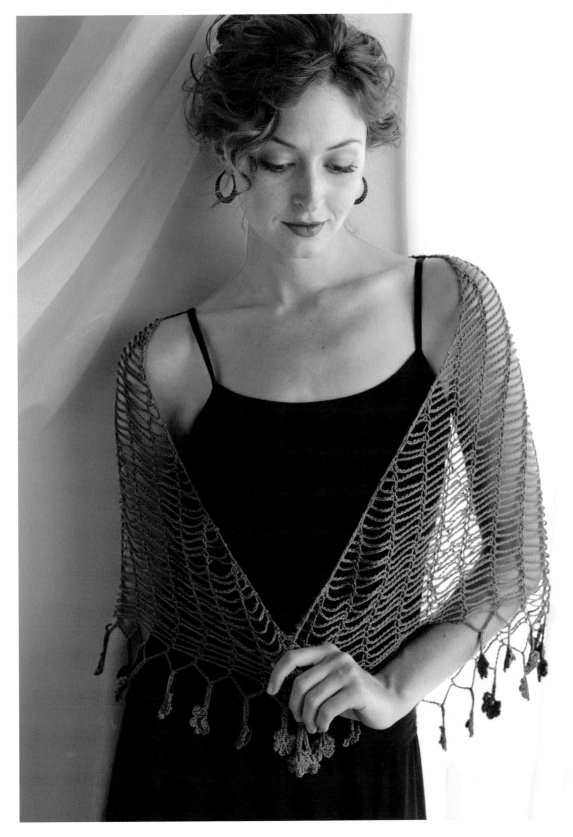

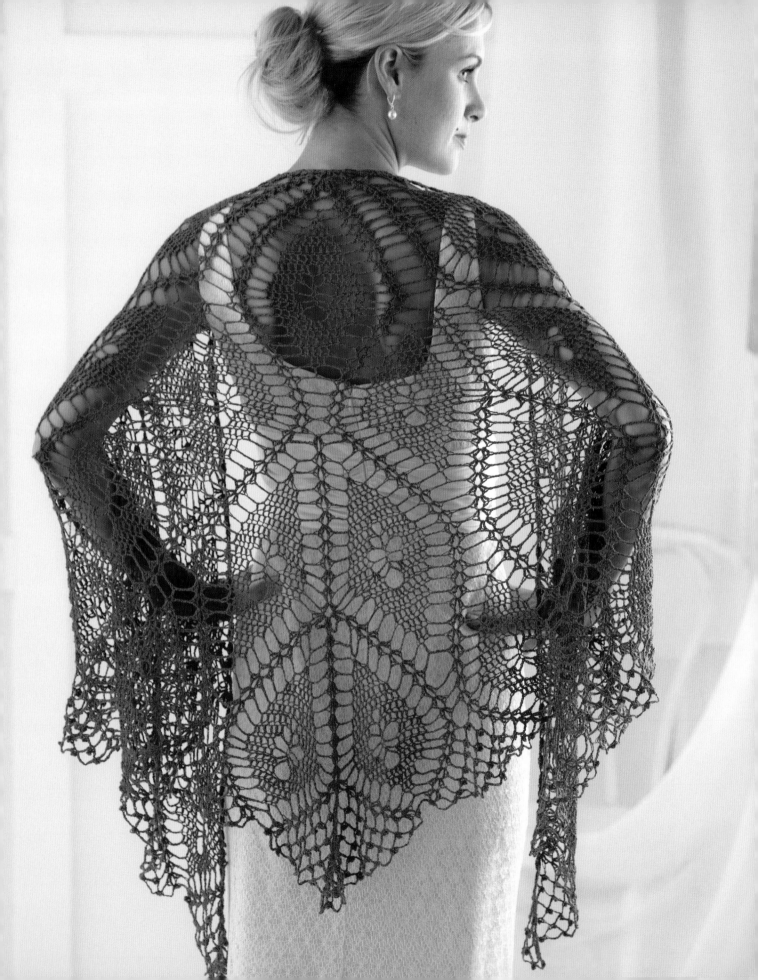

diamonds SHAWL

I found this diamond motif in a stitch reference book and immediately fell in love with it. I played around with the design for a while before I mastered it, increasing motifs within motifs to achieve this unique look. The shawl is crocheted from the top down, and the body of the shawl is increased by strategically inserting a new motif at the halfway point of the previous motif in every row. This lovely lacy shawl was actually the first piece I created for this book, and it set the tone for everything else.

YARN
Laceweight (#0 Lace); 990 yd (905 m).

shown: Buffalo Gold, #12 Lux (45% premium bison down, 20% fine cashmere, 20% mulberry silk, 15% Tencel; 330 yd [302 m]/1.4 oz [40 g]): mountain berry, 3 skeins.

HOOK
G/6 (4mm) or size needed to obtain gauge.

NOTIONS
Tapestry needle.

GAUGE
15 sts x 8 rows = 4" (10 cm).

FINISHED SIZE
68" wide x 34" long (173 x 86.5 cm).

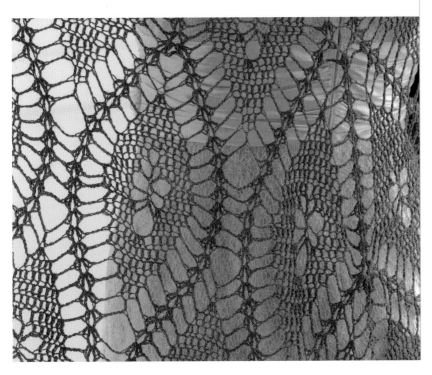

note

- Once the original three diamond motifs are started, each subsequent set of motifs are begun when the previous motifs are on Row 14.

special stitches

Beg shell (Ch 3, dc, ch 3, 2 dc) in same sp.

Shell (2 dc, ch 3, 2 dc) in same sp.

Picot p. 158.

Diamond Shawl

Shawl Body

Refer to the stitch diagram at right for assistance.

Ch 8, join with sl st to form ring.

ROW 1: Ch 3 (counts as dc), dc in ring, *ch 3, 2 dc in ring, rep from * twice, turn—3 ch-3 sps.

ROW 2: Work beg shell in first dc, ch 3, shell in next ch-3 sp, [ch 3, shell] twice in next ch-3 sp, ch 3, shell in next ch-3 sp, ch 3, shell in last dc—6 shells.

ROW 3: Sl st to first ch-3 sp, beg shell in first ch-3 sp, *ch 5, skip next ch-3 sp, shell in next ch-3 sp**, ch 3, skip next ch-3 sp, shell in next ch-3 sp, rep from *once, rep from * to ** once, turn.

ROW 4: Sl st to first ch-3 sp, beg shell in first ch-3 sp, *ch 7, skip next ch-5 sp, shell in next ch-3 sp**, ch 4, skip next ch-3 sp, shell in next ch-3 sp, rep from * once, rep from * to ** once, turn.

ROW 5: Sl st to first ch-3 sp, beg shell in first ch-3 sp, *ch 3, skip next 3 ch, dc in next ch, ch 3, shell in next ch-3 sp**, ch 5, skip next ch-5 sp, shell in next ch-3 sp, rep from * once, rep from * to ** once, turn.

ROW 6: Sl st to first ch-3 sp, beg shell in first ch-3 sp, *ch 3, skip next ch-3 sp, 3 dc in next dc, ch 3, skip next ch-3 sp, shell in next ch-3 sp**, ch 5, skip next ch-5 sp, shell in next ch-3 sp, rep from * once, rep from * to ** once, turn.

ROW 7: Sl st to first ch-3 sp, beg shell in first ch-3 sp, *ch 3, dc in next ch-sp, dc in each of next 3 dc, dc in next ch-sp, ch 3, shell in next ch-3 sp**, ch 5, skip next ch-5 sp, shell in next ch-3 sp, rep from * once, rep from * to ** once, turn.

ROW 8: Sl st to first ch-3 sp, beg shell in first ch-3 sp, *ch 3, dc in next ch-sp, dc in each of next 5 dc, dc in next ch-sp, ch 3, shell in next ch-3 sp**, ch 5, skip next ch-5 sp, shell in next ch-3 sp, rep from * once, rep from * to ** once, turn.

ROW 9: Sl st to first ch-3 sp, beg shell in first ch-3 sp, *ch 3, dc in next ch-sp, dc in each of next 7 dc, dc in next ch-sp, ch 3, shell in next ch-3 sp**, ch 5, skip next ch-5 sp, shell in next ch-3 sp, rep from * once, rep from * to ** once, turn.

ROW 10: Sl st to first ch-3 sp, beg shell in first ch-3 sp, *ch 3, dc in next ch-sp, dc in each of next 9 dc, dc in next ch-sp, ch 3, shell in next ch-3 sp**, ch 5, skip next ch-5 sp, shell in next ch-3 sp, rep from * once, rep from * to ** once, turn.

ROW 11: Sl st to first ch-3 sp, beg shell in first ch-3 sp, *ch 3, dc in next ch-sp, dc in each of next 5 dc, ch 1, skip next dc, dc in each of next 5 dc, dc in next ch-sp, ch 3, shell in next ch-3 sp**, ch 5, skip next ch-5 sp, shell in next ch-3 sp, rep from * once, rep from * to ** once, turn.

ROW 12: Sl st to first ch-3 sp, beg shell in first ch-3 sp, *ch 3, dc in next ch-sp, dc in each of next 5 dc, ch 2, skip next dc, dc in next ch-1 sp, ch 2, skip next dc, dc in each of next 5 dc, dc in next ch-sp, ch 3, shell in next ch-3 sp**, ch 5, skip next ch-5 sp, shell in next ch-3 sp, rep from * once, rep from * to ** once, turn.

ROW 13: Sl st to first ch-3 sp, beg shell in first ch-3 sp, *ch 3, dc in next ch-sp, dc in each of next 4 dc, ch 3, skip next 2 dc, skip next ch-2 sp, sc in next dc, ch 3, skip next ch-2 sp, skip next 2 dc, dc in each of next 4 dc, dc in next ch-sp, ch 3, shell in next ch-3 sp**, ch 5, skip next ch-5 sp, shell in next ch-3 sp, rep from * once, rep from * to ** once, turn.

ROW 14: Sl st to first ch-3 sp, beg shell in first ch-3 sp, *ch 3, skip next ch-3 sp, dc in each of next 5 dc, ch 4, skip next ch-4 sp, sc in next sc, ch 4, skip next ch-4 sp, dc in each of next 5 dc, ch 3, skip next ch-3 sp, shell in next ch-3 sp**, ch 5, skip next ch-5 sp, shell in next ch-3 sp, rep from * once, rep from * to ** once, turn.

ROW 15: Sl st to first ch-3 sp, (beg shell, ch 2, 2 dc) in first ch-3 sp, *ch 3, skip next ch-3 sp, skip next dc, dc in each of next 4 dc, 2 dc in next ch-4 sp, ch 3, sc in next sc, ch 3, 2 dc in next ch-4 sp, dc in each of next 4 dc, ch 3, skip next dc, skip next ch-3 sp**, shell in next ch-3 sp, ch 7, skip next ch-5 sp, shell in next ch-3 sp, rep from * once, rep from * to ** once, (shell, ch 3, 2 dc) in last ch-3 sp, turn.

stitch diagram

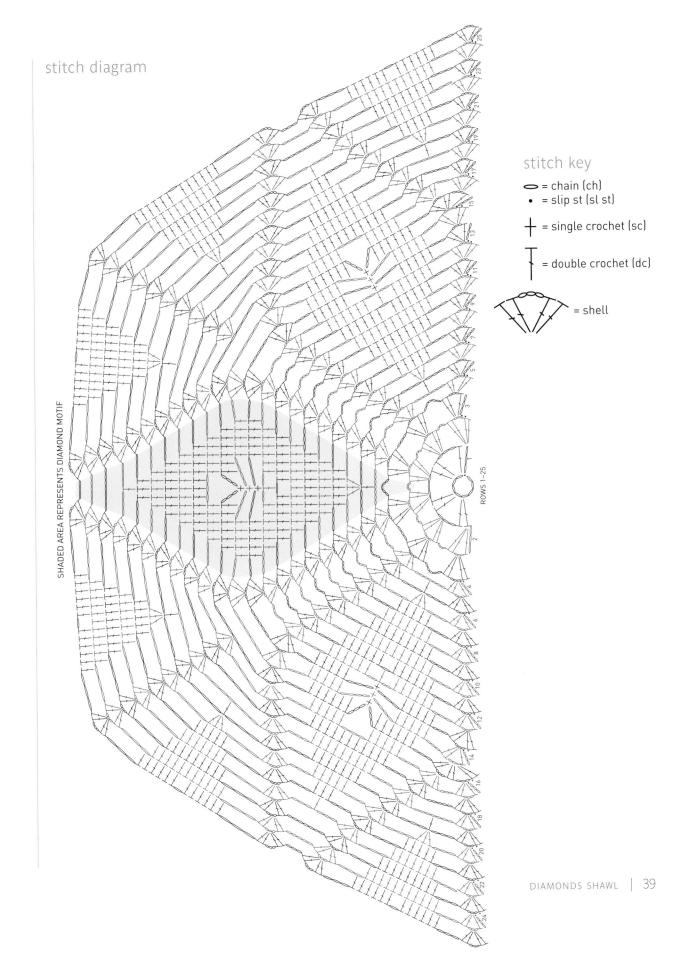

SHADED AREA REPRESENTS DIAMOND MOTIF

ROWS 1–25

stitch key

◯ = chain (ch)

• = slip st (sl st)

✚ = single crochet (sc)

⊤ = double crochet (dc)

= shell

ROW 16: Sl st to first ch-3 sp, beg shell in first ch-3 sp, ch 3, *shell in next ch-3 sp, ch 3, skip next ch-3 sp, skip next dc, dc in each of next 5 dc, ch 3, skip next 2 ch-3 sps, dc in each of next 5 dc, ch 3, skip next dc, skip next ch-3 sp, shell in next ch-3 sp, ch 3, shell in 4th ch of next ch7 sp, ch 3**, skip next 3 ch, shell in next ch, ch 3, skip next 3 ch, rep from * once, rep from * to ** once, shell in last ch-3 sp, turn.

ROW 17: Sl st to first ch-3 sp, beg shell in first ch-3 sp, *ch 5, skip next ch-3 sp, shell in next ch-3 sp, ch 3, skip next ch-3 sp, skip next dc, dc in each of next 4 dc, 3 dc in next ch-3 sp, dc in each of next 4 dc, ch 3, skip next dc, skip next ch-3 sp, shell in next ch-3 sp, ch 5, skip next ch-3 sp, shell in next shell, rep from * twice, turn.

ROW 18: Sl st to first ch-3 sp, beg shell in first ch-3 sp, *ch 7, skip next ch-5 sp, shell in next ch-3 sp, ch 3, skip next ch-3 sp, skip next dc, dc in each of next 9 dc, ch 3, skip next dc, skip next ch-3 sp, shell in next ch-3 sp, ch 7, skip next ch-5 sp, shell in next ch-3 sp, rep from * twice, turn.

ROW 19: Sl st to first ch-3 sp, beg shell in first ch-3 sp, *ch 3, skip next 3 ch, dc in next ch, ch 3, skip next 3 ch, shell in next ch-3 sp, ch 3, skip next ch-3 sp, skip next dc, dc in each of next 7 dc, ch 3, skip next dc, skip next ch-3 sp, shell in next ch-3 sp, ch 3, skip next 3 ch, dc in next ch, ch 3, skip next 3 ch, shell in next ch-3 sp, rep from * twice, turn.

ROW 20: Sl st to first ch-3 sp, beg shell in first ch-3 sp, *ch 3, skip next ch-3 sp, 3 dc in next dc, ch 3, skip next ch-3 sp, shell in next ch-3 sp, ch 3, skip next ch-3 sp, skip next dc, dc in each of next 5 dc, ch 3, skip next dc, skip next ch-3 sp, shell in next ch-3 sp, ch 3, skip next ch-3 sp, 3 dc in next dc, ch 3, skip next ch-3 sp, shell in next ch-3 sp, rep from * twice, turn.

ROW 21: Sl st to first ch-3 sp, beg shell in first ch-3 sp, *ch 3, dc in next ch-3 sp, dc in each of next 3 dc, dc in next ch-3 sp, ch 3, shell in next ch-3 sp, ch 3, skip next ch-3 sp, skip next dc, dc in each of

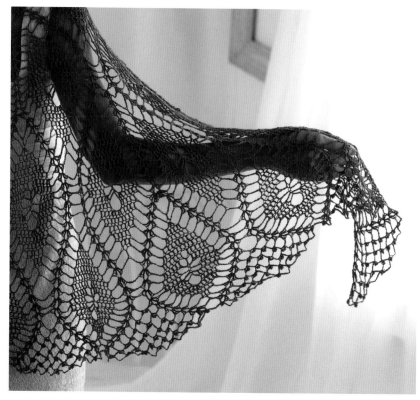

next 3 dc, ch 3, skip next dc, skip next ch-3 sp, shell in next ch-2 sp, ch 3, dc in next ch-3 sp, dc in each of next 3 dc, dc in next ch-3 sp, ch 3, shell in next ch-3 sp, rep from * twice, turn.

ROW 22: Sl st to first ch-3 sp, beg shell in first ch-3 sp, *ch 3, dc in next ch-3 sp, dc in each of next 5 dc, dc in next ch-3 sp, ch 3, shell in next ch-3 sp, ch 3, skip next ch-3 sp, skip next dc, dc in next dc, ch 3, skip next dc, skip next ch-3 sp, shell in next ch-2 sp, ch 3, dc in next ch-3 sp, dc in each of next 5 dc, dc in next ch-3 sp, ch 3, shell in next ch-3 sp, rep from * twice, turn.

ROW 23: Sl st to first ch-3 sp, beg shell in first ch-3 sp, *ch 3, dc in next ch-3 sp, dc in each of next 7 dc, dc in next ch-3 sp, ch 3, shell in next ch-3 sp, ch 5, skip next 2 ch-3 sps, shell in next ch-3 sp, ch 3, dc in next ch-3 sp, dc in each of next 7 dc, dc in next ch-3 sp, ch 3, shell in next ch-3 sp, rep from * twice, turn.

ROW 24: Sl st to first ch-3 sp, beg shell in first ch-3 sp, *ch 3, dc in next ch-3 sp, dc in each of next 9 dc, dc in next ch-3

sp, ch 3, shell in next ch-5 sp, ch 3, skip next ch-7 sp, shell in next ch-3 sp, ch 3, dc in next ch-3 sp, dc in each of next 9 dc, dc in next ch-3 sp, ch 3, shell in next ch-3 sp, rep from * twice, turn.

ROW 25: Sl st to first ch-3 sp, beg shell in first ch-3 sp, *ch 3, dc in next ch-3 sp, dc in each of next 5 dc, ch 1, skip next dc, dc in each of next 5 dc, dc in next ch-3 sp, ch 3, shell in next ch-3 sp, ch 3, skip next ch-5 sp, shell in next ch-3 sp, ch 3, dc in next ch-3 sp, dc in each of next 5 dc, ch 1, skip next dc, dc in each of next 5 dc, dc in next ch-3 sp, ch 3, skip next ch-3 sp, shell in next ch-3 sp, rep from * twice, turn.

ROW 26: Sl st to first ch-3 sp, beg shell in first ch-3 sp, *ch 3, dc in next ch-3 sp, dc in each of next 5 dc, ch 2, skip next dc, dc in next ch-1 sp, ch 2, skip next dc, dc in each of next 5 dc, dc in next ch-3 sp, ch 3, shell in next ch-3 sp, ch 3, skip next ch-3 sp, shell in next ch-3 sp, ch 3, dc in next ch-3 sp, dc in each of next 5 dc, ch 2, skip next dc, dc in next ch-1 sp, ch 2, skip next dc, dc in each of next

5 dc, dc in next ch-3 sp, ch 3, shell in next ch-3 sp, rep from * twice, turn.

ROW 27: Sl st to first ch-3 sp, beg shell in first ch-3 sp, *ch 3, dc in next ch-3 sp, dc in each of next 4 dc, ch 3, skip next ch-2 sp, sc in next dc, ch 3, skip next 2 dc, dc in each of next 4 dc, dc in next ch-3 sp, ch 3, shell in next ch-3 sp, ch 5, skip next ch-3 sp, shell in next ch-3 sp, ch 3, dc in next ch-3 sp, dc in each of next 4 dc, ch 3, skip next ch-2 sp, sc in next dc, ch 3, skip next 2 dc, dc in each of next 4 dc, dc in next ch-3 sp, ch 3, shell in next ch-3 sp, rep from * twice, turn.

ROW 28: Sl st to first ch-3 sp, beg shell in first ch-3 sp, *ch 3, skip next ch-3 sp, dc in each of next 5 dc, ch 4, skip next ch-3 sp, sc in next sc, ch 4, skip next ch-3 sp, dc in each of next 5 dc, ch 3, skip next ch-3 sp, shell in next ch-3 sp, ch 5, skip next ch-5 sp, shell in next ch-3 sp, ch 3, skip next ch-3 sp, dc in each of next 5 dc, ch 4, skip next ch-3 sp, sc in next sc, ch 4, skip next ch-3 sp, dc in each of next 5 dc, ch 3, skip next ch-3 sp, shell in next ch-3 sp, rep from * twice, turn.

ROW 29: Sl st to first ch-3 sp, (beg shell, ch 3, 2 dc) in first ch-3 sp, *ch 3, skip next ch-3 sp, skip next dc, dc in each of next 4 dc, 2 dc in next ch-4 sp, ch 3, sc in next sc, ch 3, 2 dc in next ch-4 sp, dc in each of next 4 dc, ch 3, skip next dc, skip next ch-3 sp, shell in next ch-3 sp, ch 7, skip next ch-5 sp, shell in next ch-3 sp, ch 3, skip next ch-3 sp, skip next dc, dc in each of next 4 dc, 2 dc in next ch-4 sp, ch 3, sc in next sc, ch 3, 2 dc in next ch-4 sp, dc in each of next 4 dc, ch 3, skip next dc, skip next ch-3 sp, (shell, ch 3, 2 dc) in next ch-3 sp, rep from * twice, turn.

ROW 30: Sl st to first ch-3 sp, beg shell in first ch-3 sp, *ch 3, shell in next ch-3 sp, **ch 3, skip next ch-3 sp, skip next dc, dc in each of next 5 dc, ch 3, skip next 2 ch-3 sps, dc in each of next 5 dc, ch 3, skip next ch-3 sp, shell in next ch-3 sp**, ch 3, shell in 4th ch of next ch-7 sp, ch 3, skip next 3 ch, shell in next ch-3 sp, rep from ** to ** once, rep from * twice, turn.

ROW 31: Sl st to first ch-3 sp, beg shell in first ch-3 sp, *ch 5, skip next ch-3 sp, shell in next ch-3 sp, **ch 3, skip next ch-3 sp, skip next dc, dc in each of next 4 dc, 3 dc in next ch-3 sp, dc in each of next 4 dc, ch 3, skip next dc, skip next ch-3 sp, shell in next ch-3 sp**, [ch 5, skip next ch-3 sp, shell in next ch-3 sp] twice, rep from ** to ** once, rep from * twice, turn.

ROW 32: Sl st to first ch-3 sp, beg shell in first ch-3 sp, *ch 7, skip next ch-5 sp, shell in next ch-3 sp, **ch 3, skip next dc, dc in each of next 9 dc, ch 3, skip next ch-3 sp, shell in next ch-3 sp**, [ch 7, skip next ch-5 sp, shell in next ch-3 sp] twice, rep from ** to ** once, ch 7, skip next ch-5 sp, shell in next ch-3 sp, rep from * twice, turn.

ROW 33: Sl st to first ch-3 sp, beg shell in first ch-3 sp, *ch 3, skip next 3 ch, dc in next ch, ch 3, skip next 3 ch, shell in next ch-3 sp**, ch 3, skip next ch-3 sp, skip next dc, dc in each of next 7 dc, ch 3, skip next dc, skip next ch-3 sp, shell in next ch-3 sp, rep from * to ** twice, ch 3, skip next ch-3 sp, skip next dc, dc in each of next 7 dc, ch 3, skip next dc, skip next ch-3 sp, shell in next ch-3 sp, rep from * twice, rep from * to ** once, turn.

ROW 34: Sl st to first ch-3 sp, beg shell in first ch-3 sp, *ch 3, skip next ch-3 sp, 3 dc in next dc, ch 3, skip next ch-3 sp, shell in next ch-3 sp**, ch 3, skip next ch-3 sp, skip next dc, dc in each of next 5 dc, ch 3, skip next dc, skip next ch-3 sp, shell in next ch-3 sp, rep from * to ** twice, ch 3, skip next ch-3 sp, skip next dc, dc in each of next 5 dc, ch 3, skip next dc, skip next ch-3 sp, shell in next ch-3 sp, rep from * twice, rep from * to ** once, turn.

ROW 35: Sl st to first ch-3 sp, beg shell in first ch-3 sp, *ch 3, dc in next ch-3 sp, dc in each of next 3 dc, dc in next ch-3 sp, ch 3, shell in next ch-3 sp**, ch 3, skip next ch-3 sp, skip next dc, dc in each of next 3 dc, ch 3, skip next dc, skip next ch-3 sp, shell in next ch-3 sp, rep from * to ** twice, ch 3, skip next ch-3

sp, skip next dc, dc in each of next 3 dc, ch 3, skip next dc, skip next ch-3 sp, shell in next ch-3 sp, rep from * twice, rep from * to ** once, turn.

ROW 36: Sl st to first ch-3 sp, beg shell in first ch-3 sp, *ch 3, dc in next ch-3 sp, dc in each of next 5 dc, dc in next ch-3 sp, ch 3, shell in next ch-3 sp**, ch 3, skip next ch-3 sp, skip next dc, dc in next dc, ch 3, skip next dc, skip next ch-3 sp, shell in next ch-3 sp, rep from * to ** twice, ch 3, skip next ch-3 sp, skip next dc, dc in next dc, ch 3, skip next dc, skip next ch-3 sp, shell in next ch-3 sp, rep from * twice, rep from * to ** once, turn.

ROW 37: Sl st to first ch-3 sp, beg shell in first ch-3 sp, *ch 3, dc in next ch-3 sp, dc in each of next 7 dc, dc in next ch-3 sp, ch 3, shell in next ch-3 sp**, ch 7, skip next 2 ch-3 sps, shell in next ch-3 sp, rep from * to ** twice, ch 7, skip next 2 ch-3 sps, shell in next ch-3 sp, rep from * twice, rep from * to ** once, turn.

ROW 38: Sl st to first ch-3 sp, beg shell in first ch-3 sp, *ch 3, dc in next ch-3 sp, dc in each of next 9 dc, dc in next ch-3 sp, ch 3, shell in next ch-3 sp**, ch 5, skip next ch-7 sp, shell in next ch-3 sp, rep from * to ** twice, ch 5, skip next ch-7 sp, shell in next ch-3 sp, rep from * twice, rep from * to ** once, turn.

ROW 39: Sl st to first ch-3 sp, beg shell in first ch-3 sp, *ch 3, dc in next ch-3 sp, dc in each of next 5 dc, ch 1, skip next dc, dc in each of next 5 dc, dc in next ch-3 sp, ch 3, shell in next ch-3 sp**, ch 3, skip next ch-5 sp, shell in next ch-3 sp, rep from * to ** twice, ch 3, skip next ch-5 sp, shell in next ch-3 sp, rep from * twice, rep from * to ** once, turn.

ROW 40: Sl st to first ch-3 sp, beg shell in first ch-3 sp, *ch 3, dc in next ch-3 sp, dc in each of next 5 dc, ch 2, skip next dc, dc in next ch-1 sp, ch 2, skip next dc, dc in each of next 5 dc, dc in next ch-3 sp, ch 3, shell in next ch-3 sp**, ch 3, skip next ch-3 sp, shell in next ch-3 sp, rep from * to ** twice, ch 3, skip next ch-3 sp, shell in next ch-3 sp, rep from * twice, rep from * to ** once, turn.

ROW 41: Sl st to first ch-3 sp, beg shell in first ch-3 sp, *ch 3, dc in next ch-3 sp, dc in each of next 4 dc, ch 3, skip next 2 dc, skip next ch-2 sp, sc in next dc, ch 3, skip next ch-2 sp, skip next 2 dc, dc in each of next 4 dc, dc in next ch-3 sp, ch 3, shell in next ch-3 sp**, ch 3, skip next ch-3 sp, shell in next ch-3 sp, rep from * to ** twice, ch 3, skip next ch-3 sp, shell in next ch-3 sp, rep from * twice, rep from * to ** once, turn.

ROW 42: Sl st to first ch-3 sp, beg shell in first ch-3 sp, *ch 3, skip next ch-3 sp, dc in each of next 5 dc, ch 4, skip next ch-3 sp, sc in next sc, ch 4, skip next ch-3 sp, dc in each of next 5 dc, ch 3, skip next ch-3 sp, shell in next ch-3 sp**, ch 3, skip next ch-3 sp, shell in next ch-3 sp, rep from * to ** twice, ch 3, skip next ch-3 sp, shell in next ch-3 sp, rep from * twice, rep from * to ** once, turn.

ROW 43: Sl st to first ch-3 sp, (beg shell, ch 3, 2 dc) in first ch-3 sp, *ch 3, skip next ch-3 sp, skip next dc, dc in each of next 4 dc, 2 dc in next ch-4 sp, ch 3, sc in next sc, ch 3, 2 dc in next ch-4 sp, dc in each of next 4 dc, ch 3, skip next dc, skip next ch-3 sp, shell in next ch-3 sp**, ch 3, skip next ch-3 sp, shell in next ch-3 sp, ch 3, skip next ch-3 sp, skip next dc, dc in each of next 4 dc, 2 dc in next ch-4 sp, ch 3, sc in next sc, ch 3, 2 dc in next ch-4 sp, dc in each of next 4 dc, ch 3, skip next dc, skip next ch-3 sp, (shell, ch 3, 2 dc) in next ch-3 sp, rep from * to ** once, ch 3, skip next ch-3 sp, shell in next ch-3 sp, rep from * twice, ch 3, skip next ch-3 sp, shell in next ch-3 sp, ch 3, skip next ch-3 sp, skip next dc, dc in each of next 4 dc, 2 dc in next ch-4 sp, ch 3, sc in next sc, ch 3, 2 dc in next ch-4 sp, dc in each of next 4 dc, ch 3, skip next dc, skip next ch-3 sp, (shell, ch 3, 2 dc) in next ch-3 sp, turn.

ROW 44: Sl st to first ch-3 sp, beg shell in first ch-3 sp, *ch 3, shell in next ch-3 sp, **ch 3, skip next ch-3 sp, skip next dc, dc in each of next 5 dc, ch 3, skip next 2 ch-3 sps, dc in each of next 5 dc, ch 3, skip next dc, skip next ch-3, shell

in next ch-3 sp**, ch 3, skip next ch-3 sp, shell in next ch-3 sp, rep from ** to ** once, ch 3, shell in next ch-3 sp, rep from ** to ** once, [ch 3, skip next ch-3 sp, shell in next ch-3 sp, rep from ** to ** once] twice, ch 3, shell in next ch-3 sp, rep from ** to ** once, [ch 3, skip next ch-3 sp, shell in next ch-3 sp, rep from ** to ** once] twice, ch 3, shell in next ch-3 sp, rep from ** to ** once, ch 3, skip next ch-3 sp, shell in next ch-3 sp, rep from ** to ** once, ch 3, shell in next ch-3 sp, turn.

ROW 45: Sl st to first ch-3 sp, beg shell in first ch-3 sp, *ch 5, skip next ch-3 sp, shell in next ch-3 sp**, ***ch 3, skip next ch-3 sp, skip next dc, dc in each of next 4 dc, 3 dc in next ch-3 sp, dc in each of next 4 dc, ch 3, skip next ch-3 sp***, shell in next ch-3 sp*, rep from * to * 4 times, [ch 5, shell] in each of next 2 ch-3 sps, rep from *** to *** once, rep from * to * across, ending last rep at **, turn.

ROW 46: Sl st to first ch-3 sp, beg shell in first ch-3 sp, *ch 7, skip next ch-5 sp, shell in next ch-3 sp**, ch 3, skip next ch-3 sp, skip next dc, dc in each of next 9 dc, ch 3, skip next dc, skip next ch-3 sp, shell in next ch-3 sp*, rep from * to * 4 times, ch 7, skip next ch-5 sp, shell in next ch-3 sp, rep from * to * across, ending last rep at **, turn.

ROW 47: Sl st to first ch-3 sp, beg shell in first ch-3 sp, *ch 3, skip next 3 ch, dc in next ch, ch 3, skip next 3 ch, shell in next ch-3 sp**, ch 3, skip next ch-3 sp, skip next dc, dc in each of next 7 dc, ch 3, skip next dc, skip next ch-3 sp, shell in next ch-3 sp*, rep from * to * 4 times, rep from * to ** once, rep from * to * across, ending last rep at **, turn.

ROW 48: Sl st to first ch-3 sp, beg shell in first ch-3 sp, *ch 3, skip next ch-3 sp, 3 dc in next dc, ch 3, skip next ch-3 sp, shell in next ch-3 sp**, ch 3, skip next ch-3 sp, skip next dc, dc in each of next 5 dc, ch 3, skip next dc, skip next ch-3 sp, shell in next ch-3 sp*, rep from * to * 4 times, rep from * to ** once, rep from * to * across, ending last rep at **, turn.

ROW 49: Sl st to first ch-3 sp, beg shell in first ch-3 sp, *ch 3, dc in next ch-3 sp, dc in each of next 3 dc, dc in next ch-3 sp, ch 3, shell in next ch-3 sp**, ch 3, skip next ch-3 sp, skip next dc, dc in each of next 3 dc, ch 3, skip next dc, skip next ch-3 sp, shell in next ch-3 sp*, rep from * to * 4 times, rep from * to ** once, rep from * to * across, ending last rep at **, turn.

ROW 50: Sl st to first ch-3 sp, beg shell in first ch-3 sp, *ch 3, dc in next ch-3 sp, dc in each of next 5 dc, dc in next ch-3 sp, ch 3, shell in next ch-3 sp**, ch 3, skip next ch-3 sp, skip next dc, dc in next dc, ch 3, skip next dc, skip next ch-3 sp, shell in next ch-3 sp*, rep from * to * 4 times, rep from * to ** once, rep from * to * across, ending last rep at **, turn.

ROW 51: Sl st to first ch-3 sp, beg shell in first ch-3 sp, *ch 3, dc in next ch-3 sp, dc in each of next 7 dc, dc in next ch-3 sp, ch 3, shell in next ch-3 sp**, ch 7, skip next 2 ch-3 sps, shell in next ch-3 sp*, rep from * to * 4 times, rep from * to ** once, rep from * to * across, ending last rep at **, turn.

ROW 52: Sl st to first ch-3 sp, beg shell in first ch-3 sp, *ch 3, dc in next ch-3 sp, dc in each of next 9 dc, dc in next ch-3 sp, ch 3, shell in next ch-3 sp, ch 5, skip next ch-7 sp, shell in next ch-3 sp*, rep from * to * 4 times, rep from * to ** once, rep from * to * across, ending last rep at **, turn.

ROW 53: Sl st to first ch-3 sp, beg shell in first ch-3 sp, *ch 3, dc in next ch-3 sp, dc in each of next 5 dc, ch 1, skip next dc, dc in each of next 5 dc, dc in next ch-3 sp, ch 3, shell in next ch-3 sp**, ch 3, skip next ch-5 sp, shell in next ch-3 sp*, rep from * to * 4 times, rep from * to ** once, rep from * to * across, ending last rep at **, turn.

ROW 54: Sl st to first ch-3 sp, beg shell in first ch-3 sp, *ch 3, dc in next ch-3 sp, dc in each of next 5 dc, ch 2, skip next dc, dc in next ch-1 sp, ch 2, skip next dc, dc in each of next 5 dc, dc in next ch-3

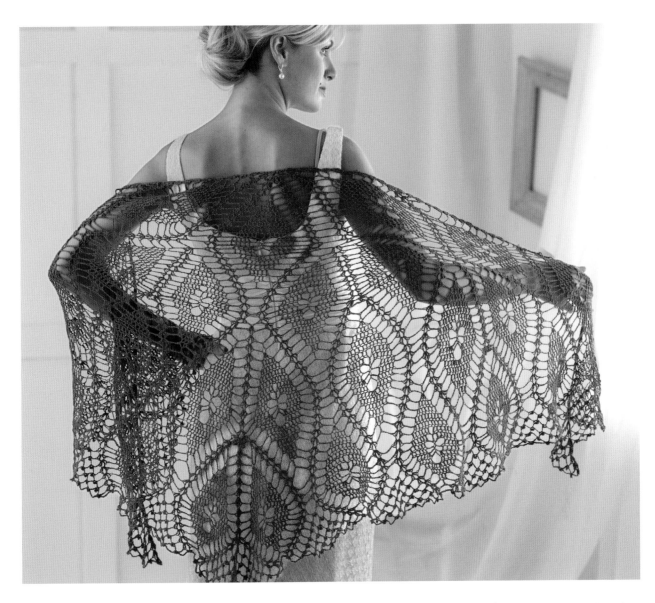

sp, ch 3, shell in next ch-3 sp**, ch 5, skip next ch-3 sp, ch 3, shell in next ch-3 sp*, rep from * to * 4 times, rep from * to ** once, rep from * to * across, ending last rep at **, turn.

ROW 55: Sl st to first ch-3 sp, beg shell in first ch-3 sp, *ch 3, dc in next ch-3 sp, dc in each of next 4 dc, ch 3, skip next 2 dc, skip next ch-2 sp, sc in next dc, ch 3, skip next ch-2 sp, skip next 2 dc, dc in each of next 4 dc, dc in next ch-3 sp, ch 3, shell in next ch-3 sp**, ch 5, skip next ch-5 sp, shell in next ch-3 sp*, rep from * across, to * 4 times, rep from * to **

once, rep from * to * ending last rep at **, turn.

ROW 56: Sl st to first ch-3 sp, beg shell in first ch-3 sp, *ch 3, skip next ch-3 sp, dc in each of next 5 dc, ch 4, skip next ch-3 sp, sc in next sc, ch 4, skip next ch-3 sp, dc in each of next 5 dc, ch 3, skip next ch-3 sp, shell in next ch-3 sp**, ch 5, skip next ch-5 sp, shell in next ch-3 sp*, rep from * to * 4 times, ch 3, skip next ch-3 sp, dc in each of next 5 dc, ch 4, skip next ch-3 sp, sc in next sc, ch 4, skip next ch-3 sp, dc in each of next 5 dc, ch 3, skip next ch-3 sp, (shell,

ch 5, shell) in next ch-3 sp, rep from * to * across, ending last rep at **, turn.

ROW 57: Sl st to first ch-3 sp, ch 3, (dc, ch 5, shell) in first ch-3 sp, *ch 3, skip next ch-3 sp, skip next dc, dc in each of next 4 dc, 2 dc in next ch-4 sp, ch 3, sc in next sc, ch 3, 2 dc in next ch-4 sp, dc in each of next 4 dc, ch 3, skip next dc, skip next ch-3 sp**, shell in next ch-3 sp, ch 5, skip next ch-5 sp, shell in next ch-3 sp*, rep from * to * 5 times, ch 5, skip next ch-3 sp, shell in next ch-3 sp, rep from * to * across, ending last rep at **, (shell, ch 5, 2 dc) in last ch-3 sp, turn.

ROW 58: Ch 3, dc in next dc, *ch 5, (sc, ch 3, sc) in next ch-5 sp, ch 5**, shell in next ch-3 sp, ch 3, skip next ch-3 sp, skip next dc, dc in each of next 5 dc, ch 3, skip next 2 ch-3 sps, dc in each of next 5 dc, ch 3, skip next dc, skip next ch-3, shell in next ch-3 sp*, rep from * to * 5 times, ch 5, 2 dc in next ch-5 sp, ch 5, shell in next ch-3 sp, rep from * to * across, ending last rep at **, dc in each of last 2 dc, turn.

ROW 59: Ch 3, dc in next dc, *[ch 5, sc, ch 3, sc] in each of next 2 ch-5 sps, ch 5**, shell in next ch-3 sp, ch 3, skip next ch-3 sp, skip next dc, dc in each of next 4 dc, 3 dc in next ch-3 sp, dc in each of next 4 dc, ch 3, skip next dc, skip next ch-3 sp, shell in next sh-3 sp, rep from * to * 5 times, ch 5, (sc, ch 3, sc) in next ch-5 sp, ch 5, dc in each of next 2 dc, ch 5, (sc, ch 3, sc) in next ch-5 sp, ch 5, shell in next ch-3 sp, rep from * to * across, ending last rep at **, dc in each of last 2 dc, turn.

ROW 60: Ch 3, dc in next dc, *[ch 5, sc, ch 3, sc] in each of next 3 ch-5 sps, ch 5**, shell in next ch-3 sp, ch 3, skip next ch-3 sp, skip next dc, dc in each of next 9 dc, ch 3, skip next dc, skip next ch-3 sp, shell in next sh-3 sp, rep from * to * 5 times, [ch 5, sc, ch 3, sc] in each of next 2 ch-5 sps, ch 5, dc in each of next 2 dc, [ch 5, sc, ch 3, sc] in each of next 2 ch-5 sps, ch 5, shell in next ch-3 sp, rep from * to * across, ending last rep at **, dc in each of last 2 dc, turn.

ROW 61: Ch 3, dc in next dc, *[ch 5, sc, ch 3, sc] in each of next 4 ch-5 sps, ch 5**, shell in next ch-3 sp, ch 3, skip next ch-3 sp, skip next dc, dc in each of next 7 dc, ch 3, skip next dc, skip next ch-3 sp, shell in next sh-3 sp, rep from * to * 5 times, [ch 5, sc, ch 3, sc] in each of next 3 ch-5 sps, ch 5, dc in each of next 2 dc, [ch 5, sc, ch 3, sc] in each of next 3 ch-5 sps, ch 5, shell in next ch-3 sp, rep from * to * across, ending last rep at **, dc in each of last 2 dc, turn.

ROW 62: Ch 3, dc in next dc, *[ch 5, sc, ch 3, sc] in each of next 5 ch-5 sps, ch 5**, shell in next ch-3 sp, ch 3, skip next ch-3 sp, skip next dc, dc in each of next 5 dc, ch 3, skip next dc, skip next ch-3 sp, shell in next sh-3 sp, rep from * to * 5 times, [ch 5, sc, ch 3, sc] in each of next 4 ch-5 sps, ch 5, dc in each of next 2 dc, [ch 5, sc, ch 3, sc] in each of next 4 ch-5 sps, ch 5, shell in next ch-3 sp, rep from * to * across, ending last rep at **, dc in each of last 2 dc, turn.

ROW 63: Ch 3, dc in next dc, *[ch 5, sc, ch 3, sc] in each of next 6 ch-5 sps, ch 5**, shell in next ch-3 sp, ch 3, skip next ch-3 sp, skip next dc, dc in each of next 3 dc, ch 3, skip next dc, skip next ch-3 sp, shell in next sh-3 sp, rep from * to * 5 times, [ch 5, sc, ch 3, sc] in each of next 5 ch-5 sps, ch 5, dc in each of next 2 dc, [ch 5, sc, ch 3, sc] in each of next 5 ch-5 sps, ch 5, shell in next ch-3 sp, rep from * to * across, ending last rep at **, dc in each of last 2 dc, turn.

ROW 64: Ch 3, dc in next dc, *[ch 5, sc, ch 3, sc] in each of next 7 ch-5 sps, ch 5**, shell in next ch-3 sp, ch 3, skip next ch-3 sp, skip next dc, dc in each of next 3 dc, ch 3, skip next dc, skip next ch-3 sp, shell in next sh-3 sp, rep from * to * 5 times, [ch 5, sc, ch 3, sc] in each of next 6 ch-5 sps, ch 5, dc in each of next 2 dc, [ch 5, sc, ch 3, sc] in each of next 6 ch-5 sps, ch 5, shell in next ch-3 sp, rep from * to * across, ending last rep at **, dc in each of last 2 dc, turn.

ROW 65: Ch 3, dc in next dc, *[ch 5, sc, ch 3, sc] in each of next 8 ch-5 sps, ch 5**, shell in next ch-3 sp, ch 3, skip next ch-3 sp, skip next dc, dc in each of next 3 dc, ch 3, skip next dc, skip next ch-3 sp, shell in next sh-3 sp, rep from * to * 5 times, [ch 5, sc, ch 3, sc] in each of next 7 ch-5 sps, ch 5, dc in each of next 2 dc, [ch 5, sc, ch 3, sc] in each of next 7 ch-5 sps, ch 5, shell in next ch-3 sp, rep from * to * across, ending last rep at **, dc in each of last 2 dc, turn. Fasten off. Weave in loose ends.

Wet or steam block to finished measurements. Weave in loose ends with a tapestry needle.

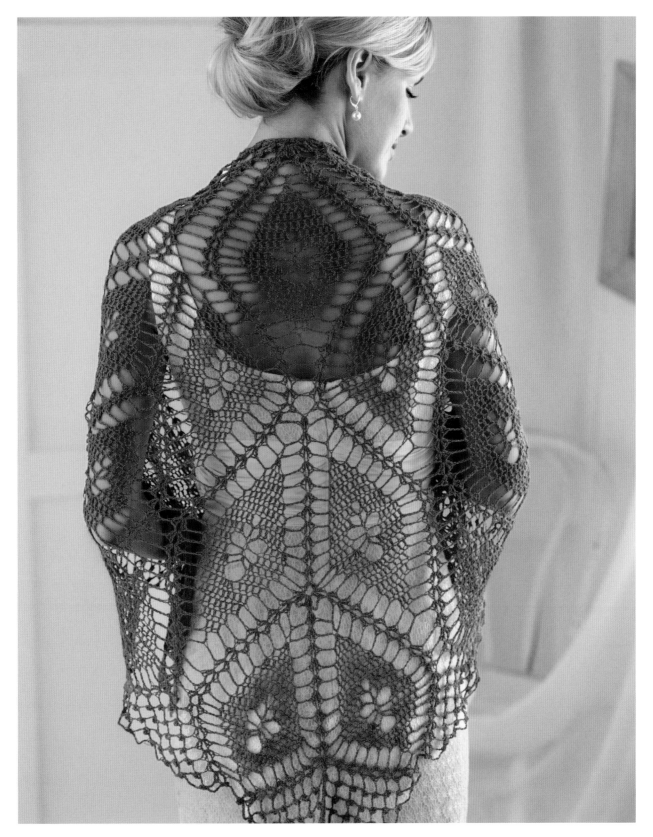

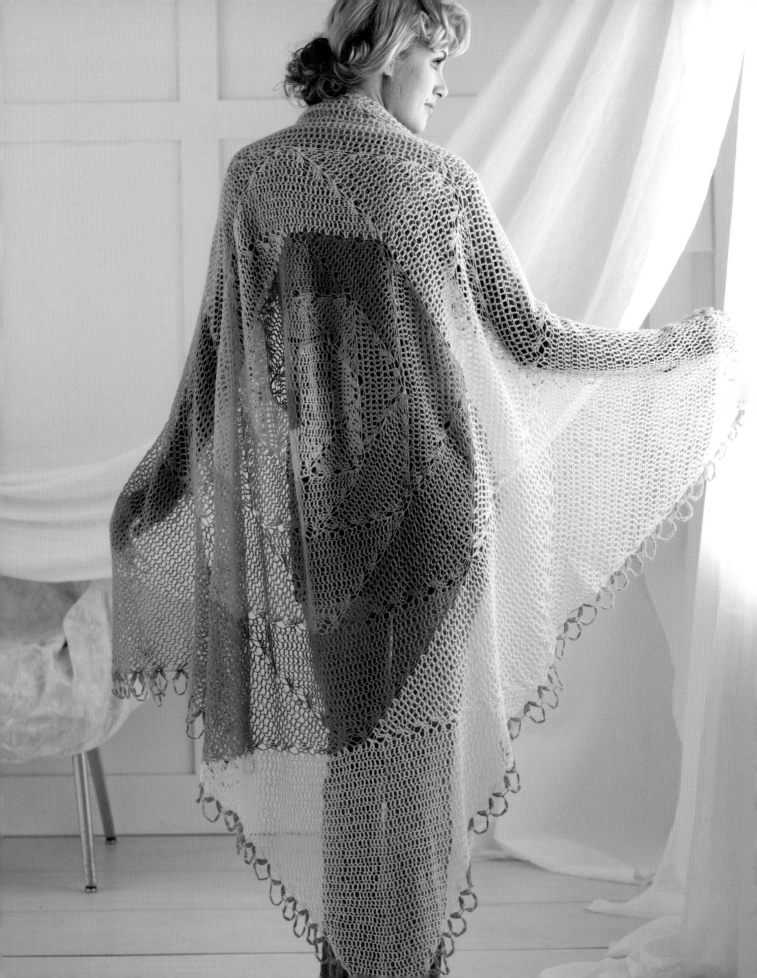

spiral waves SHAWL

I won't deny it; I am drawn to spirals, especially those found in the natural world. The growth spiral, such as that in a nautilus shell, is a naturally occurring pattern in nature, and the spiral's growth is proportional to its size. I had an idea to combine a growth spiral with a log cabin square. Using four colors, I began with four little squares in the center. On each following round, I began each color by picking up stitches along two colors and then decreased out in a triangle. And so, this large, versatile shawl was born. Wear it long and draped over your shoulders or fold it in half like a rectangle or triangle. You can even roll the edge to create a shawl collar; the possibilities are endless!

YARN

Fingering weight (#1 Super Fine); 825 yd (754.4 m) MC, 650 (594.4 m) yd CC1, 650 (594.4 m) yd CC2, 650 yd (594.4 m) CC3—2,775 yd (2537.5 m) total.

shown: Filatura di Crosa, Superior (70% cashmere/30% schappe silk; 330 yd [301.8 m]/.88 oz [25 g]): #32 light denim (MC), 3 balls; #17 pale yellow (CC1), 2 balls; #03 light blue (CC2), 2 balls; #31 mustard (CC3), 2 balls.

HOOK

G/6 (4mm) or size needed to obtain gauge.

NOTIONS

Tapestry needle.

GAUGE

10 sts x 9 rows sc = 4" (10 cm).

FINISHED SIZE

60" (152.5 cm) square.

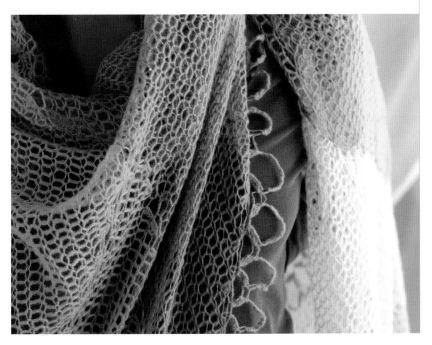

special stitches

Foundation single crochet (fsc) p. 157.

2 treble crochet cluster (2-tr cl) p. 158.

Spiral Waves Shawl

Refer to stitch diagram A at right and the construction diagram on p. 50 for assistance.

Beginning Squares

ROW 1: With MC, work 10 fsc, switch to CC1, with CC1, work 10 fsc—20 sts.

ROW 2: With CC1, ch 1, sc in each of first 10 sc, change to MC, sc in each sc across, turn—20 sc.

ROW 3: With MC, ch 1, sc in each of first 10 sc, change to CC1, sc in each sc across, turn—20 sc.

ROWS 4–10: Rep Rows 2–3 three times, rep Row 2 once more. Fasten off both yarns.

ROW 11: With RS facing, join CC3 with sl st in first st, ch 1, sc in each of first 10 sc, change to CC2, sc in each sc across—20 sc.

ROW 12: With CC2, ch 1, sc in each of first 10 sc, change to CC3, sc in each sc across, turn—20 sc.

ROWS 13–20: Rep Rows 11–12 four times—20 sts. Fasten off CC2. Do not fasten off CC3.

Triangles Level 1 (TL1)

CC3 TL1: With CC3, turn work 90 degrees clockwise and work in ends of rows.

ROW 1: Ch 1, work 10 sc evenly across CC3 square, work 10 sc evenly across CC2 square, turn—20 sc.

ROW 2: Ch 1, sc2tog in first 2 sc, sc in each sc across to within last 2 sts, sc2tog in last 2 sc, turn—18 sts.

ROWS 3–10: Rep Row 2—2 sts.

ROW 11: Ch 1, sc2tog in next 2 sc. Fasten off.

CC2 TL1: Turn work 90 degrees clockwise. Join CC2 with sl st in top right-hand corner sc, working across CC2 square and CC1 square, rep Rows 1–11 with CC2. Fasten off.

CC1 TL1: Turn work 90 degrees clockwise. Join CC1 with sl st in top right-hand corner sc, working across CC1 square and MC square, rep Rows 1–11 with CC1. Fasten off.

MC TL1: Turn work 90 degrees clockwise. Join MC with sl st in top right-hand corner sc, working across MC square and CC3 square, rep Rows 1–11 with MC. Do not fasten off.

Triangles Level 2 (TL2)

MC TL2: Turn work 45 degrees clockwise and work in ends of rows of MC TL1 and CC3 TL1.

ROW 1: With MC, ch 1, work 15 sc evenly across MC TL1 and work 15 sc evenly across CC3 TL1, turn—30 sc.

ROW 2: Ch 1, sc2tog in first 2 sts, sc across to within last 2 sts, sc2tog in last 2 sc, turn—28 sts.

ROWS 3–15: Rep Row 2—2 sts.

ROW 16: Ch 1, sc2tog in next 2 sc. Fasten off.

CC3 TL2: Turn work 90 degrees and work in ends of rows of CC3 TL1 and CC2 TL1. Join CC3 with sl st in top right-hand corner sc, rep Rows 1–16 of MC TL2 with CC3. Fasten off.

CC2 TL2: Turn work 90 degrees and work in ends of rows of CC2 TL1 and CC1 TL1. Join CC2 with sl st in top right-hand corner sc, rep Rows 1–16 of MC TL2 with CC2. Fasten off.

CC1 TL2: Turn work 90 degrees and work in ends of rows of CC1 TL1 and MC TL1. Join CC1 with sl st in top right-hand corner sc, rep Rows 1–16 of MC TL2 with CC1. Do not fasten off.

Triangles Level 3 (TL3)

CC1 TL3: Turn work 45 degrees and work in ends of rows CC1 TL2 and MC TL2.

ROW 1: Ch 1, work 20 sc evenly across CC1 TL2 and work 20 sc evenly across MC TL2, turn—40 sc.

ROW 2: Ch 1, sc2tog in first 2 sts, sc across to within last 2 sts, sc2tog in last 2 sc, turn—38 sts.

ROWS 3–20: Rep Row 2.

ROW 21: Ch 1, sc2tog in next 2 sc. Fasten off.

MC TL3: Turn work 90 degrees and work in ends of rows of MC TL2 and CC3 TL2. Join MC with sl st in top right-hand corner sc, rep Rows 1–21 with MC. Fasten off.

CC3 TL3: Turn work 90 degrees and work in ends of rows CC3 TL2 and CC2 TL2. Join CC3 with sl st in top right-hand corner sc, rep Rows 1–21 of CC1 TL3 with CC3. Fasten off.

CC2 TL3: Turn work 90 degrees and work in ends of rows CC2 TL2 and CC1 TL2. Join CC2 with sl st in top right-hand corner sc, rep Rows 1–21 of CC1 TLC with CC2. Do not fasten off.

Triangles Level 4 (TL4)

CC2 TL4: Turn work 45 degrees and work in ends of rows of CC2 TL3 and CC1 TL3.

ROW 1: Ch 1, work 25 sc evenly across CC2 TL3 and work 25 sc evenly across CC1 TL3, turn—50 sc.

ROW 2: Ch 1, sc2tog in first 2 sc, sc across to within last 2 sts, sc2tog in last 2 sc, turn—48 sts.

ROWS 3–25: Rep Row 2—2 sts.

ROW 26: Ch 1, sc2tog in next 2 sc. Fasten off.

CC1 TL4: Turn work 90 degrees and work in ends of rows of CC1 TL3 and MC TL3. Join CC1 with sl st in top right-hand corner sc, rep Rows 1–26 of CC2 TL4 with CC1. Fasten off.

MC TL4: Turn work 90 degrees and work in ends of rows of MC TL3 and CC3 TL3. Join MC with sl st in top right-hand corner sc, rep Rows 1–26 of CC2 TL4 with MC. Fasten off.

CC3 TL4: Turn work 90 degrees and work in ends of rows of CC3 TL3 and CC2 TL3. Join CC3 with sl st in top right-hand corner sc, rep Rows 1–26 of CC2 TL4 with CC3. Do not fasten off.

stitch diagram A

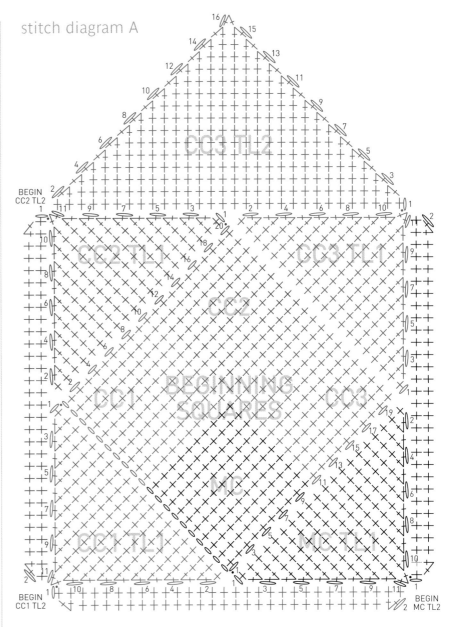

stitch key

⬯ = chain (ch)

• = slip st (sl st)

✝ = single crochet (sc)

⋀ = sc2tog

┬ = double crochet (dc)

= 2-tr cluster

construction diagram

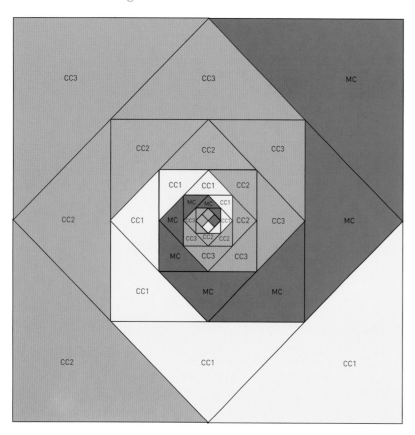

Triangles Level 5 (TL5)

CC3 TL5: Turn work 45 degrees and work in ends of rows of CC3 TL4 and CC2 TL4.

ROW 1: Ch 1, work 30 sc evenly across CC3 TL4 and work 30 sc evenly across CC2 TL4, turn—60 sc.

ROW 2: Ch 1, sc2tog in first 2 sc, sc across to within last 2 sts, sc2tog in last 2 sc, turn—58 sts.

ROWS 3–30: Rep Row 2—2 sts.

ROW 31: Ch 1, sc2tog in next 2 sc. Fasten off.

CC2 TL5: Turn work 90 degrees and work in ends of rows of CC2 TL4 and CC1 TL4. Join CC2 with sl st in top right-hand corner sc, rep Rows 1–31 of CC3 TL5 with CC2. Fasten off.

CC1 TL5: Turn work 90 degrees and work in ends of rows of CC1 TL4 and MC TL4. Join CC1 with sl st in top right-hand corner sc, rep Rows 1–31 of CC3 TL5 with CC1. Fasten off.

MC TL5: Turn work 90 degrees and work in ends of rows MC TL4 and CC3 TL4. Join MC with sl st in top right-hand corner sc, rep Rows 1–31 of CC3 TL4 with MC. Do not fasten off.

Triangles Level 6 (TL6)

MC TL6: Turn work 45 degrees and work in ends of rows MC TL5 and CC3 TL5.

ROW 1: Ch 1, work 35 sc evenly across MC TL5 and work 35 sc evenly across CC3 TL5, turn—70 sc.

ROW 2: Ch 1, sc2tog in first 2 sc, sc across to within last 2 sts, sc2tog in last 2 sc, turn—68 sts.

ROWS 3–35: Rep Row 2—2 sts.

ROW 36: Ch 1, sc2tog in next 2 sts. Fasten off.

CC3 TL6: Turn work 90 degrees and work in ends of rows of CC3 TL5 and CC2 TL5. Join CC3 with sl st in top right-hand corner sc, rep Rows 1–36 of MC TL6 with CC3. Fasten off.

CC2 TL6: Turn work 90 degrees and work in ends of rows of CC2 TL6 and CC1 TL6. Join CC2 with sl st in top right-hand corner sc, rep Rows 1–36 of MC TL6 with CC2. Fasten off.

CC1 TL6: Turn work 90 degrees and work in ends of rows of CC1 TL6 and MC TL6. Join CC1 with sl st in top right-hand corner sc, rep Rows 1–36 of MC TL6 with CC1. Do not fasten off.

Triangles Level 7 (TL7)
CC1 TL7: Turn work 45 degrees and work in ends of rows of CC1 TL6 and MC TL6.

ROW 1: Ch 1, work 40 sc evenly across CC1 TL6 and work 40 sc evenly across MC TL6, turn—80 sc.

ROW 2: Ch 1, sc2tog in first 2 sc, sc across to within last 2 sts, sc2tog in last 2 sc, turn—78 sts.

ROWS 3–40: Rep Row 2—2 sts.

ROW 41: Ch 1, sc2tog in next 2 sc. Fasten off.

MC TL7: Turn work 90 degrees and work in ends of rows of MC TL6 and CC3 TL6. Join MC with sl st in top right-hand corner sc, rep Rows 1–41 of CC1 TL7 with MC. Fasten off.

CC3 TL7: Turn work 90 degrees and work in ends of rows of CC3 TL6 and CC2 TL6. Join CC3 with sl st in top right-hand corner sc, rep Rows 1–41 of CC1 TL7 with CC3. Fasten off.

CC2 TL7: Turn work 90 degrees and work in ends of rows of CC2 TL6 and CC1 TL6. Join CC2 with sl st in top right-hand corner sc, rep Rows 1–41 of CC1 TL7 with CC2. Do not fasten off.

Triangles Level 8 (TL8)
CC2 TL8: Turn work 45 degrees and work in ends of rows of CC2 TL7 and CC1 TL7.

ROW 1: Ch 1, work 45 sc evenly across CC2 TL7 and work 45 sc evenly across CC1 TL7, turn—90 sc.

ROW 2: Ch 1, sc2tog in first 2 sc, sc

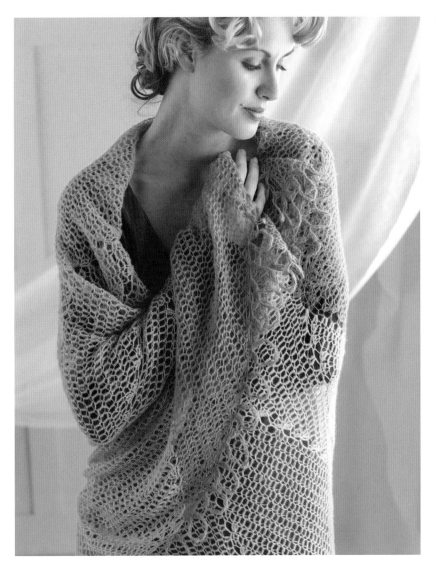

across to within last 2 sts, sc2tog in last 2 sc, turn—88 sts.

ROWS 3–45: Rep Row 2—2 sts.

ROW 46: Ch 1, sc2tog in next 2 sc. Fasten off.

CC1 TL8: Turn work 90 degrees and work in ends of rows of CC1 TL7 and MC TL7. Join CC1 with sl st in top right-hand corner sc, rep Rows 1–46 of CC2 TL8 with CC1. Fasten off.

MC TL8: Turn work 90 degrees and work in ends of rows MC TL7 and CC3 TL7. Join MC with sl st in top right-hand corner sc, rep Rows 1–46 of CC2 TL8 with MC. Fasten off.

CC3 TL8: Turn work 90 degrees and work in ends of rows of CC3 TL7 and CC2 TL7. Join CC3 with sl st in top right-hand corner sc, rep Rows 1–46 of CC2 TL8 with CC3. Do not fasten off.

Triangles Level 9 (TL9)
CC3 TL9: Turn work 45 degrees and work in ends of rows of CC3 TL8 and CC2 TL8.

ROW 1: Ch 1, work 50 sc evenly across CC3 TL8 and work 50 sc evenly across CC2 TL8, turn—100 sc.

ROW 2: Ch 1, sc2tog in first 2 sc, sc across to within last 2 sts, sc2tog in last 2 sc, turn—98 sts.

ROWS 3–50: Rep Row 2—2 sts.

ROW 51: Ch 1, sc2tog in next 2 sc. Fasten off.

CC2 TL9: Turn work 90 degrees and work in ends of rows of CC2 TL8 and CC1 TL8. Join CC2 with sl st in top right-hand corner sc, rep Rows 1–51 of CC3 TL9 with CC2. Fasten off.

CC1 TL9: Turn work 90 degrees and work in ends of rows of CC1 TL8 and MC TL8. Join CC1 with sl st in top right-hand corner sc, rep Rows 1–51 of CC3 TL9 with CC1. Fasten off.

MC TL9: Turn work 90 degrees and work in ends of rows of MC TL8 and CC3 TL8. Join MC with sl st in top right-hand corner sc, rep Rows 1–51 of CC3 TL9 with MC. Do not fasten off.

Edging

Refer to stitch diagram B for assistance.

With MC, ch 4, *work 2-tr cl in same corner st, [ch 3, dc in 3rd ch from hook] 3 times, 2-tr cl in same corner st, 2-tr cl in same corner st, [ch 3, dc in 3rd ch from hook] 3 times, 2-tr cl in same corner st, **skip next 2 sts, 2-tr cl in next st, [ch 3, dc in 3rd ch from hook] 3 times, 2-tr cl in same sp as last 2-tr cl, rep from ** to corner, skip next 2 sts, rep from * around. You should have about 34 reps per side and 2 reps in each corner—144 reps around, join with sl st to top of ch-4 at beg of rnd. Fasten off.

Wet or steam block to finished measurements. Weave in loose ends with a tapestry needle.

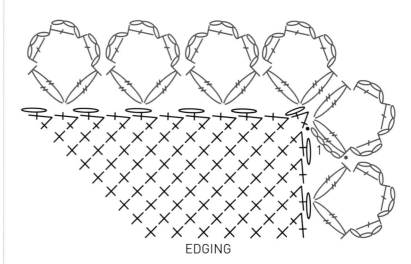

stitch diagram B

EDGING

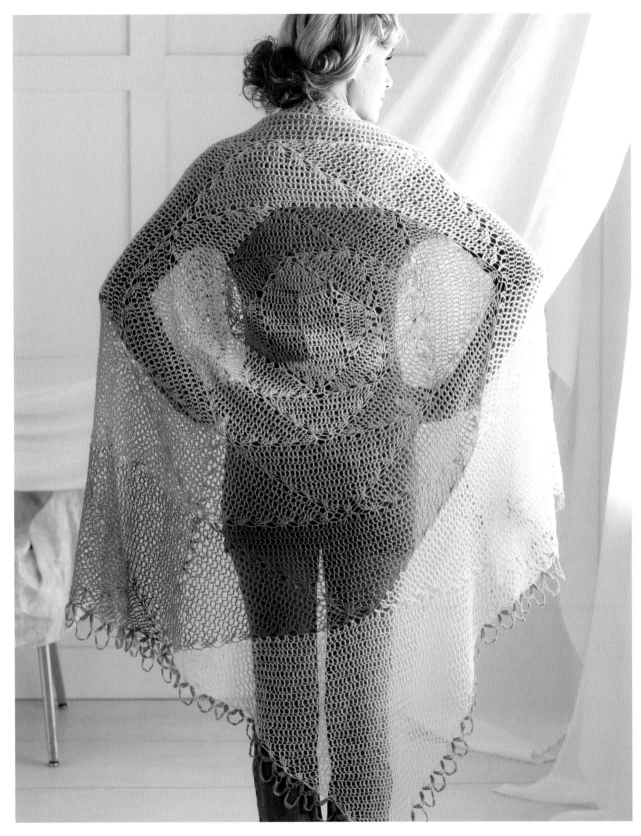

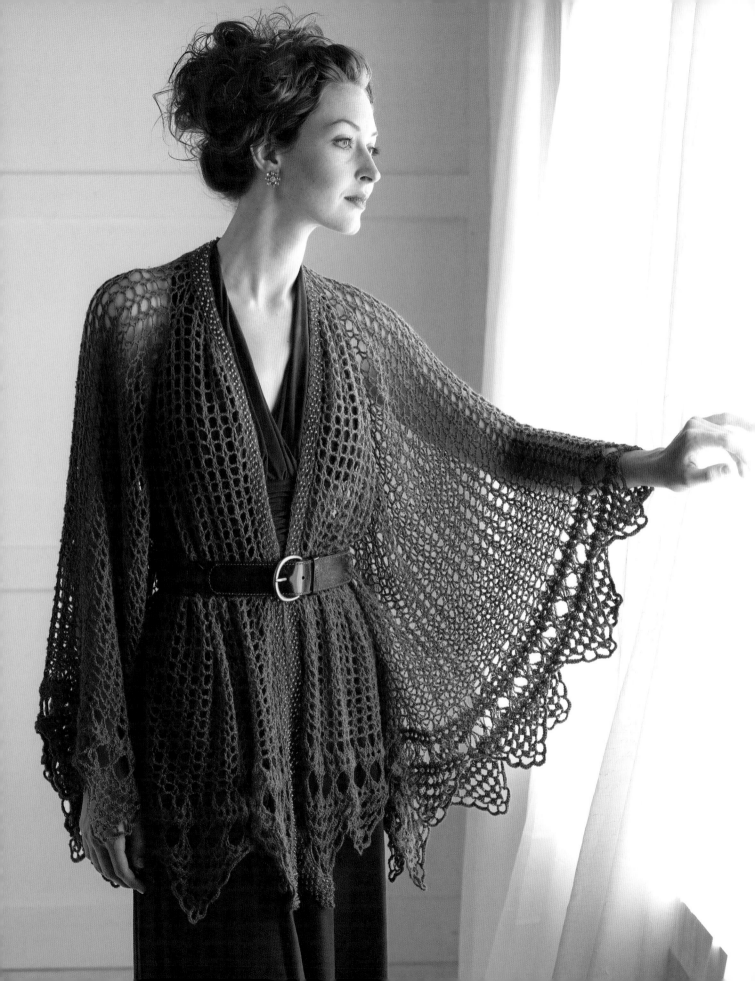

shimmer beaded LACE CAPE

Belted capes, such as this one, are my favorite type of wrap to wear. They have a polished and structured look and are visually slimming due to the ratio of the wide "sleeves" to the cinched waist. In addition, the large "sleeves" create a lovely dramatic effect as you move. This top-down raglan continues on to a flowing cape with belt holes and a pretty lace edging that is joined perpendicularly to the lower edge. The front bands are created with a very simple single crochet bead pattern. Wear it with or without a belt to create a variety of different looks.

YARN

Laceweight (#0 Lace); 2,200 yd (2,011 m) up to 3,472 yd (3,174 m) depending on yarn choice and gauge.

shown: Valley Yarns, 2/14 Alpaca Silk (80% Alpaca/20% Silk; 1,736 yd [1,588 m]/½ lb [227 g]): cognac, 2 cones.

HOOK

G/6 (4mm) or size needed to obtain gauge.

NOTIONS

500 size 6° seed beads (shown: Miyuki 6-142S S/L smoky amethyst); Big Eye beading needle; split-ring stitch markers; tapestry needle.

GAUGE

5 shells x 7 rows = 4" (10 cm) in lace stitch patt (after blocking).

FINISHED SIZE

60" wide x 56" long (152.5 x 142 cm).

special stitches

Shell (Dc, ch 2, dc) in same st or sp.

Corner shell ([Dc, ch 2] 3 times, dc) in same sp.

Neck inc shell ([Dc, ch 2] twice, dc) in same sp.

Bead crochet

Slip bead (already strung onto yarn) next to last st made, sc in next st. Bead is placed between stitches and is shown on back side of work. If you want bead to show on front side of work, work bead stitches on wrong side of work.

Shimmer Beaded Lace Cape

Refer to stitch diagrams A and B at right for assistance.

Ch 61.

ROW 1: Ch 5 (counts as dc, ch 2), dc in 6th ch from hook, *ch 2, skip next 2 ch, shell in next ch-sp, rep from * across, turn—21 shells.

ROW 2: Sl st into first shell, ch 5 (counts as dc, ch 2), shell in same sp, ch 2, work corner shell in next shell, (ch 2, shell) in each of next 3 shells, ch 2, work corner shell in next shell, (ch 2, shell) in each of next 9 shells, ch 2, work corner shell in next shell, (ch 2, shell) in each of next 3 shells, ch 2, work corner shell in next shell, [ch 2, dc] 3 times in last shell, turn—2 neck inc shells, 4 corner shells, 15 shells.

ROW 3: Sl st into first shell, ch 5 (counts as dc, ch 2), shell in same sp, (ch 2, shell) in each of next 2 shells, ch 2, work corner shell in next shell, (ch 2, shell) in each of next 5 shells, ch 2, work corner shell in next shell, (ch 2, shell) in each of next 11 shells, ch 2, work corner shell in next shell, (ch 2, shell) in each of next 5 shells, ch 2, work corner shell

in next shell, (ch 2, shell) in each of next 2 shells, [ch 2, dc] 3 times in last shell, turn—2 neck inc shells, 4 corner shells, 25 shells.

ROW 4: Sl st into first shell, ch 5 (counts as dc, ch 2), shell in same sp, (ch 2, shell) in each of next 4 shells, ch 2, work corner shell in next shell, (ch 2, shell) in each of next 7 shells, ch 2, work corner shell in next shell, (ch 2, shell) in each of next 13 shells, ch 2, work corner shell in next shell, (ch 2, shell) in each of next 7 shells, ch 2, work corner shell in next shell, (ch 2, shell) in each of next 4 shells, [ch 2, dc] 3 times in last shell, turn—2 neck inc shells, 4 corner shells, 35 shells.

ROW 5: Sl st into first shell, ch 5 (counts as dc, ch 2), dc in same sp, (ch 2, shell) in each of next 6 shells, ch 2, work corner shell in next shell, (ch 2, shell) in each of next 9 shells, ch 2, work corner shell in next shell, (ch 2, shell) in each of next 15 shells, ch 2, work corner shell in next shell, (ch 2, shell) in each of next 9 shells, ch 2, work corner shell in next shell, (ch 2, shell) in each of next 7 shells, turn—47 shells, 4 corner shells. Place a marker in each corner ch-2 sp and move marker up as work progresses.

ROWS 6–24: Sl st into first shell, ch 5 (counts as dc, ch 2), dc in same sp, *(ch 2, shell) in each shell to marked corner sp, work corner shell in next ch-2 sp, rep from * 3 times, (ch 2, shell) in each shell across, turn—199 shells, 4 corner shells at end of last row.

Note: When the cape is about 16" (40.5 cm) in length (around Row 25, based on gauge), each corner shell is replaced by ch 14 for belt holes. On the following row and thereafter, the corner inc are worked every other row.

ROW 25: Sl st into first shell, ch 5 (counts as dc, ch 2), dc in same sp, (ch 2, shell) in each of next 25 shells, ch 14, skip next (ch 2, corner shell, ch 2), shell in next shell, (ch 2, shell) in each of next 47 shells, ch 14, skip next (ch 2, corner shell, shell in next shell, ch 2), (ch 2, shell) in each of next 53 shells, ch 14, (ch 2, corner shell, ch 2), shell in next shell, (ch 2, shell) in each of next 47 shells, ch 14, skip corner shell on last row, (ch 2, shell) in each of next 26 shells, turn—199 shells, 4 ch-14 sps for belt holes.

ROW 26: Sl st into first shell, ch 5 (counts as dc, ch 2), dc in same sp, *(ch 2, shell) in each shell to next ch-14 sp, [ch 2, skip next 2 ch, shell in next ch] twice, ch 2, [shell in next ch, ch 2, skip

stitch diagram A

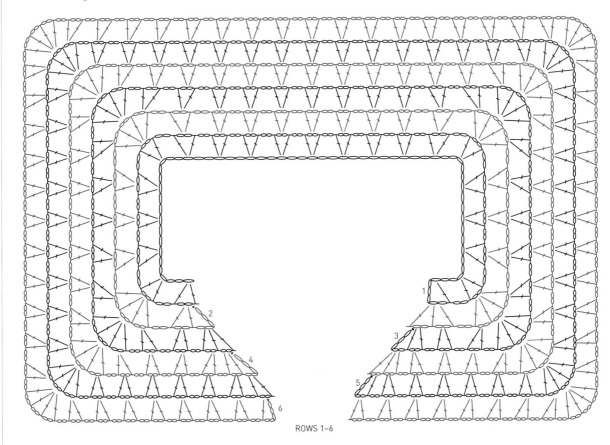

ROWS 1–6

stitch diagram B

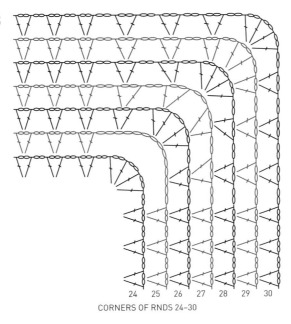

24 25 26 27 28 29 30

CORNERS OF RNDS 24–30

stitch key

⬭ = chain (ch)
• = slip st (sl st)
✛ = single crochet (sc)
✝ = double crochet (dc)

next 2 ch] twice, rep from * 3 times, shell in next shell, (ch 2, shell) in each shell across, turn—215 shells.

ROW 27: Sl st into first shell, ch 5 (counts as dc, ch 2), dc in same sp, (ch 2, shell) in each shell across—215 shells. Place marker in each corner ch-2 sp and move marker up as work progresses.

ROW 28: Sl st into first shell, ch 5 (counts as dc, ch 2), dc in same sp, *(ch 2, shell) in each shell across to marked corner ch-2 sp, corner shell in next ch-2 sp, rep from * 3 times, (ch 2, shell) in each shell across, turn—215 shells, 4 corner shells.

ROW 29: Sl st into first shell, ch 5 (counts as dc, ch 2), dc in same sp, (ch 2, shell) in each shell across to next marked corner ch-2 sp, ch 2, shell in next ch-2 sp, rep from * 3 times, (ch 2, shell) in each shell across, turn—227 shells.

ROWS 30–39: Rep Rows 28 and 29—267 shells at end of last row.

ROW 40: Sl st into first shell, ch 5 (counts as dc, ch 2), shell in same sp, *(ch 2, shell) in each shell across to marked corner ch-2 sp, corner shell in next ch-2 sp, rep from * 3 times, (ch 2, shell) in each shell across to last shell, [ch 2, dc] 3 times in last shell, turn—261 shells, 4 corner shells, 2 neck inc shells.

ROW 41: Rep Row 29—277 shells.

Fasten off.

Edging
Refer to stitch diagram C, at right, for assistance.

ROW 1: Ch 17, sl st into first shell on last row of cape, 2 dc in 4th ch from hook, ch 3, skip next ch, 3 dc in next ch, ch 7, skip next 8 ch, 3 dc in next ch, ch 3, skip next ch, 3 dc in last ch, turn.

ROW 2: Ch 5, (3 dc, ch 3, 3 dc) in next ch-3 sp, ch 7, skip next ch-7 sp, (3 dc, ch 3, 3 dc) in next ch-3 sp, ch 2, sl st in next shell on cape, ch 2, turn.

ROW 3: (3 dc, ch 3, 3 dc) in next ch-3 sp, ch 3, sc around ch-7 sps on 2 prev rows,

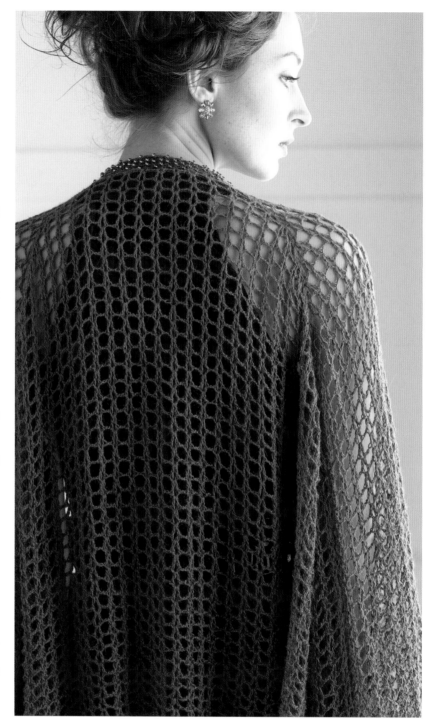

ch 3, (3 dc, ch 3, 3 dc) in next ch-3 sp, turn.

ROW 4: Ch 5, (3 dc, ch 3, 3 dc) in next ch-3 sp, ch 7, skip next 2 ch-3 sps, (3 dc, ch 3, 3 dc) in next ch-3 sp, ch 2, sl st in next shell on cape, ch 2, turn.

ROW 5: (3 dc, ch 3, 3 dc) in next ch-3 sp, ch 7, skip next ch-7 sp, (3 dc, ch 3, 3 dc) in next ch-3 sp, ch 3, 3 dc in next ch-5 sp.

ROW 6: Ch 6 (counts as dc, ch 3) work 3 dc in next ch-3 sp, ch 3, (3 dc, ch 3, 3 dc) in next ch-3 sp, ch 3, sc around ch-7 sps on 2 prev rows, ch 3, (3 dc, ch 3, 3 dc) in next ch-3 sp, ch 2, sl st in next shell on cape, ch 2, turn.

ROW 7: (3 dc, ch 3, 3 dc) in next ch-3 sp, ch 7, skip next 2 ch-3 sps, (3 dc, ch 3, 3 dc) in next ch-3 sp, (ch 3, 3 dc) in each of next 2 ch-3 sps, turn.

ROW 8: Ch 6 (counts as dc, ch 3), (3 dc, ch 3) in each of next 2 ch-2 sps, (3 dc, ch 3, 3 dc) in next ch-3 sp, ch 7, skip next ch-7 sp, (3 dc, ch 3, 3 dc) in next ch-3 sp, ch 2, sl st in next shell on cape, ch 2, turn.

ROW 9: (3 dc, ch 3, 3 dc) in next ch-3 sp, ch 3, sc around ch-7 sps on 2 prev rows, ch 3, (3 dc, ch 3, 3 dc) in next ch-3 sp, (ch 3, 3 dc) in each of next 3 ch-3 sps, turn.

ROW 10: Ch 6 (counts as dc, ch 3), (3 dc, ch 3) in each of next 3 ch-3 sps, (3 dc, ch 3, 3 dc) in next ch-3 sp, ch 7, skip next 2 ch-3 sps, (3 dc, ch 3, 3 dc) in next ch-3 sp, ch 2, sl st in next shell on cape, ch 2, turn.

ROW 11: (3 dc, ch 3, 3 dc) in next ch-3 sp, ch 7, skip next ch-7 sp (3 dc, ch 3, 3 dc) in next ch-3 sp, ch 3, (dc, ch 5) in each of next 4 ch-5 sps, dc in same sp, (ch 5, dc) in each of next 3 ch-3 sps, ch 3, sl st into beg ch-5 sp 2 rows below, turn.

ROW 12: 3 sc in next ch-3 sp, [sc in next dc, 5 sc in next ch-5 sp] 7 times, sc in next dc, 3 sc in next ch-3 sp, ch 3, (3 dc, ch 3, 3 dc) in next ch-3 sp, ch 3, sc around ch-7 sps on 2 prev rows, ch 3, (3 dc, ch 3, 3 dc) in next ch-3 sp, ch 2, sl st in next shell on cape, ch 2.

stitch diagram C

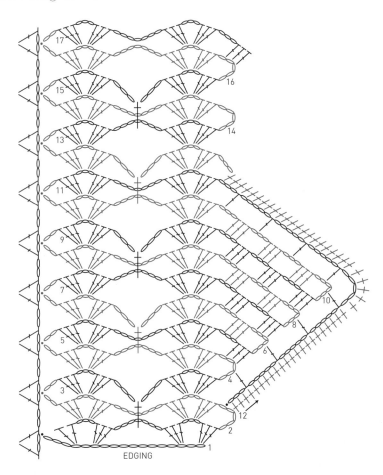

EDGING

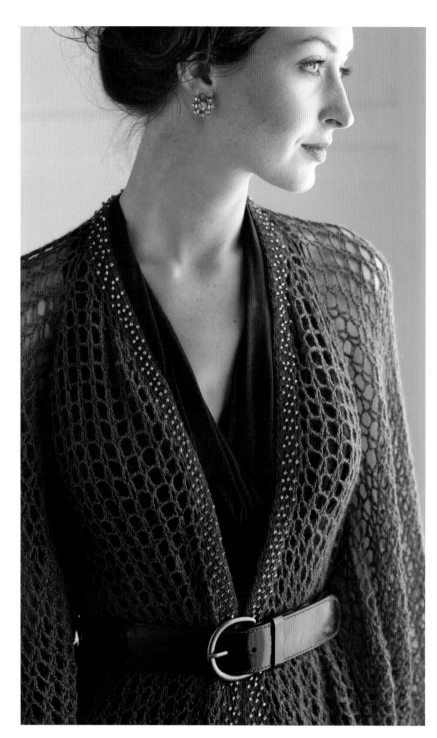

ROW 13: (3 dc, ch 3, 3 dc) in next ch-3 sp, ch 7, skip next 2 ch-3 sps, (3 dc, ch 3, 3 dc) in next ch-3 sp, turn.

Rep Rows 2–13 for entire lower edge of cape, ending with Row 12, omitting last ch-2. Fasten off.

Beaded Front Bands

ROW 1: With RS facing, join yarn with sl st to bottom right corner of front. Work 201 sc evenly around right front, neck and left front edges. Fasten off. Place yarn end in beading needle. String about 100 beads on yarn. Remove beading needle.

Note: There are so many beads used on each row that I found it easier to cut yarn and string 100 beads per row. If you feel more comfortable stringing 500 beads, you can string them all now. Keep in mind that there may be some breakage, so string a few extra beads each time.

ROW 2: Join yarn with sl st in first sc, ch 1, sc in first sc, *draw bead up close to last st made, sc in each of next 2 sc (bead is placed between sts), rep from * across, turn—201 sc, 100 beads.

ROW 3: Ch 1, sc in each sc across, turn. Fasten off. String about 99 beads on yarn.

ROW 4: Join yarn with sl st in first sc, ch 1, sc in first sc, *sc in next sc, draw bead up close to last st made, sc in next sc (bead is placed between sts), rep from * across to last 2 sts, sc in each of last 2 sc—201 sts, 99 beads.

ROW 5: Ch 1, sc in each sc across. Fasten off. String about 100 beads on yarn.

ROWS 6–10: Rep Rows 2–5 once, rep Row 2 once more. Fasten off.

Wet or steam block to finished measurements. Weave in loose ends with a tapestry needle.

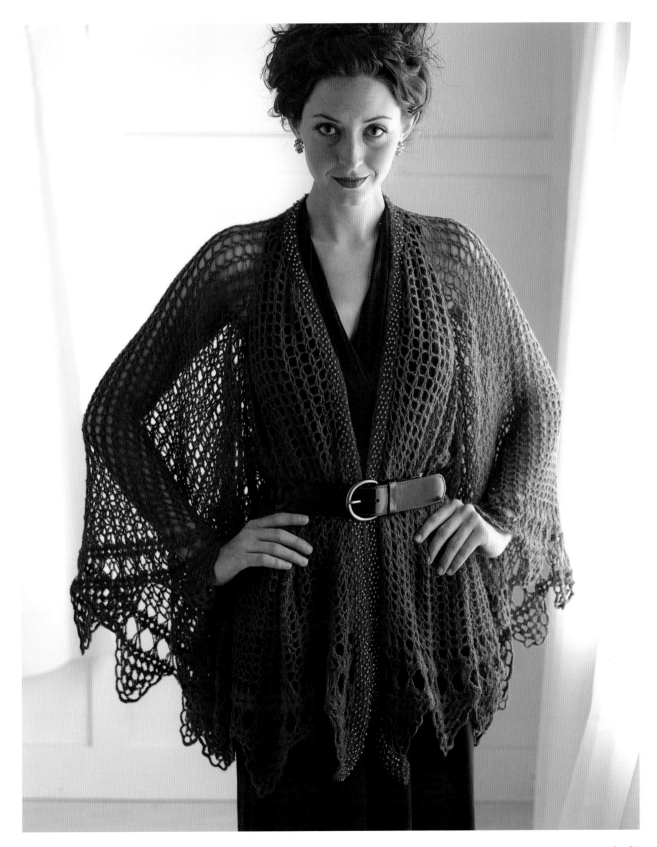

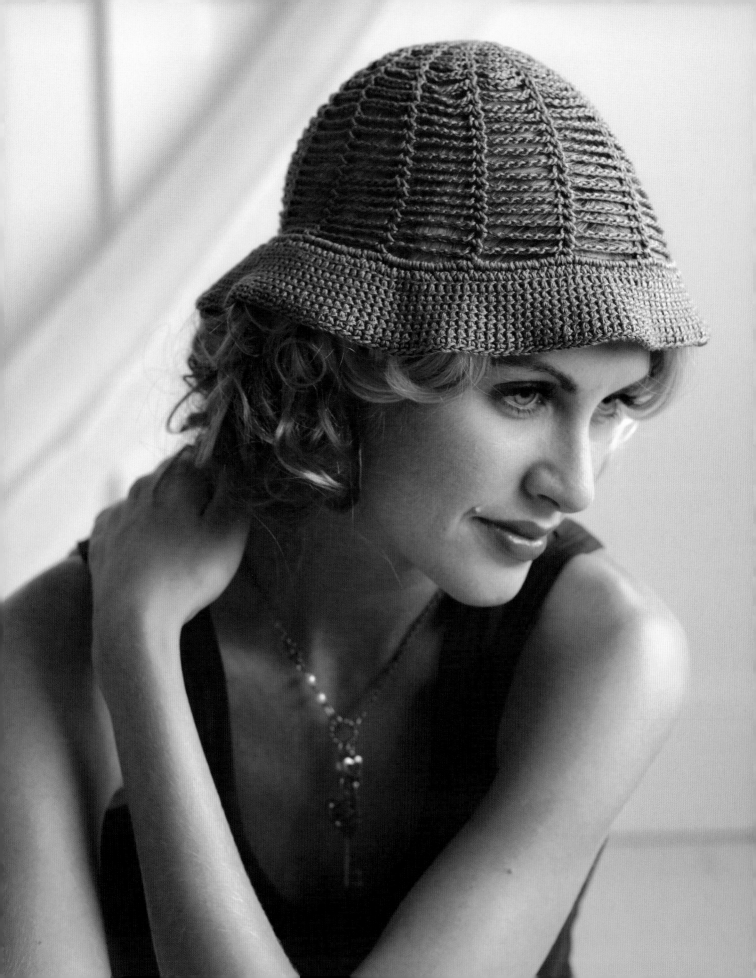

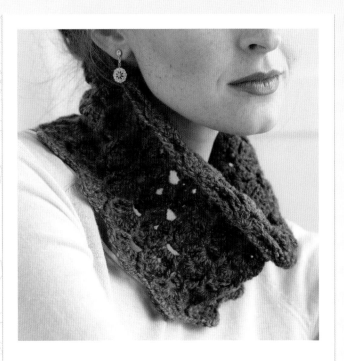

accessories

Lighter yarns add a lovely sophistication to crochet accessories that is sometimes lacking in chunkier pieces. This chapter includes chic hats, stylish scarves, and even a fantastic bag. A wide variety of techniques will give you plenty of options, whether you'd like something sweet and delicate or a more elaborately elegant piece.

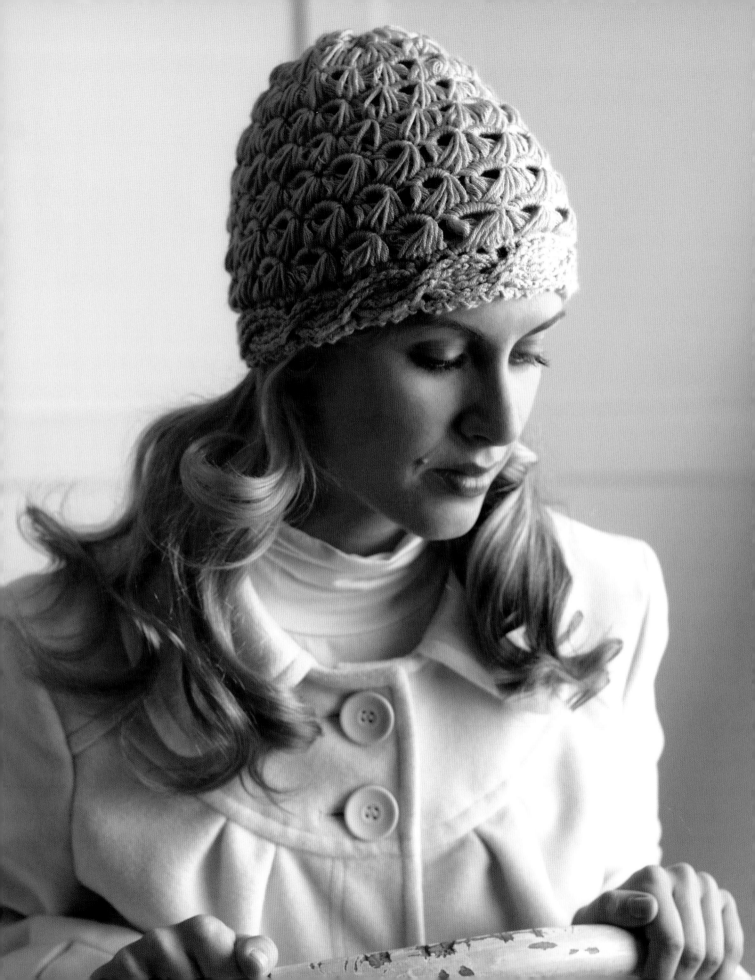

cables and lace BROOMSTICK HAT

This hat is a play on the juxtaposition of cables and lace. The brim's cable is dense, textured, and thick—great for keeping your ears protected in a blustering storm. The body of the hat is worked in broomstick lace, which is also textured, but light. At first glance, you might think the openwork would not be very warm, but the twisted loops of broomstick lace have little pockets of air in the center, which help trap warmth.

YARN
DK weight (#3 Light); 168 yd (154 m).

shown: Lion Brand Yarn, Microspun (100% microfiber acrylic; 168 yd [154 m]/2.5 oz [70 g]): sterling #910-150, 1 skein.

HOOK
E/4 (3.5mm) or size needed to obtain gauge.

NOTIONS
3 straight or 1 circular U.S. 17 (12.75mm) knitting needle(s); tapestry needle.

GAUGE
6 sts = 1" (2.5 cm); 11 rows in Cable Band patt = 4" (10 cm).

FINISHED SIZE
20" (51 cm) in circumference.

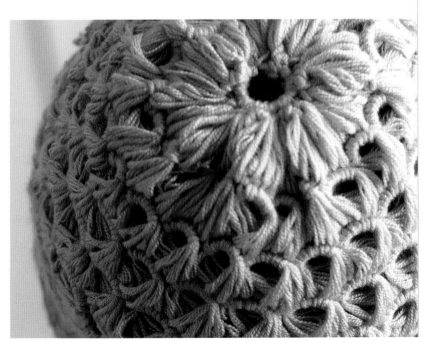

special stitches

Broomstick Lace

Pull up a long loop with yarn on hook, slip loop off of hook and onto knitting needle as stitch holder. *Working to the right, insert hook into next stitch (figure 1), pull up a long loop, and slip loop off of hook and onto knitting needle as a stitch holder. Repeat from * across or as directed by pattern. Slip loops off of knitting needle (as long as you are gentle with your work and don't leave it unattended, it is safe to slip the loops off of the knitting needle). Insert crochet hook into first 6 loops, sl st into grouped 6 loops (figure 2) and draw up yarn long enough to be about the height of the loops, ch 1 (figure 3), 6 sc in same group of loops (figure 4), **group next 6 loops together, 6 sc in next group of loops (figure 5), repeat from ** across or as directed by pattern.

Back post double crochet (bpdc) p. 156.

Front post treble crochet (fptr) p. 157.

Front post double crochet (fpdc) p. 157.

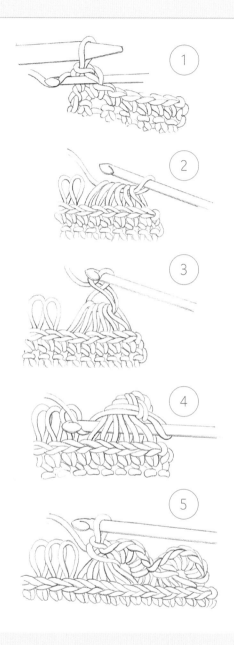

Cables and Lace Broomstick Hat

Cabled Band

Refer to stitch diagram A for assistance.

Ch 10.

ROW 1: Dc in 4th ch from hook and in each ch across—8 dc.

ROW 2: Ch 3, skip first st, bpdc around the post of each st across—8 sts.

ROW 3: Ch 3, skip first 5 sts, fptr around post of next st, fptr around post of next st, working behind last 2 sts made, dc in 4th and 5th sts; working in front of all sts, fptr in 2nd and 3rd st, dc in last st—8 sts.

ROW 4: Ch 3, skip first st, bpdc in each st across—8 sts.

ROW 5: Ch 3, skip first st, fpdc in each st across—8 sts.

ROW 6: Rep Row 4.

ROWS 7–60: Rep Rows 3–6 thirteen times; rep Rows 3–4. Fasten off, leaving a 12" (30.5 cm) tail for sewing seam. Sew last row to foundation ch.

Bottom Edging

With RS facing, join yarn in any row-end st on one side edge of Band. Working in ends of rows across one side of Band, (sl st, ch 1, sl st) in end of each row around, join with sl st in first sl st at beg of rnd. Fasten off—60 ch-1 sps.

Hat Body

Refer to stitch diagram B on p. 68 for assistance.

FOUNDATION RND: Working in opposite ends of rows, join with sl st to any row-end st, ch 1, 2 sc in each row-end st around, join with sl st in first sc at beg of rnd—120 sc. Do not turn.

RND 1: Pull up a long lp with yarn on hook, slip lp off of hook and onto knitting needle as st holder, *working to the right, pick up a lp in next st, pull up long lp, slip lp off of hook and onto knitting needle as stitch holder, rep from * until

you have used every st—120 lps on needle. Slip lps off of knitting needle (as long as you are gentle with your work and don't leave it unattended, it is safe to slip the lps off of the knitting needle).

Insert crochet hook into first 6 lps, sl st into grouped 6 lps and draw up yarn long enough to be about the height of the lps, ch 1, 6 sc in same group of lps, **group next 6 lps together, 6 sc in next group of lps, rep from ** around, join with sl st in first sc. Do not turn.

RND 2: Sl st in each of next 3 sts, pull up long lp with yarn on hook, slip lp off of hook and onto knitting needle as st holder, *working to the right, pick up a lp in next st, pull up long lp, slip lp off of hook and onto knitting needle as st holder, rep from * until you have used every st. Slip lps off of knitting needle.

Insert crochet hook into 6 lps, sl st into grouped 6 lps and draw up yarn long enough to be about the height of the lps, ch 1, 6 sc in same group of lps, **group next 6 lps together, 6 sc in next group of lps, rep from ** around, join with sl st in first sc.

RNDS 3–4: Rep Rnd 2.

RND 5 (DEC RND): Sl st in each of next 3 sts, pull up long lp with yarn on hook, slip lp off of hook and onto knitting needle as st holder, *working to the right, pick up a lp in next stitch, pull up long lp, slip lp off of hook and onto knitting needle as st holder, rep from * until you have used every st. Slip lps off of knitting needle.

Insert crochet hook into 6 lps, sl st into grouped 6 lps and draw up yarn long enough to be about the height of the lps, ch 1, 4 sc in same group of lps, **group next 6 lps together, 4 sc in group of lps, rep from ** across, join with sl st in first sc. Do not turn—80 sc.

RND 6: Sl st in each of next 2 sts, pull up long lp with yarn on hook, slip lp off of hook and onto knitting needle as st holder, *working to the right, pick up a lp in next st, pull up long lp, slip lp off of hook and onto knitting needle as st

stitch diagram A

FOUNDATION ROW

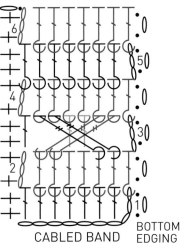

CABLED BAND | BOTTOM EDGING

stitch key

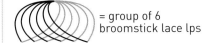

- ⌒ = chain (ch)
- • = slip st (sl st)
- + = single crochet (sc)
- = double crochet (dc)
- = Front Post dc (FPdc)
- = Back Post dc (BPdc)
- = Front Post tr (FPtr)
- = group of 4 broomstick lace lps
- = group of 6 broomstick lace lps

stitch diagram B

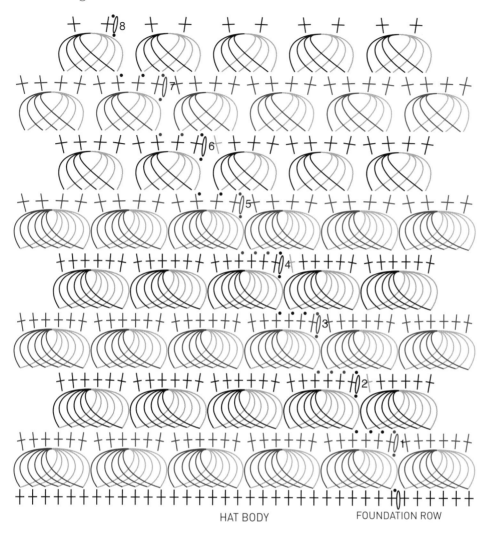

HAT BODY FOUNDATION ROW

holder, rep from * until you have used every st, slip lps off of knitting needle.

Insert hook into 4 lps, sl st into grouped 4 lps and draw up yarn long enough to be about the height of the lps, ch 1, 4 sc in same group of lps, **group next 4 lps together, 4 sc in grouped 4 lps, rep from ** around, join with sl st in first sc. Do not turn.

RND 7: Rep Rnd 6.

RND 8 (DEC RND): Sl st in each of next 2 sts, pull up long lp with yarn on hook, slip lp off of hook and onto knitting needle as st holder, *working to the right, pick up a lp in next st, pull up long lp, slip lp off of hook and onto knitting needle as st holder, rep from * until you have used every st. Slip lps off of knitting needle.

Insert crochet hook into 4 lps, sl st into grouped 4 lps and draw up yarn long enough to be about the height of the lps, ch 1, 2 sc in same group of lps, **group next 4 lps together, 2 sc in group of lps, rep from ** around, join with sl st in first sc—40 sts.

Fasten off, leaving long tail for drawing center tight. With tapestry needle, weave tail through each st on Row 8, pull tightly to draw the sts together. Fasten off securely.

Wet or steam block to finished measurements. Weave in loose ends with a tapestry needle.

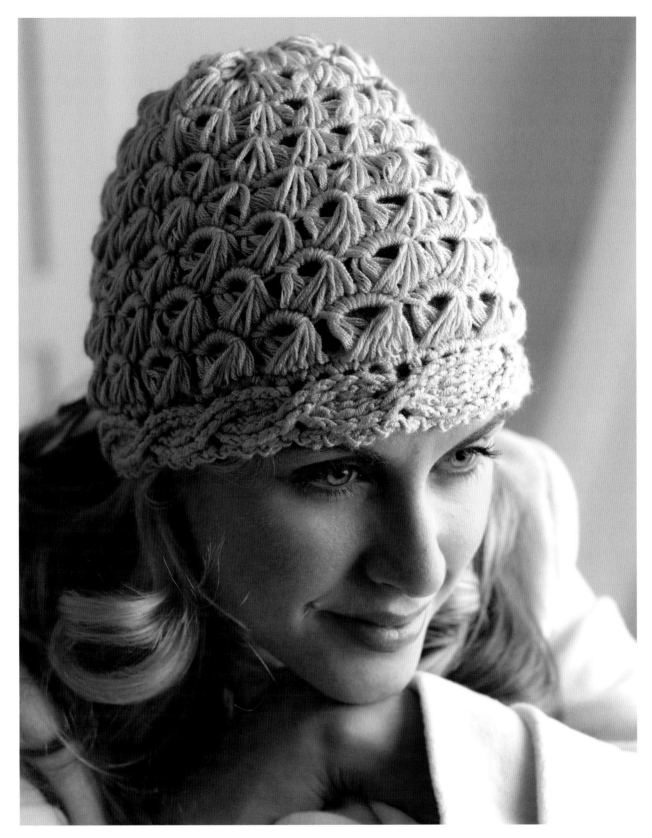

thin scarves AMOUR SEQUIN LACE SCARF
SKINNY FLOWER SCARF

These two one-skein scarves would make perfect gifts, if you can stand to part with them. The Skinny Flower Scarf is worked in a simple stitch pattern and is quick to make. The Amour Sequin Lace Scarf is a bit more complex, but the result is well worth the effort. Both scarves are long enough to wrap around your neck a few times and are pretty enough to dress up a simple outfit instantly!

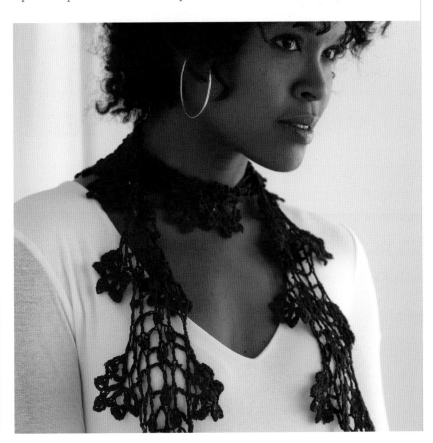

amour sequin lace SCARF

YARN

Fingering weight (#1 Super Fine); 200 yd (182.8 m).

shown: Tilli Tomas, Sequin Lace (100% spun silk with petit sequins; 200 yd [182.9 m]/1.75 oz [50 g]): ruby wine, 1 skein.

HOOK

G/6 (4mm) or size needed to obtain gauge.

NOTIONS

Tapestry needle.

GAUGE

24 sts x 8 rows = 4" (10 cm) in (ch 3, dc) mesh (after blocking).

FINISHED SIZE

54" long x 6" wide (137 x 15 cm).

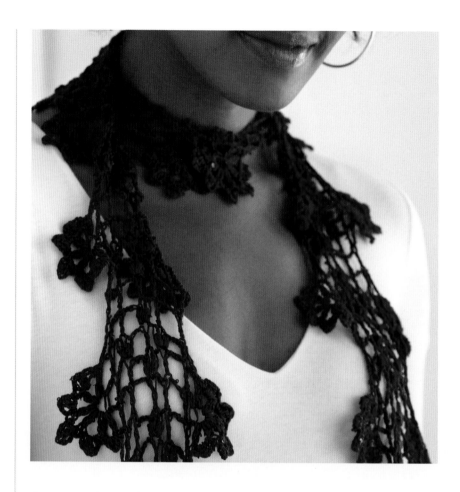

special stitches

Cluster (cl)

[Yarn over hook, insert hook in next space, yarn over hook, draw yarn through space, yarn over hook, draw yarn through 2 loops on hook] twice, yarn over hook, draw yarn through 3 loops on hook.

Bobble p. 156.

Amour Sequin Lace Scarf

Refer to the amour stitch diagram at right for assistance.

Ch 25.

ROW 1: Sc in 6th ch from hook forming a ch-5 ring, ch 2, skip 2 ch, dc in next ch, *ch 3, skip 3 ch, dc in next ch; rep from * 3 times, turn.

ROW 2: Ch 6, dc in first dc, *ch 3, dc in next dc, ch 2, (bobble, ch 1, bobble) in next dc, ch 2, dc in next dc, ch 3, skip next ch-3 sp, dc in next dc, ch 2, skip next ch-2 sp, [cl, ch 3] twice, cl, ch 1, dc) in next ch-5 ring, turn.

ROW 3: Ch 3, (dc, ch 2, sc) in next ch-1 sp, *(sc, ch 2, cl, ch 2, sc) in each of next 2 ch-3 sps, sl st in next ch-2 sp, ch 4, dc in next dc, ch 2, (bobble, ch 1, bobble) in next dc, ch 2, skip next ch-2 sp, dc in next ch-1 sp, ch 2, skip next ch-2 sp, (bobble, ch 1, bobble) in next dc, ch 2, dc in next dc, turn.

ROW 4: Ch 8, sl st in 6th ch from hook, ch 2, dc in next dc, ch 3, skip next ch-2 sp, dc in next ch-1 sp, ch 2, skip next ch-2 sp, (bobble, ch 1, bobble) in next dc, ch 2, skip next ch-2 sp, dc in next ch-1 sp, ch 3, skip next ch-2 sp, dc in next dc, turn.

ROW 5: Ch 6, [dc in next dc, ch 3] twice, skip next ch-2 sp, dc in next ch-1 sp, skip next ch-2 sp, [ch 3, dc in next dc] twice, ch 2, skip next ch-2 sp, [[cl, ch 3] 5 times, cl] in next ch-5 ring, sc in ch-6 sp at beg of row 2 rows below, turn.

ROW 6: (Sc, ch 2, cl, ch 2, sc) in each of next 5 ch-3 sps, sl st in next ch-2 sp, ch 4, dc in next dc, ch 3, dc in next dc, ch 2, (bobble, ch 1, bobble) in next dc, ch 2, dc in next dc, ch 3, dc in next dc, turn.

ROW 7: Ch 8, sl st in 6th ch from hook, ch 2, dc in next dc, ch 2, (bobble, ch 1, bobble) in next dc, ch 2, skip next ch-2 sp, dc in next ch-1 sp, ch 2, skip next ch-2 sp, (bobble, ch 1, bobble) in next dc, ch 2, dc in next dc, turn.

ROW 8: Ch 6, dc in next dc, ch 3, skip next ch-2 sp, dc in next ch-1 sp, ch 2, (bobble, ch 1, bobble) in next dc, ch 2, skip next ch-2 sp, dc in next ch-1 sp, ch 3, skip next ch-2 sp, dc in next dc, ch 2, [[cl, ch 3] 5 times, cl] in next ch-5 ring, sc in ch-6 sp at beg of row 2 rows below, turn.

ROW 9: (Sc, ch 2, cl, ch 2, sc) in each of next 5 ch-3 sps, sl st in next ch-2 sp, ch 4, dc in next dc, ch 3, dc in next dc, ch 3, skip next ch-2 sp, dc in next ch-1 sp, ch 3, dc in next dc, skip next ch-2 sp, ch 3, dc in next dc, turn.

ROW 10: Ch 8, sl st in 6th ch from hook, ch 2, dc in next dc, ch 3, dc in next dc, ch 2, (bobble, ch 1, bobble) in next dc, ch 2, dc in next dc, ch 3, dc in next dc, turn.

ROW 11: Ch 6, dc in next dc, ch 2, (bobble, ch 1, bobble) in next dc, ch 2, skip next ch-2 sp, dc in next ch-1 sp, ch 2, skip next ch-2 sp, (bobble, ch 1, bobble) in next dc, ch 2, dc in next dc, ch 2, skip next ch-2 sp, [[cl, ch 3] 5 times, cl] in next ch-5 ring, sc in ch-6 sp at beg of row 2 rows below, turn.

ROW 12: (Sc, ch 2, cl, ch 2, sc) in each of next 5 ch-3 sps, sl st in next ch-2 sp, ch 4, dc in next dc, ch 3, skip next ch-2 sp, dc in next ch-1 sp, ch 2, skip next ch-2 sp, (bobble, ch 1, bobble) in next dc, ch 2, skip next ch-2 sp, dc in next ch-1 sp, ch 3, skip next ch-2 sp, dc in next dc, turn.

ROW 13: Ch 8, sl st in 6th ch from hook, ch 2, [dc in next dc, ch 3] twice, skip next ch-2 sp, dc in next ch-1 sp, skip next ch-2 sp, [ch 3, dc in next dc] twice, turn.

ROW 14: Ch 6, dc in next dc, ch 3, dc in next dc, ch 2, (bobble, ch 1, bobble) in next dc, ch 2, dc in next dc, ch 3, dc in next dc, ch 2, [[cl, ch 3] 5 times, cl] in next ch-5 ring, sc in ch-6 sp at beg of row 2 rows below, turn.

ROW 15: (Sc, ch 2, cl, ch 2, sc) in each of next 5 ch-3 sps, sl st in next ch-2 sp, ch 4, dc in next dc, ch 2, (bobble, ch 1, bobble) in next dc, ch 2, skip next ch-2 sp, dc in next ch-1 sp, ch 2, skip next ch-2 sp, (bobble, ch 1, bobble) in next dc, ch 2, dc in next dc, turn.

Rep Rows 4–15 until scarf measures 54" (137 cm), or until you run out of yarn, ending with Row 9 or 15 of patt. Fasten off.

Wet or steam block to finished measurements. Weave in loose ends with a tapestry needle.

amour stitch diagram

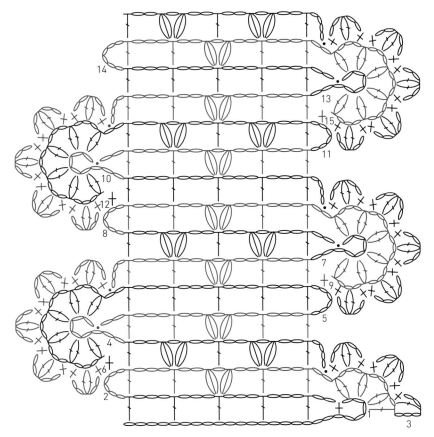

stitch key

⬯ = chain (ch)

• = slip st (sl st)

+ = single crochet (sc)

† = double crochet (dc)

⧗ = cluster

⬙ = bobble

skinny flower SCARF

YARN

DK weight (#3 light);146 yd (133.5 m).

shown: Tahki, Cotton Classic Lite (100% mercerized cotton; 146 yd [133.5 m]/1.75 oz [50 g]): #3861 midnight blue, 1 skein.

HOOK

E/4 (3.5mm) or size needed to obtain gauge.

NOTIONS

Tapestry needle.

GAUGE

1 rep = 2" tall x 2" wide (5 x 5 cm).

FINISHED SIZE

92" long x 2" wide (234 x 5 cm).

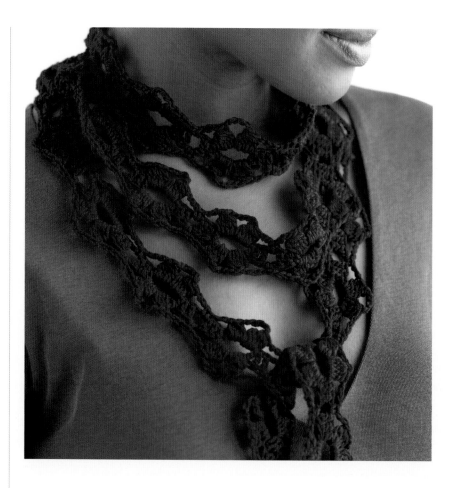

special stitches

Cluster (cl)

[Yarn over hook, insert hook in next stitch or space, yarn over hook, draw yarn through stitch or space, yarn over hook, draw yarn through 2 loops on hook] 5 times, yarn over hook, draw yarn through 6 loops on hook.

Skinny Flower Scarf

Refer to flower stitch diagram at right for assistance.

Ch 453.

ROW 1: Dc in 4th ch from hook, dc in each of next 2 ch, ch 2, skip next 2 ch, dc in each of next 3 ch, *ch 1, skip next ch, dc in each of next 3 ch, ch 2, skip next 2 ch, dc in each of next 3 ch, rep from * across, ch 2, sl st in last ch.

ROW 2: Turn to work across opposite side of foundation ch, ch 1, sc in first ch, ch 3, *(cl, ch 5, cl) in next ch-2 sp, ch 3**, sc in next ch-1 sp, ch 3, rep from * across, ending last rep at **, sc in last ch, ch 2, sl st in next corner.

ROW 3: Turn to work across top of Row 1, ch 1, sc in top of ch-3 at beg of Row 1, ch 3, *(cl, ch 5, cl) in next ch-2 sp, ch 3**, sc in next ch-1 sp, ch 3, rep from * across, ending last rep at **, sc in last ch-2 sp.

Fasten off.

Wet or steam block to finished measurements. Weave in loose ends with a tapestry needle.

flower stitch diagram

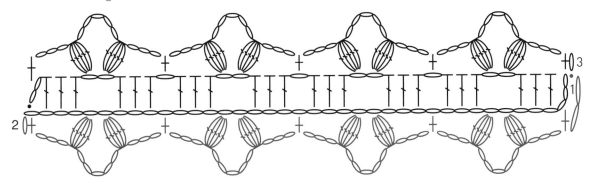

stitch key

⬭ = chain (ch)

• = slip st (sl st)

✛ = single crochet (sc)

⊤ = double crochet (dc)

⦀ = 5-dc cluster

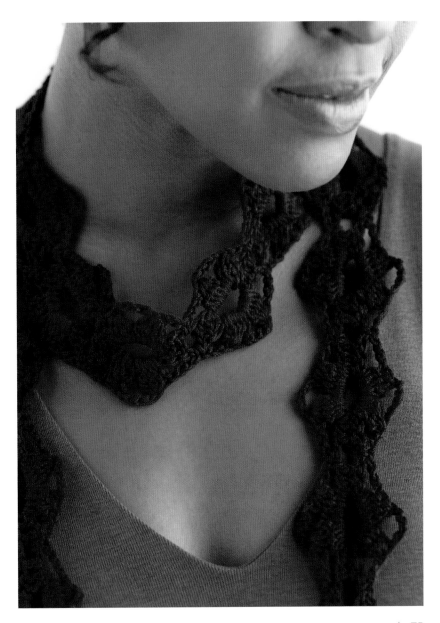

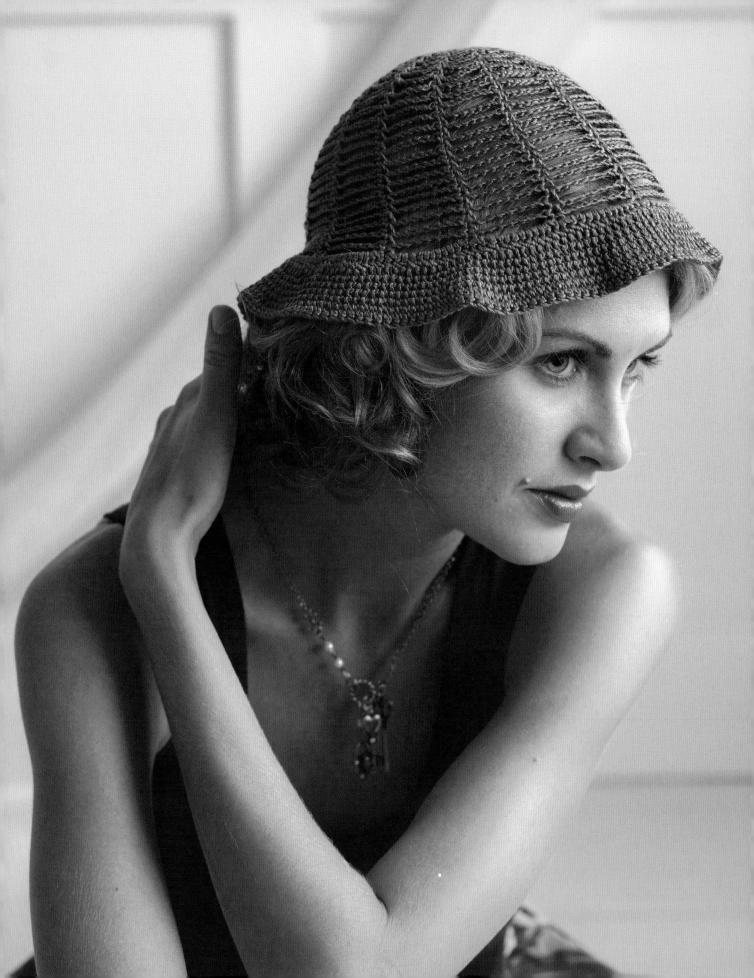

chains BUCKET HAT

I love the contrast of this hat's ultra-fluid chains with the dense linked stitches of the brim. The stretch and flexibility of the chains allow the hat to easily fit any head, and the linked double-treble crochet brim has a lot more structure for keeping the sun off your face, ears, and neck. With a super simple stitch pattern and no seaming required, this hat is quick to make and can be ready to give as a gift (or to keep for yourself) in a flash. You'll find yourself wanting to make several of these in different colors to add to your wardrobe!

YARN

DK weight (#3 Light); 120 yd (109.7 m).

shown: Stitch Diva Studios, Studio Silk (100% silk; 120 yd [109.7 m]/1.75 oz [50 g]): snakeskin, 1 skein

HOOK

E/4 (3.5mm) or size needed to obtain gauge.

NOTIONS

Split-ring stitch marker; tapestry needle.

GAUGE

First 5 rnds = 2" (5 cm) in diameter. One rep in st patt (sc, ch 7) = 1½" (3.8 cm) wide.

FINISHED SIZE

21" (53.5 cm) circumference in Rnd 1 of Brim.

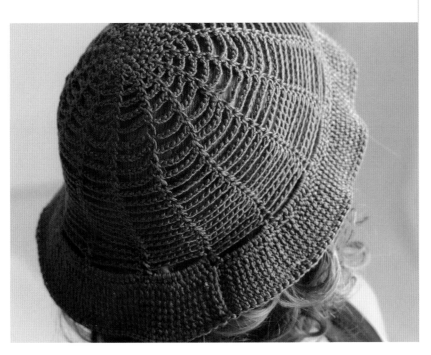

- Hat is worked in the round, in a spiral—do not join at the ends of the rounds.

special stitches

Linked Triple Treble Crochet (L-trtr):
Insert hook down through upper horizontal loop of last stitch, yarn over hook, draw up a loop, *insert hook down through next horizontal loop on last stitch, yarn over hook, draw yarn through. Repeat from * 5 times, insert hook in next stitch on last round, [yarn over hook, draw yarn through 2 loops on hook] 8 times—1 L-trtr made.

To work the first L-trtr after the beginning ch-8, insert hook in 2nd ch from hook, yarn over hook, draw up a loop, *insert hook in next ch, yarn over hook, draw up a loop, repeat from * 5 times, insert hook in next stitch on last rnd, yarn over hook, draw up a loop, [yarn over hook, draw yarn through 2 loops on hook] 8 times.

Joining/Last Linked Stitch p. 158.

Chains Bucket Hat

Refer to the stitch diagram at right for assistance.

Hat Body

RND 1: Ch 2, 7 sc in 2nd ch from hook, do not join.

Pm in first st of last rnd. Move marker up as work progresses to indicate first st of each rnd.

RND 2: 2 sc in each st around—14 sts.

RND 3: (Sc, ch 1) in each sc around.

RND 4: (Sc, ch 2) in each sc around.

RND 5: (Sc, ch 3) in each sc around.

RND 6: (Sc, ch 4) in each sc around.

RND 7: (Sc, ch 5) in each sc around.

RND 8: (Sc, ch 6) in each sc around.

RND 9: (Sc, ch 7) in each sc around.

RNDS 10–25: Rep Rnd 9. At end of last rnd, join with sl st in next sc. Do not fasten off.

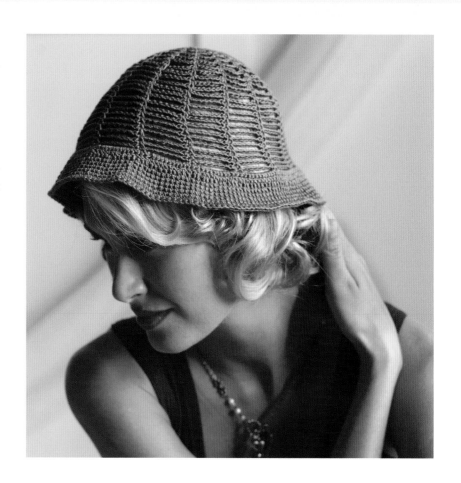

Note: Hat should measure 4" (10 cm) from Rnd 9.

Brim

RND 1: *2 sc in sc, 10 sc in next ch-7 sp, rep from * around, join with sl st in first sc at beg of rnd—168 sc.

RND 2: Ch 8, work L-trtr in each st around, except work Joining/last linked stitch for last st.

Fasten off.

Wet or steam block to finished measurements. Weave in loose ends with a tapestry needle.

stitch diagram

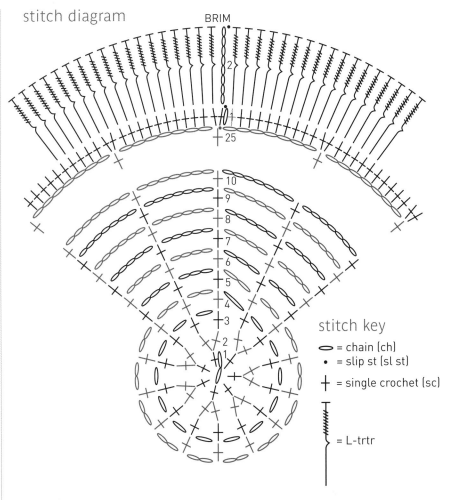

stitch key

⬮ = chain (ch)

• = slip st (sl st)

+ = single crochet (sc)

〰 = L-trtr

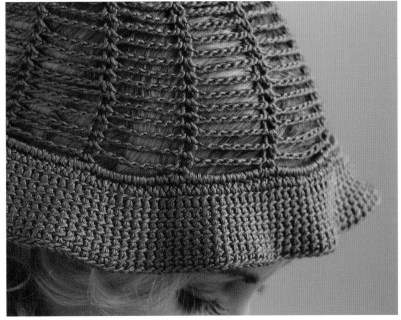

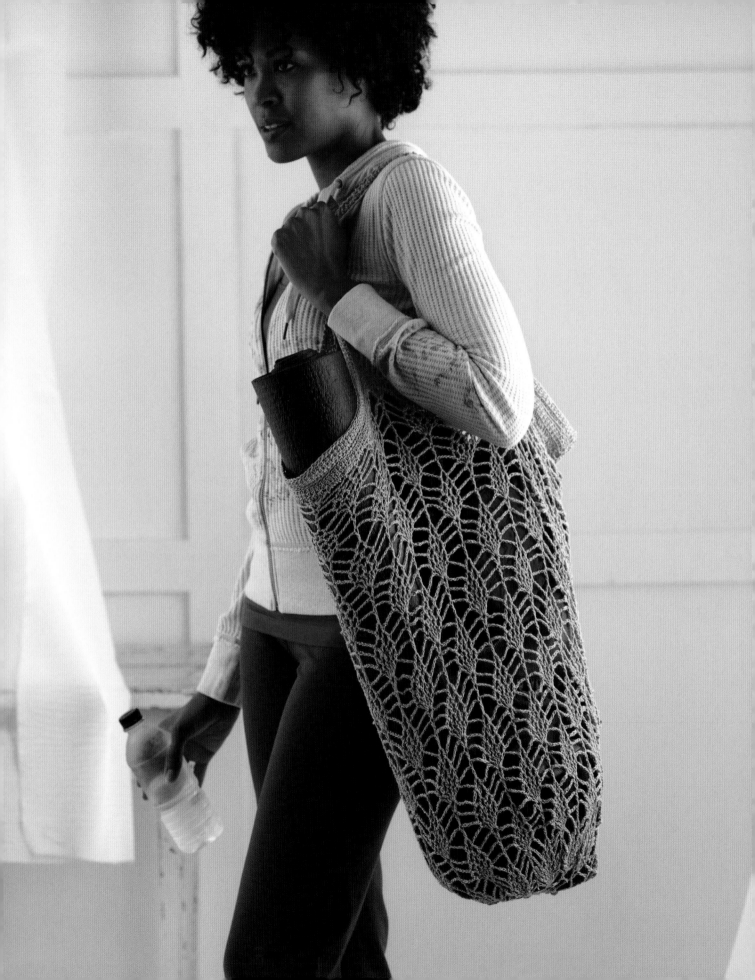

willow BAG

Who says reusable can't be pretty? This bag is not only useful and environmentally friendly, but it will also give you the chance to show off some mad crochet lace skills! The pattern is deceptively simple to crochet; all the increases are worked into the first round of stitches, so there is no increasing or decreasing within the stitch pattern. The durable linen yarn is machine washable and dryable. It gets softer each time you wash it, making it the perfect strong yet low-maintenance choice for this bag. Use the bag to go to the market or the beach, or stow your yoga mat and water bottle for a trip to the gym; this bag will carry it all!

YARN

Sportweight (#2 Fine); 534 yd (488.5 m).

shown: Louet North America, Euroflax Sport weight (100% Wet Spun Linen; 270 yd [247 m]/3½ oz [100 g]): 55 willow, 2 skeins.

HOOK

E/4 (3.5mm) or size needed to obtain gauge.

NOTIONS

Tapestry needle.

GAUGE

First 3 rnds = 4" (10 cm) in diameter.

FINISHED SIZE

22" long x 24" wide at the opening (56 x 61 cm). Straps are 10" (25 cm) long.

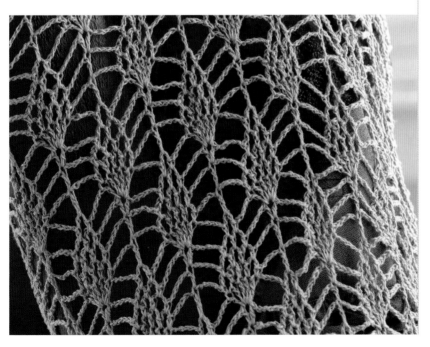

notes

- If you wind the yarn a couple of times before you begin your project, it will soften up the yarn—your hands will appreciate it!

- Bag is worked in one piece. It begins at the circular base, is worked up the sides, and then the handles are worked right onto the bag.

special stitches

Linked Double Treble Crochet (L-dtr) p. 158.

To work the first L-dtr after the beg ch-5, insert hook in 2nd ch from hook, yarn over hook, draw yarn through, insert hook in next ch, yarn over hook, draw yarn through, insert hook in next ch, yarn over hook, draw yarn through, insert hook in next stitch, yarn over hook, draw yarn through stitch, [yarn over hook, draw yarn through 2 loops on hook] 4 times. To join at the end of the linked stitch rnd, pull up loops in ch stitches of beginning ch-5 at beginning of rnd (stitch to the left) and continue as a normal L-dtr.

Joining/Last Linked Stitch p. 158.

Foundation single crochet (fsc) p. 157.

Willow Market Bag

Refer to stitch diagram A at right for assistance with beginning the circular base. Refer to stitch diagram B at right for a reduced sample of the patt (also reduced sample of the strap).

Ch 8, join with sl st to form a ring.

RND 1: Ch 6 (counts as dc, ch 3), [dc, ch 3] 11 times in ring, join with sl st to 3rd ch at beg of rnd—12 ch-3 sps.

RND 2: Ch 8 (counts as dc, ch 5), *dc in next dc, ch 5, rep from * around, join with sl st to 3rd ch at beg of rnd—12 ch-5 sps.

RND 3: Ch 4 (counts as dc, ch 1), dc in first st, ch 5, *[dc, ch 1, dc] in next dc, ch 5, rep from * around, join with sl st to 3rd ch at beg of rnd—12 ch-5 sps.

RND 4: Sl st into first ch-1 sp, ch 4 (counts as dc, ch 1), [[dc, ch 1] 3 times, dc] in same ch-1 sp, ch 5, sc in next ch-5 sp, ch 5, *[[dc, ch 1] 4 times, dc] in next ch-1 sp, ch 5, sc in next ch-5 sp, ch 5, rep from * around, join with sl st to 3rd ch at beg of rnd—24 ch-5 sps.

RND 5: Ch 1, sc in first dc, (ch 3, sc) in each of next 4 dc, ch 5, skip next ch-5 sp, dc in next sc, ch 5, skip next ch-5 sp, *sc in next dc, (ch 3, sc) in each of next 4 dc, ch 5, skip next ch-5 sp, dc in next sc, ch 5, skip next ch-5 sp, rep from * around, join with sl st to first sc at beg of rnd—24 ch-5 sps.

RND 6: Sl st into next ch-3 sp, ch 1, sc in same sp, (ch 3, sc) in each of next 3 ch-3 sps, ch 5, skip next ch-5 sp, dc in next dc, ch 5, skip next ch-5 sp, *sc in next ch-3 sp, (ch 3, sc) in each of next 3 ch-3 sps, ch 5, skip next ch-5 sp, dc in next dc, ch 5, skip next ch-5 sp, rep from * around, join with sl st to first sc at beg of rnd—24 ch-5 sps.

RND 7: Sl st into next ch-3 sp, ch 1, sc in same sp, (ch 3, sc) in each of next 2 ch-3 sps, ch 5, skip next ch-5 sp, (dc, ch 1, dc) in next dc, ch 5, skip next ch-5 sp, *sc in next ch-3 sp, (ch 3, sc) in each of next 2 ch-3 sps, ch 5, skip next ch-5 sp, (dc, ch 1, dc) in next dc, ch 5, skip next ch-5 sp, rep from * around, join with sl st to top of first sc at beg of rnd—24 ch-5 sps.

RND 8: Sl st into next ch-3 sp, ch 1, sc in same sp, ch 3, sc in next ch-3 sp, ch 5, skip next ch-5 sp, ([dc, ch 1] 4 times, dc) in next ch-1 sp, ch 5, skip next ch-5 sp, *sc in next ch-3 sp, ch 3, sc in next ch-3 sp, ch 5, skip next ch-5 sp, ([dc, ch 1] 4 times, dc) in next ch-1 sp, ch 5, skip next ch-5 sp, rep from * around, join with sl st to first sc at beg of rnd—24 ch-5 sps.

RND 9: Sl st into next ch-3 sp, ch 8 (counts as dc, ch 5), skip next ch-5 sp, sc in next dc, (ch 3, sc) in each of next 4 dc, ch 5, skip next ch-5 sp, *dc in next ch-3 sp, ch 5, skip next ch-5 sp, sc in next dc, (ch 3, sc) in each of next 4 dc, ch 5, skip next ch-5 sp, rep from * around, join with sl st to 3rd ch at beg of rnd—24 ch-5 sps.

RND 10: Ch 8 (counts as dc, ch 5), skip next ch-5 sp, sc in next ch-3 sp, (ch 3, sc) in each of next 3 ch-3 sps, ch 5, skip next ch-5 sp, *dc in next dc, ch 5, skip next ch-5 sp, sc in next ch-3 sp, (ch 3, sc) in each of next 3 ch-3 sps, ch 5, skip next ch-5 sp, rep from * around, join with sl st to 3rd ch at beg of rnd.

stitch diagram A

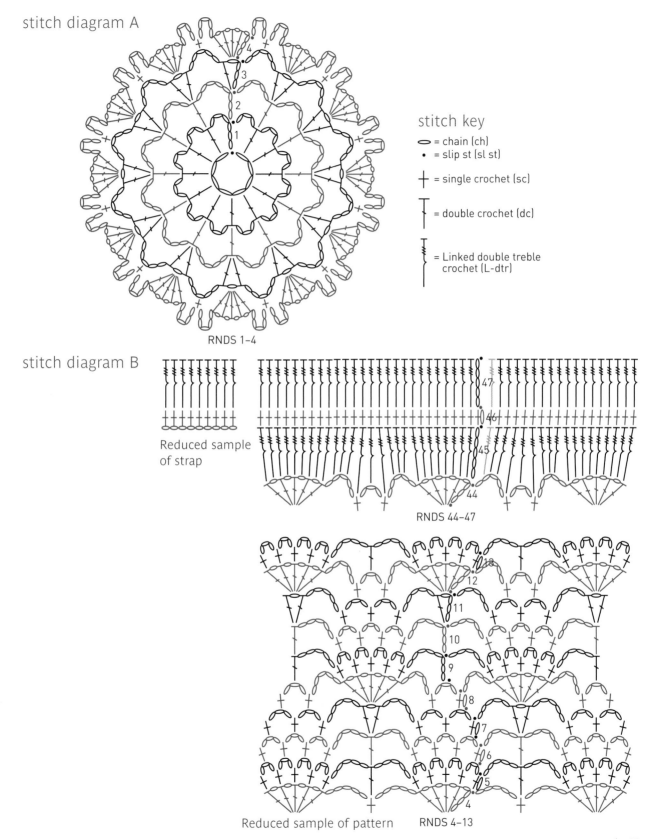

stitch key

⬮ = chain (ch)

• = slip st (sl st)

✛ = single crochet (sc)

╎ = double crochet (dc)

╪ = Linked double treble crochet (L-dtr)

RNDS 1–4

stitch diagram B

Reduced sample of strap

RNDS 44–47

Reduced sample of pattern RNDS 4–13

RND 11: Ch 4 (counts as dc, ch 1), dc in first dc, ch 5, skip next ch-5 sp, sc in next ch-3 sp, (ch 3, sc) in each of next 2 ch-3 sps, ch 5, skip next ch-5 sp, *(dc, ch 1, dc) in next ch-1 sp, ch 5, skip next ch-5 sp, sc in next ch-3 sp, (ch 3, sc) in each of next 2 ch-3 sps, ch 5, skip next ch-5 sp, rep from * around, join with sl st to 3rd ch at beg of rnd.

RND 12: Sl st into next ch-1 sp, ch 4 (counts as dc, ch 1), ([dc, ch 1] 3 times, dc) in same ch-1 sp, ch 5, skip next ch-5 sp, sc in next ch-3 sp, ch 3, sc in next ch-3 sp, ch 5, skip next ch-5 sp, *([dc, ch 1] 4 times, dc) in next ch-1 sp, ch 5, skip next ch-5 sp, sc in next ch-3 sp, ch 3, sc in next ch-3 sp, ch 5, skip next ch-5 sp, rep from * around, join with sl st in 3rd ch at beg of rnd.

RND 13: Ch 1, sc in first dc, (ch 3, sc) in each of next 4 dc, ch 5, skip next ch-5 sp, dc in next ch-3 sp, ch 5, skip next ch-5 sp, *sc in next dc, (ch 3, sc) in each of next 4 dc, ch 5, skip next ch-5 sp, dc in next ch-3 sp, ch 5, skip next ch-5 sp, rep from * around, join with sl st to first sc at beg of rnd.

RNDS 14–44: Rep Rnds 6–13 three times; rep Rnds 6–12 once. Do not fasten off.

RND 45: Ch 5 (counts as first L-dtr), L-dtr evenly around, working 1 L-dtr in each dc, sc, ch-1 sp, and ch-3 sp and working 3 L-dtr in each ch-5 sp, join to beg ch while completing last L-dtr—216 L-dtr.

RND 46: Ch 1, sc in each of next 36 sts, work 72 fsc, skip next 36 sts, sc in each of next 72 sts, work 72 fsc, skip next 36 sts, sc in each of next 36 sts, join with sl st to first sc at beg of rnd—288 sts.

RND 47: Ch 5, work 1 L-dtr in each st around, except work a Joining/last linked stitch for last st.

Fasten off.

Wet or steam block to finished measurements. Weave in loose ends with a tapestry needle.

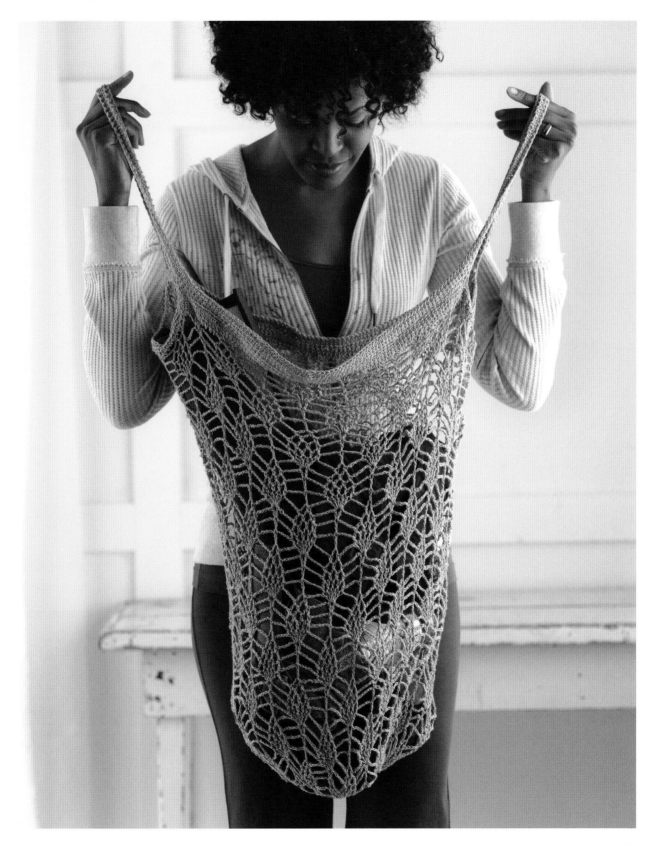

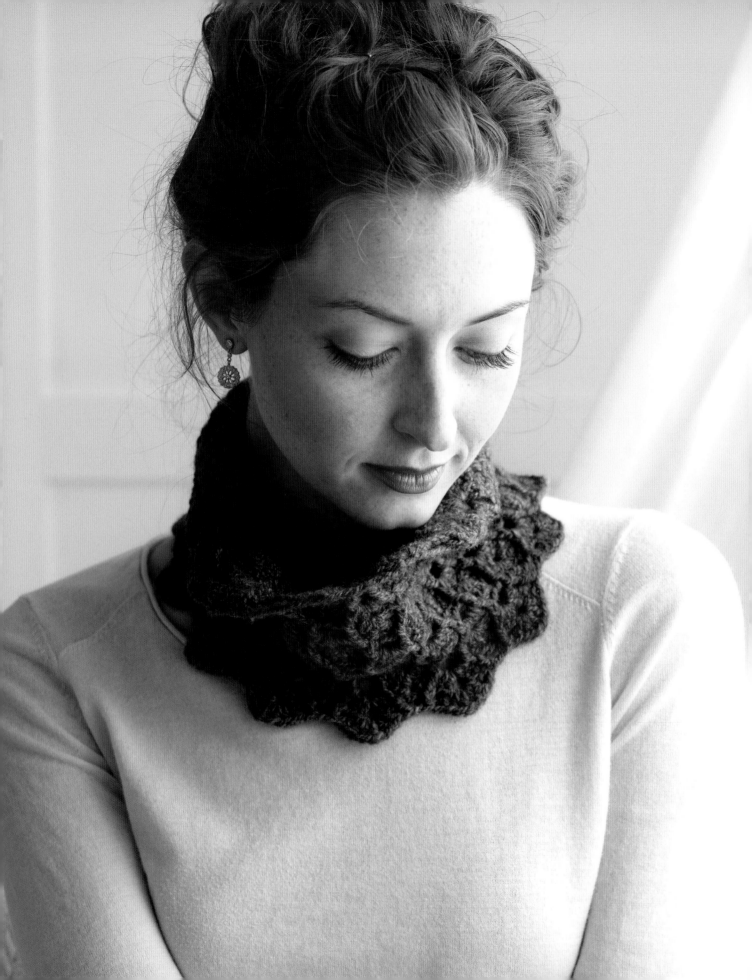

honeycomb NECK WARMER

A simple and elegant alternative to a scarf, this neck warmer slips easily over your head and tucks neatly into your coat. The pretty scalloped edge created by the shells makes it just as pretty to wear alone over a sweater to keep your neck nice and toasty. The intricate texture of the offset hourglass shaping in post stitches and shells reminds me of the network texture of honeycomb and will probably make observers want to take a closer look.

YARN

DK weight (#3 Light); 150 yd (137 m).

shown: Bijou Basin Ranch, 50/50 Yak/ Cormo Wool Blend Yarn (50% pure yak/50% American cormo wool; 150 yd [137 m]/ 2 oz [56.6 g]): heathered gray/brown, 1 skein.

HOOK

G/6 (4mm) or size needed to obtain gauge.

NOTIONS

Tapestry needle.

GAUGE

2 patt reps (20 sts) x 11 rows = 3½" (9 cm) in stitch patt.

FINISHED SIZE

20" (51 cm) in circumference x 6" (15 cm) tall.

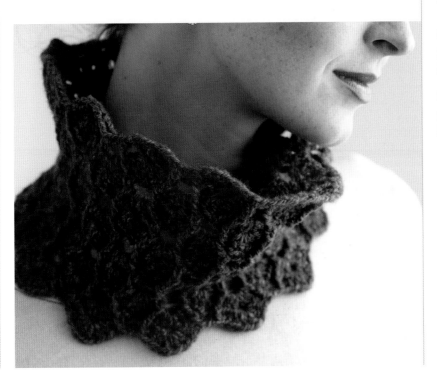

special stitches

Front post double crochet (fpdc) p. 157.

Honeycomb Neck Warmer

Refer to the stitch diagram at right for a reduced sample of patt.

Ch 100, join with sl st to form ring, taking care not to twist.

RND 1: Ch 3 (counts as dc), (2 dc, ch 1, 3 dc) in same sp, *skip next 3 ch, dc in next ch, ch 1, skip next ch, dc in next ch, skip 3 ch**, (3 dc, ch 1, 3 dc) in next ch, rep from * around, ending last rep at **, join with sl st to top of ch-3 at beg of rnd.

RND 2: Sl st to next ch-1 sp, ch 3 (counts as dc), (2 dc, ch 1, 3 dc) in same sp, *skip next 3 dc, fpdc around post of next dc, ch 1, sk next ch-1 sp, fpdc around post of next dc, skip next 3 dc**, (3 dc, ch 1, 3 dc) in next ch-1 sp, rep from * around, ending last rep at **, join with sl st to top of ch-3 at beg of rnd.

RND 3: Sl st to next ch-1 sp, ch 4 (counts as dc, ch 1), dc in same sp, *skip next 3 dc, fpdc around post of next fpdc, (2 dc, ch 1, 2 dc) in next ch-1 sp, fpdc around post of next fpdc, skip next 3 dc**, (dc, ch 1, dc) in next ch-1 sp, rep from * around, ending last rep at **, join with sl st to 3rd ch of ch-4 at beg of rnd.

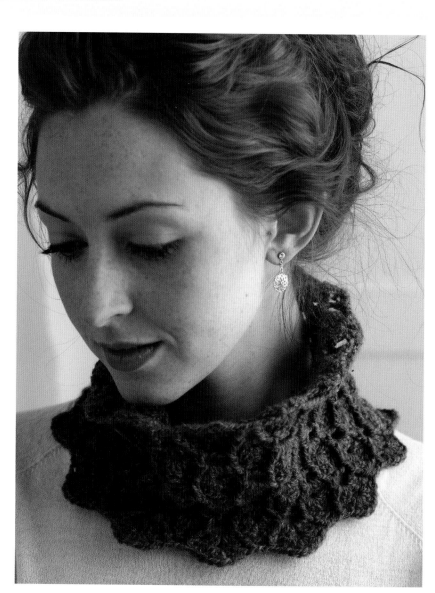

stitch diagram

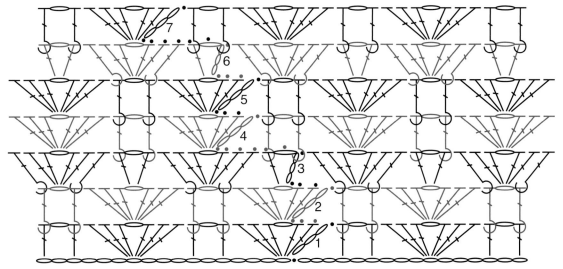

Reduced sample of pattern

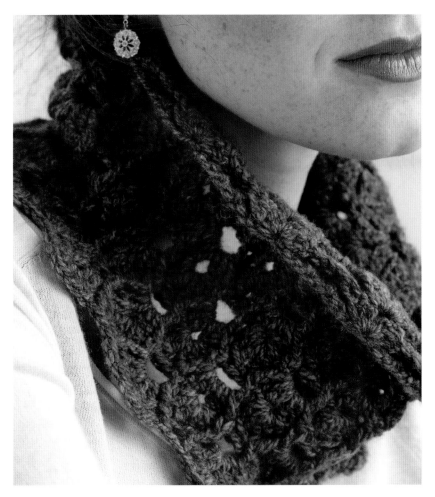

stitch key

⬭ = chain (ch)

• = slip st (sl st)

† = double crochet (dc)

‡ = Front Post dc (FPdc)

RND 4: Sl st in next (ch-1 sp, 4 dc, ch-1 sp), ch 3 (counts as dc), (2 dc, ch 1, 3 dc) in same ch-1 sp, *skip next 3 dc, work fpdc around post of next dc, ch 1, skip next ch-1 sp, fpdc around post of next dc, skip next 3 dc**, (3 dc, ch 1, 3 dc) in next ch-1 sp, rep from * around, ending last rep at **, skip 2 dc, join with sl st to top of ch-3 at beg of rnd.

RNDS 5–20: Rep Rnds 2–4 five times, then rep Rnd 2 once.

Fasten off.

Wet or steam block to finished measurements. Weave in loose ends with a tapestry needle.

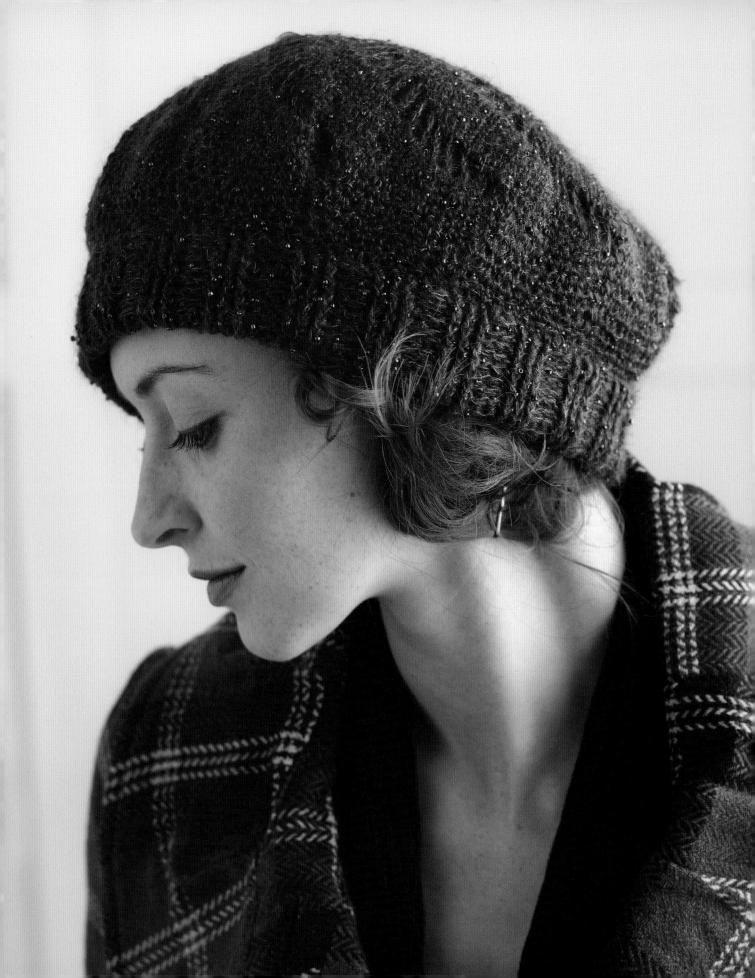

visage LACE BERET

Back in my modeling days in the big city, the other girls and I used to dance until dawn at a teen club called Visage. We wore a lot of black back in those days, but I was always a sucker for a little bling. Had I owned a sparkly, beaded, and glittered beret like this one, it would have been my signature piece, so I honored those memories by naming this hat after that oft-visited club. The post stitch faux-ribbed brim is doubled, making it snug and warm, and the beaded yarn adds subtle sparkle that will complement many ensembles.

YARN

Laceweight (#0 Lace); 345 yd (315 m).

shown: Tilli Tomas, Symphony (63% super kid mohair/10% silk/9% wool/18% nylon with beads; 345 yd [315 m]/3.5 oz [100 g]): midnight borealis, 1 skein.

HOOK

D/3 (3.25mm) or size needed to obtain gauge.

NOTIONS

Split-ring stitch marker; tapestry needle.

GAUGE

First 2 rnds = 3½" (9 cm) in diameter; 18 sts = 4" (10 cm).

FINISHED SIZE

22" (56 cm) in circumference.

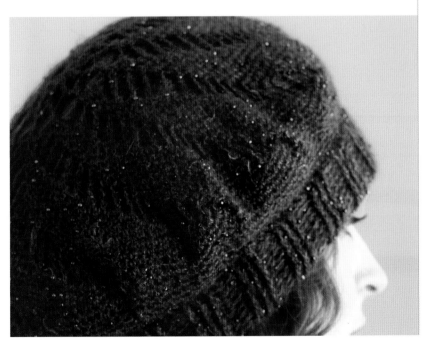

special stitches

2 treble crochet cluster (2-tr cl) p. 158.

3 treble crochet cluster (3-tr cl) p. 158.

Front post double crochet (fpdc) p. 157.

Back post double crochet (bpdc) p. 156.

Back post double crochet 2 together (bpdc2tog) p. 156.

Visage Beret

Refer to stitch diagram A at right for assistance.

Ch 8, join with sl st to form ring.

RND 1: Ch 4, 2-tr cl in ring, ch 3, *3-tr cluster in ring, ch 3, rep from * 10 times, join with sl st to top of first cl at beg of rnd—12 ch-3 sps.

RND 2: Sl st in next ch-3 sp, ch 1, sc in ch-3 sp, ch 5, *sc in next ch-3 sp, ch 5, rep from * around, join with sl st to top of 1st st at beg of rnd—12 ch-5 sps.

RND 3: Ch 1, sc in first sc, 2 sc in next ch-5 sp, ch 5, *sc in next sc, 2 sc in next ch-5 sp, ch 5, rep from * around, join with sl st to top of sc at beg of rnd—3 sc per rep (12 reps).

RND 4: Ch 1, skip first st, sc in each of next 2 sts, 2 sc in next ch-5 sp, ch 5, *skip next sc, sc in each of next 2 sc, 2 sc in next ch-5 sp, ch 5, rep from * around, join with sl st to top of sc at beg of rnd—4 sc per rep.

RND 5: Ch 1, skip first st, sc in each of next 3 sts, 2 sc in next ch-5 sp, ch 5, *skip next sc, sc in each of next 3 sts, 2 sc in next ch-5 sp, ch 5, rep from * around, join with sl st to top of sc at beg of rnd—5 sc per rep.

RND 6: Ch 1, skip first st, sc in each of next 4 sts, 2 sc in next ch-5 sp, ch 5, *skip next sc, sc in each of next 4 sts, 2 sc in next ch-5 sp, ch 5, rep from * around, join with sl st to top of sc at beg of rnd—6 sc per rep.

RND 7: Ch 1, skip first st, sc in each of next 5 sts, 2 sc in next ch-5 sp, ch 5, *skip next sc, sc in each of next 5 sts, 2 sc in next ch-5 sp, ch 5, rep from * around, join with sl st to top of sc at beg of rnd—7 sc per rep.

RND 8: Ch 1, skip first st, sc in each of next 6 sts, 2 sc in next ch-5 sp, ch 5, *skip next sc, sc in each of next 6 sts, 2 sc in next ch-5 sp, ch 5, rep from * around, join with sl st to top of sc at beg of rnd—8 sc per rep.

RND 9: Ch 1, skip first st, sc in each of next 7 sts, 2 sc in next ch-5 sp, ch 5, *skip next sc, sc in each of next 7 sts, 2 sc in next ch-5 sp, ch 5, rep from * around, join with sl st to top of sc at beg of rnd—9 sc per rep.

RND 10: Ch 1, skip first st, sc in each of next 8 sts, 2 sc in next ch-5 sp, ch 5, *skip next sc, sc in each of next 8 sts, 2 sc in next ch-5 sp, ch 5, rep from * around, join with sl st to top of sc at beg of rnd—10 sc per rep.

stitch key

⌒ = chain (ch)

• = slip st (sl st)

┼ = single crochet (sc)

┬ = double crochet (dc)

= Front Post dc (FPdc)

= Back Post dc (BPdc)

= 2-tr cluster

= 3-tr cluster

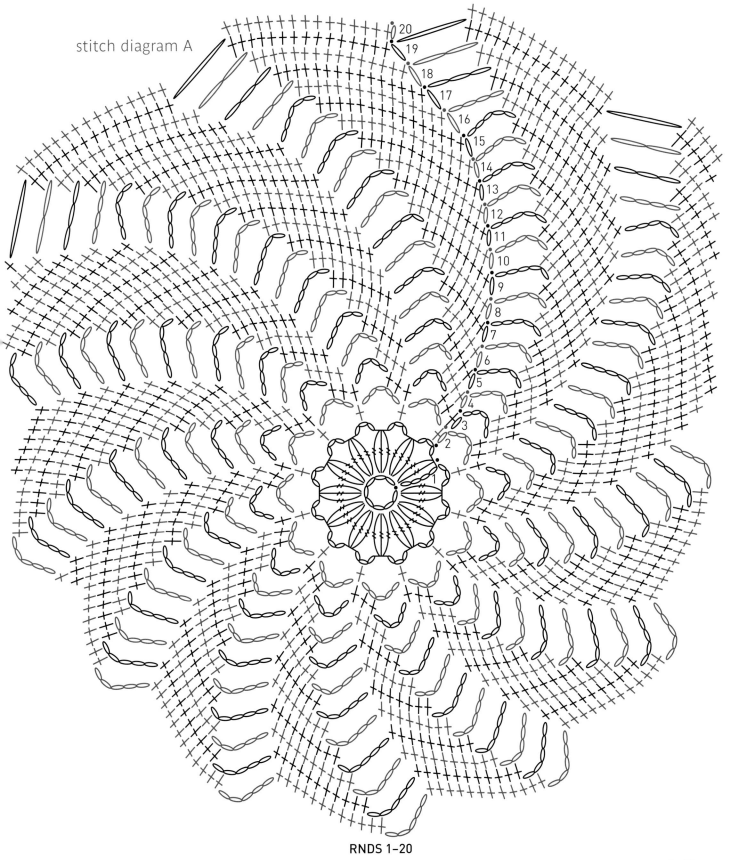

RNDS 1–20

stitch diagram B

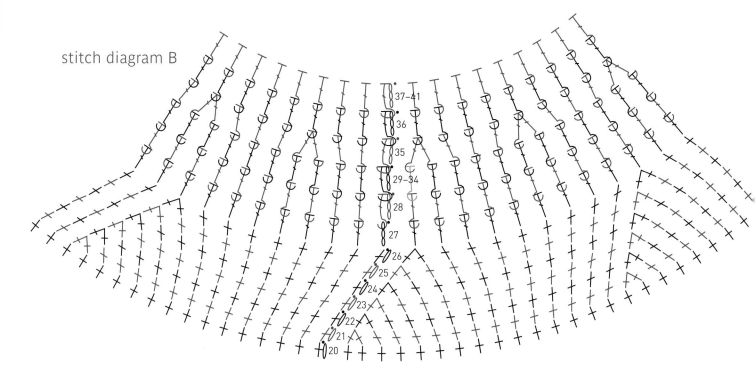

RND 11: Ch 1, skip first st, sc in each of next 9 sts, 2 sc in next ch-5 sp, ch 5, *skip next sc, sc in each of next 9 sts, 2 sc in next ch-5 sp, ch 5, rep from * around, join with sl st to top of sc at beg of rnd—11 sc per rep.

RND 12: Ch 1, skip first st, sc in each of next 10 sts, 2 sc in next ch-5 sp, ch 5, *skip next sc, sc in each of next 10 sts, 2 sc in next ch-5 sp, ch 5, rep from * around, join with sl st to top of sc at beg of rnd—12 sc per rep.

RND 13: Ch 1, skip first st, sc in each of next 11 sts, 2 sc in next ch-5 sp, ch 5, *skip next sc, sc in each of next 11 sts, 2 sc in next ch-5 sp, ch 5, rep from * around, join with sl st to top of sc at beg of rnd—13 sc per rep.

RND 14: Ch 1, skip first st, sc in each of next 12 sts, 2 sc in next ch-5 sp, ch 5, *skip next sc, sc in each of next 12 sts, 2 sc in next ch-5 sp, ch 5, rep from * around, join with sl st to top of sc at beg of rnd—14 sc per rep.

RND 15: Ch 1, skip first st, sc in each of next 13 sts, 2 sc in next ch-5 sp, ch 5, *skip next sc, sc in each of next 13 sts,

2 sc in next ch-5 sp, ch 5, rep from * around, join with sl st to top of sc at beg of rnd—15 sc per rep.

RND 16: Ch 1, skip first 2 sts, sc in next 13 sts, 2 sc in next ch-5 sp, ch 4, *skip next 2 sc, sc in next 13 sts, 2 sc in next ch-5 sp, ch 4, rep from * around, join with sl st to top of sc at beg of rnd—15 sc per rep.

RND 17: Ch 1, skip first 2 sts, sc in next 13 sts, 2 sc in next ch-4 sp, ch 3, *skip next 2 sc, sc in next 13 sts, 2 sc in next ch-5 sp, ch 3, rep from * around, join with sl st to top of sc at beg of rnd—15 sc per rep.

RND 18: Ch 1, skip first 2 sts, sc in next 13 sts, 2 sc in next ch-3 sp, ch 2, *skip next 2 sc, sc in next 13 sts, 2 sc in next ch-5 sp, ch 2, rep from * around, join with sl st to top of sc at beg of rnd—15 sc per rep.

RND 19: Ch 1, skip first 2 sts, sc in next 13 sts, 2 sc in next ch-2 sp, ch 1, *skip next 2 sc, sc in next 13 sts, 2 sc in next ch-5 sp, ch 1, rep from * around, join with sl st to top of sc at beg of rnd—15 sc per rep.

Refer to stitch diagram B for assistance with remainder of patt.

RND 20: Ch 1, *sc in each of next 15 sts, skip next ch-1 sp, rep from * around, join with sl st to top of sc at beg of rnd—180 sc.

RND 21: Ch 1, *sc in each of next 13 sts, sc2tog in next 2 sts, rep from * around, join with sl st to top of sc at beg of rnd—168 sc.

RND 22: Ch 1, *sc in each of next 12 sts, sc2tog in next 2 sts, rep from * around, join with sl st to top of sc at beg of rnd—156 sc.

RND 23: Ch 1, *sc in each of next 11 sts, sc2tog in next 2 sts, rep from * around, join with sl st to top of sc at beg of rnd—144 sc.

RND 24: Ch 1, *sc in each of next 10 sts, sc2tog in next 2 sts, rep from * around, join with sl st to top of sc at beg of rnd—132 sc.

RND 25: Ch 1, *sc in each of next 9 sts, sc2tog in next 2 sts, rep from * around, join with sl st to top of sc at beg of rnd—120 sc.

RND 26: Ch 1, *sc in each of next 8 sts, sc2tog in next 2 sts, rep from * around, join with sl st to top of sc at beg of rnd—108 sc.

RND 27: Ch 3, dc in each st around, dec 3 sts evenly spaced around by working dc2tog—105 sc.

Band

RND 28: Ch 3, fpdc around post of first ch-3, fpdc around post of next 2 dc, bpdc around post of next 2 dc, *fpdc around post of each of next 3 dc, bpdc around post of each of next 2 dc, rep from * around, join with sl st to top of first st at beg of rnd—105 sts.

Note: On each foll rnd, work the first fpdc around both the post of the stitch below and the ch-3 on the same prev row. It makes a slightly wider stitch but hides the ch-3 at the beg of each row.

RNDS 29–34: Ch 3, fpdc around post of first ch-3 and first dc, fpdc around post of next 2 dc, bpdc around post of each of next 2 dc, *fpdc around post of each of next 3 dc, bpdc around post of each of next 2 dc, rep from * around, join with sl st to top of first st at beg of rnd—105 sts.

RND 35: Ch 3, fpdc around post of first ch-3 and first dc, fpdc around post of next 2 dc, bpdc2tog in next 2 dc, *fpdc around post of each of next 3 sts, bpdc2tog in next 2 sts, rep from * around, join with sl st to top of first st at beg of rnd—84 sts.

RND 36: Ch 3, fpdc around post of first ch-3 and first dc, fpdc around post of next 2 dc, bpdc around post of next dc, *fpdc around post of each of next 3 sts, bpdc around post of next st, rep from * around.

RNDS 37–41: Rep Rnd 36. Do not fasten off.

Finishing

Turn hat inside out and fold ribbed band in half to inside. Holding Rnd 41 even with Rnd 27, sc in each st around, working through both thicknesses as you go,

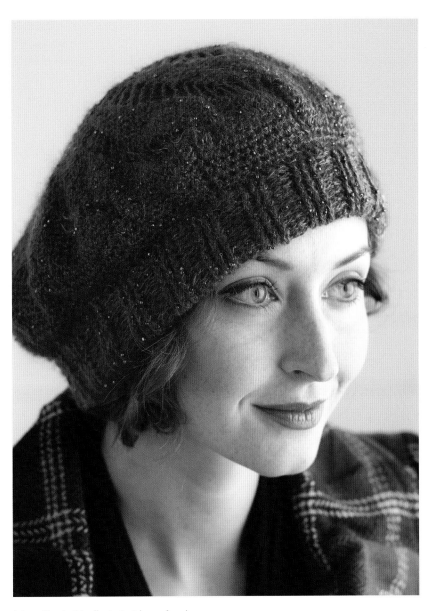

join with sl st to first st at beg of rnd. Fasten off.

Wet or steam block to finished measurements. Weave in loose ends with a tapestry needle.

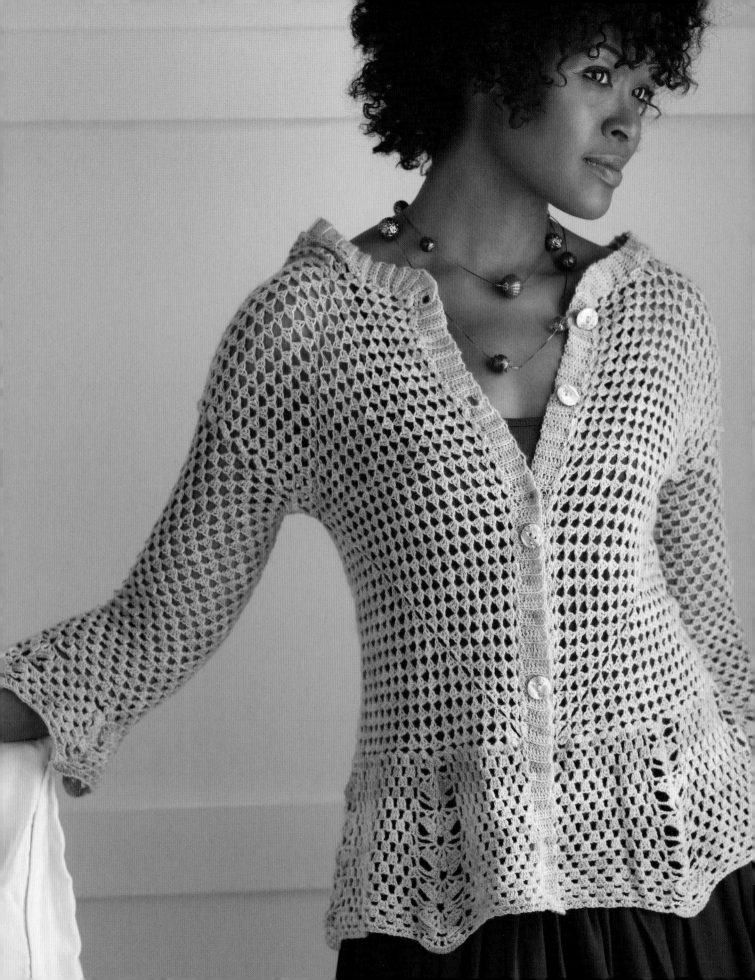

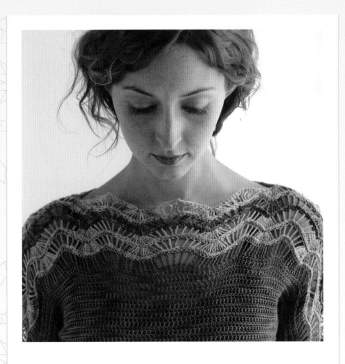

tops and cardigans

Although it is very tempting to pick up a thick yarn to make your sweaters quickly, choosing a lighter yarn and taking the extra time to work with it will create a garment that is infinitely more flattering to your figure. As you will see in this chapter, lighter yarn doesn't always have to be crocheted with tiny hooks. My passions for both geometry and crochet design have led me to create the beautiful, versatile, and often mathematically inspired garments you will find in the following pages.

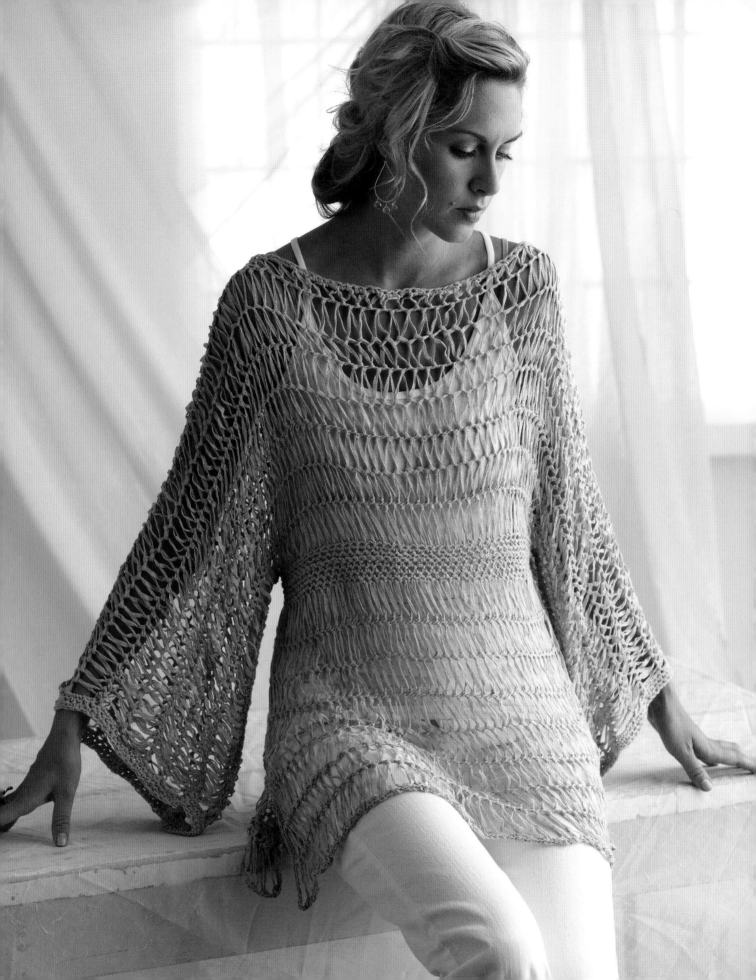

tranquil HAIRPIN LACE TUNIC

This tunic sweater is almost completely crocheted with hairpin lace, a very stretchy, open fabric of strips that are joined as you go. There is a solid single crochet waistband, lending structure to the tunic and loosely defining the waist. The unique texture of the flat ribbon yarn is prominently displayed by the open construction, and the simple repetitive stitch pattern creates a clean look for the finished garment. With a relaxed fit and airy but elegant appearance, this is a truly beautiful and versatile piece.

YARN

Worsted weight (#4 Medium); 450 (500, 625, 750) yd (411.5 [457, 571.5, 686] m).

shown: S. Charles Collezione, Sahara (44% viscose/36% bamboo/20% linen; 87 yd [79.5 m]/1.75 oz [50 g]): #03 blue mist, 6 (6, 8, 9) balls.

HOOK

G/6 (4mm) or size needed to obtain gauge.

NOTIONS

Tapestry needle; hairpin lace frame/loom, set to 4" (10 cm) wide; scrap yarn (optional).

GAUGE

Each strip is 3" (7.5 cm) wide (after joining), 4 sc rows of hairpin lace (2 lps on each side) = 1" (2.5 cm). On Waistband, 8 sts x 12 rows in sc = 4" (10 cm).

Hairpin lace is very stretchy so these measurements are approximate. This garment is worn loosely, with lots of stretch.

FINISHED SIZE

Size S (M, L, XL) fits 36 (40, 44, 48)" (91.5 [1.5, 112, 122] cm) bust circumference (meant to be worn loosely). Tunic measures 48 (50, 50, 52)" (122 [127, 127, 132] cm) from cuff to cuff, across shoulders. 26 (26, 29, 32)" (66 [66, 73.5, 81] cm) long. Tunic shown is a size S.

notes

- Tunic is worked in long strips. The strips are joined cuff to cuff for the sleeves and bodice. The lower body strips are joined separately in 2 pieces: front and back. Top, front, and back are joined together at the waist.

- When a strip is described as having 80 loops, that number is per side. There is a sc row per loop on one side. It takes 2 sc rows to acquire a loop on each side of frame.

special stitches

Hairpin Lace, see sidebar on p. 102.

3 double crochet cluster (3-dc cl) p. 156.

3 treble crochet cluster (3-tr cl) p. 158.

2 double-treble crochet cluster (2-dtr cl) p. 157.

3 double-treble crochet cluster (3-dtr cl) p. 157.

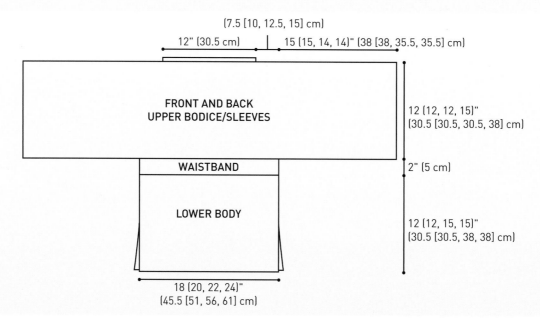

Tranquil Hairpin Lace Tunic

Loop Joining Technique
This technique joins two strips together through one loop at a time without any additional yarn.

Lay two strips side by side on a table in front of you. Insert your hook into the first loop on right strip and then insert the hook into the facing first loop on left strip. Pull 2nd loop through first loop on hook. *Insert hook into next loop on right strip, pull through loop on hook.

Insert hook into next loop on left strip, pull through loop on hook. Repeat from * until all loops are joined. There will be one loop remaining. Sew this loop to the last sc at top of either right or left strip. Using the tail from one of the strips, tack down the last loop before weaving in the loose end.

Upper Bodice/Sleeves
Make 8 (8, 8, 10) hairpin lace strips with 96 (100, 100, 104) lps per side. Using Loop Joining Technique, join 4 (4, 4, 5) strips together for Front. Using Loop Joining Technique, join the rem 4 (4, 4, 5) strips

together for Back. Refer to the Construction Diagrams on p. 104 for assistance.

Shoulder Seam
Note: Directions are given for a 12" (30.5 cm) wide neck opening. The sample garment delicately balances on the corners of the shoulders and can be worn off one shoulder. For a smaller neck opening, you may want to join more loops across the shoulders in equal numbers on each side, just remember that the tunic needs to slip easily over your head.

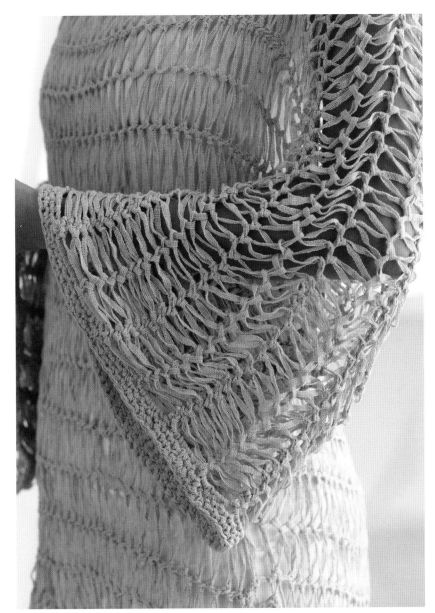

With Front piece on left and Back piece on right, place pieces side by side in front of you. Using the Loop Joining Technique, starting with the lp on the right, join the first 36 (38, 38, 40) lps on each strip together. Fasten off. Skip next 24 lps on both pieces for neck opening. Using the Loop Joining Technique, join the last 36 (38, 38, 40) lps on each side. Fasten off.

Front Neck Edging: With RS facing, join yarn with sl st to first lp join on second shoulder joining, sc in each of the skipped 24 lps across Back neck edge, sc in each of the skipped 24 lps across Front neck edge, join with sl st in first sc at beg of rnd. Fasten off.

Sleeve Seams: To join bottom edges of Front to Back, beginning at cuff, using Loop Joining Technique, starting with the lp on the right, join first 30 (30, 28, 28) lps on each side. Fasten off. Skip next 36 (40, 44, 48) lps on both pieces. Using the Loop Joining Technique, join the last 30 (30, 28, 28) lps on each side. Fasten off.

Sleeve Edging

RND 1: Join yarn with sl st in any lp on cuff edge, ch 1, sc evenly around cuff, sl st to first sc at beg of round to join.

RNDS 2–3: Ch 1, sc in each st around, join with sl st to top of first sc at beg of rnd, do not fasten off.

Upper Waistband

ROW 1 (BACK BOTTOM EDGING): With RS facing, join yarn with sl st in last sc on Front bottom edge, sc in each of the skipped 36 (40, 44, 48) lps across Back bottom edge, sc in each of the skipped 36 (40, 44, 48) lps across Front bottom edge, join with sl st in top of first sc at beg of rnd—72 (80, 88, 96) sc.

RND 2: Ch 1, sc in each sc around, join with sl st to top of first sc at beg of rnd.

RND 3: Rep Rnd 2. Fasten off.

hairpin lace

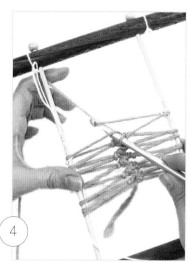

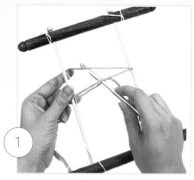

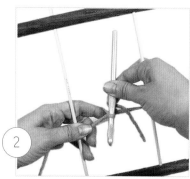

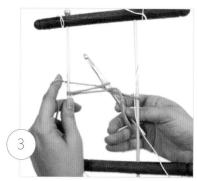

SAFETY LINES (OPTIONAL): Safety lines are really helpful in working hairpin lace. The safety line keeps the loops straight and in order after you remove the strip from the loom, making it easier to join the strips together later.

To create a safety line, cut a length of contrasting scrap yarn slightly longer than double the length of the strip you are making. After placing the first hairpin loop on the loom, thread one end of the scrap yarn through the loop from the bottom and tie to the top spacer of the loom on the left side. Tie the other end of the scrap yarn to the top spacer of the loom on the right side. Wrap excess scrap yarn around bottom spacer to keep it from becoming entangled while working the hairpin lace strip. Work the entire hairpin lace strip, working over the safety lines. When strip is complete, untie safety line and remove strip from loom. Tie 2 ends of safety line in a knot to hold loops in position while joining strips. After strips have been joined and/or edged, safety line can be removed and reused on subsequent strips.

Step 1:

Getting started and making first stitch: Hold the frame with spacer at bottom and rods 4" (10 cm) apart. With yarn, make loop with slipknot and place loop on left rod (counts as first loop), with knot in center between rods. Slide other spacer on top of rods (if desired, attach safety line as described above). Yarn end wraps from front to back around right rod, and yarn from ball is in front of right rod. Insert hook through loop from bottom to top. Hook yarn and draw through loop.

Step 2:

Moving hook to back, making room for wrapping yarn around loom: **Drop loop from hook, with hook behind frame. Insert hook from back to front through same loop (just dropped), turn frame clockwise from right to left, keeping yarn to back of frame. This allows the yarn to wrap around the frame without the hook getting tangled in the wrap, while retaining the position to continue stitching up the center.

Step 3:

Finish 2nd stitch: Insert hook under front strand of left loop, yarn over hook, pull loop through. Yarn over hook, pull through 2 loops on hook (single crochet made).**

Step 4:

Continue: Repeat from ** to ** for desired length of strip. This photo shows what the strip looks like with about 10 stitches complete. Remember: you are crocheting in rows of 1 stitch-per-row vertical crochet. As loom becomes full, remove bottom spacer and slide some of the loops off of the loom, leaving a few loops on the loom. When strip is complete, fasten off and remove remaining loops from loom. Tie two ends of safety line in a knot at top of strip.

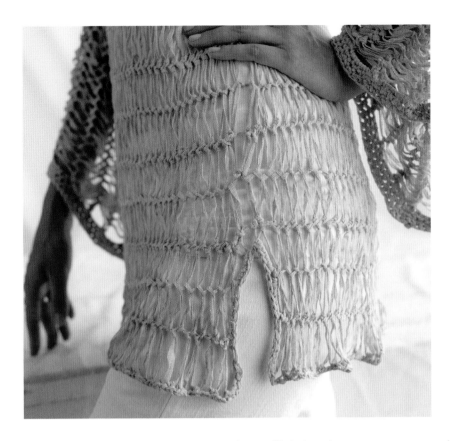

Lower Body

Refer to the Construction Diagrams on p. 104 for assistance.

Longer Strips: Make 2 (2, 3, 3) hairpin lace strips with 72 (80, 88, 96) lps on each side. Fasten off, leaving a long tail.

Using the Loop Joining Technique, join the 2 (2, 3, 3) strips together for upper portion of Lower Body.

Shorter Strips: Make 4 hairpin lace strips with 36 (40, 44, 48) lps on each side. Fasten off.

Using the Loop Joining Technique, join 2 shorter strips together and join them as one piece to first 36 (40, 44, 48) lps on one side of joined longer strip for Front Lower Body. Using the Loop Joining Technique, join other 2 shorter strips together and join them as one piece to last 36 (40, 44, 48) free lps of same side of longer strips for Back Lower Body.

Lower Waistband

RND 1: Working in free lps of top edge of assembled longer strips, join yarn with sl st in first lp, ch 1, sc in same lp and in each lp across, sl st to first sc at beg of rnd to join.

RNDS 2–3: Ch 1, sc in each st around, join with sl st to top of first sc at beg of rnd, do not fasten off.

RND 4 (JOINING RND): Align beg of rnd at left underarm on Upper Waistband, ch 1, working through double thickness of Upper and Lower Waistbands, matching sts, sc in each sc around, join with sl st in top of first sc at beg of rnd. Fasten off. Weave in loose ends.

Join the ends of the 2 (2, 3, 3) longer strips of Lower Bodice together as follows: Using long tail and tapestry needle, sew last sc made to first sc made at beg of same strip. Weave in loose ends. Do not join the ends of shorter strips on bottom of Lower Body. The openings on each lower side of tube will become side vents on tunic.

Bottom Edging: With RS facing, join yarn with sl st to any free lp on lower edge of Back, ch 1, sc in same lp, 1 sc in each lp across to last lp, 4 sc in same lp, turn and work 4 sc in edge of next lp on Back side vent, turn, 4 sc in edge of next 2 end lps on Front side vent, turn, 1 sc in each lp across bottom edge of Front to last lp, 4 sc in same lp, turn and work 4 sc in edge of next lp on Front side vent, turn, 4 sc in edge of next 2 end lps on Back side vent, turn, 1 sc in each rem lp across bottom to beg of rnd, join with sl st to top of first sc at beg of rnd. Fasten off.

Steam block to finished measurements. Weave in loose ends with a tapestry needle.

construction diagrams

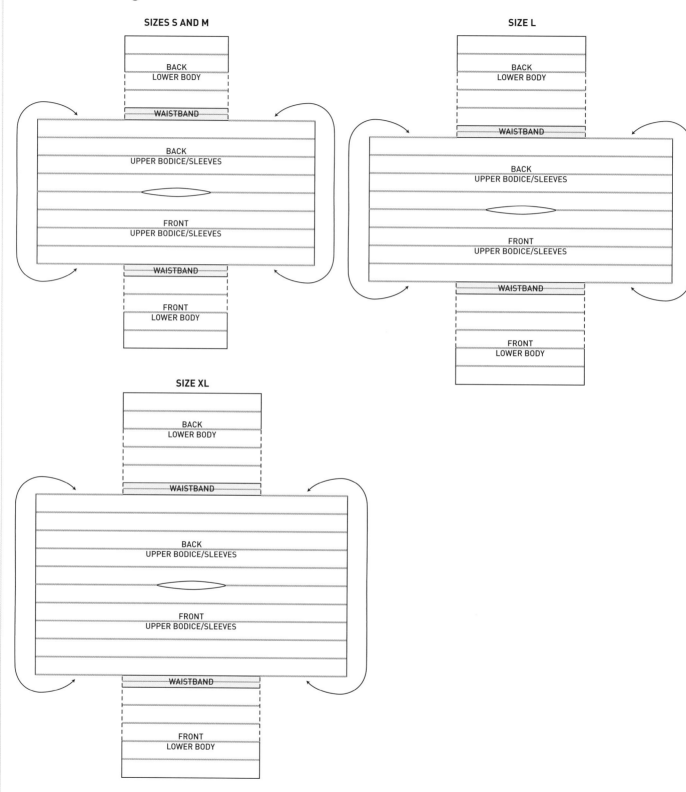

SIZES S AND M

BACK
LOWER BODY

WAISTBAND

BACK
UPPER BODICE/SLEEVES

FRONT
UPPER BODICE/SLEEVES

WAISTBAND

FRONT
LOWER BODY

SIZE L

BACK
LOWER BODY

WAISTBAND

BACK
UPPER BODICE/SLEEVES

FRONT
UPPER BODICE/SLEEVES

WAISTBAND

FRONT
LOWER BODY

SIZE XL

BACK
LOWER BODY

WAISTBAND

BACK
UPPER BODICE/SLEEVES

FRONT
UPPER BODICE/SLEEVES

WAISTBAND

FRONT
LOWER BODY

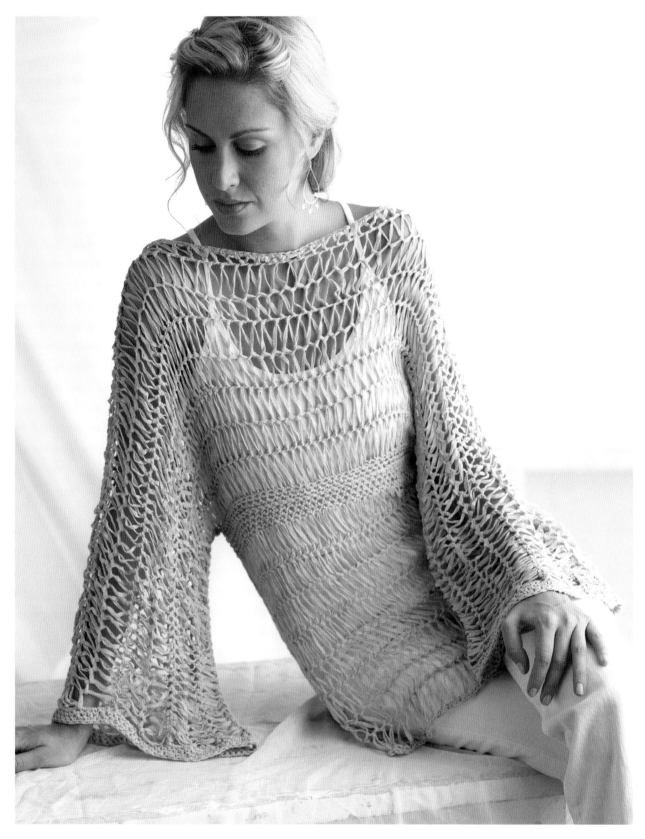

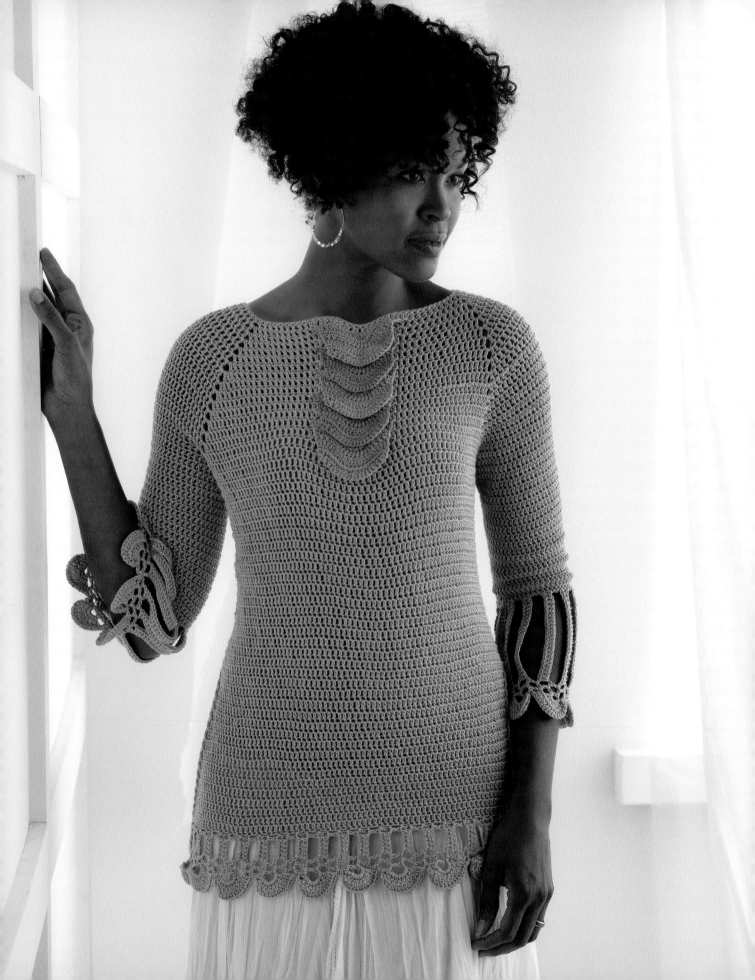

cascade PULLOVER TUNIC

I have to say that I am a shoe lover. In fact, the medallion embellishments on the front of this cozy pullover were inspired by a pair of expensive shoes that were worn in an episode of one of my favorite television shows. The medallion inspiration was repeated in the rounded details worked into the hip section for added ease and in the unusual edging at the hem and sleeve cuffs. This pullover can be dressed up or down for a variety of occasions, providing a little warmth without being heavy or bulky.

YARN

DK weight (#3 light); 863 (1,044, 1,250, 1,495) yd (789 [955, 1,143, 1,367] m) MC, 80 yd (73 m) each CC1 and CC2—1,023 (1,204, 1,410, 1,655) yd (936 [1,101, 1,290, 1,514] m) total.

shown: Patons Yarn, Grace (100% mercerized cotton; 136 yd [125 m]/1.75 oz [50 g]): 62027 ginger (MC), 7 (8, 10, 11) skeins; 62130 sky (CC1), 1 skein; 62244 wasabi (CC2), 1 skein.

HOOK

D/3 (3.25mm) or size needed to obtain gauge.

NOTIONS

Split-ring stitch markers; tapestry needle.

GAUGE

18 sts x 10 rows = 4" (10 cm) in dc.

FINISHED SIZE

Size S (M, L, XL) fits 35½ (41, 46, 51½)" (90 [104, 117, 131] cm). Tunic is 23½ (24¾, 26, 27)" (59.5 [63, 66, 68.5] cm) long. Tunic shown is a size S.

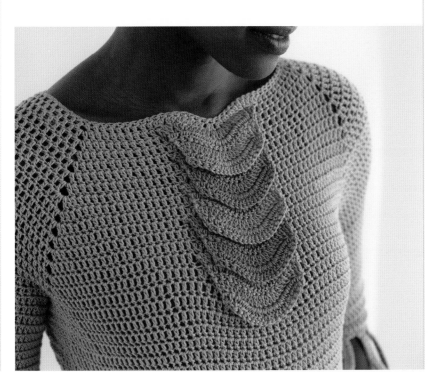

- Remember to switch to back loops for the 18 center front stitches only.

- The yoke and sweater are worked in spirals, not rounds, to eliminate the ch-3 at the beginning of each round.

- At the end of every row of Edging, join to every other dc at end of last rnd of Body.

Foundation single crochet (fsc) p. 157.

Double crochet 2 together through back loop only (dc2tog-blo) p. 156.

Front post double crochet (fpdc) p. 157.

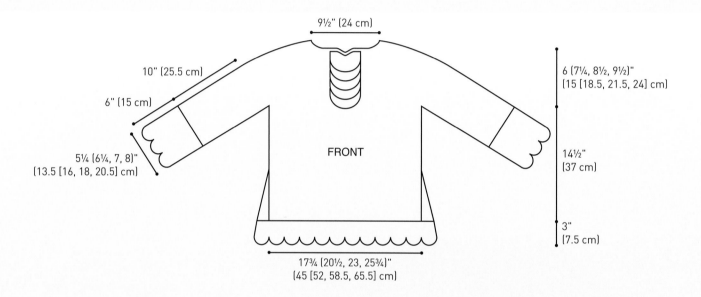

Cascade Pullover Tunic

Work 84 fsc, join with sl st to form ring, taking special care not to twist.

RND 1: Ch 3 (counts as dc), dc in each of next 32 sts, [dc2tog-blo over next 2 sts] 3 times, 2 dc-blo in each of next 6 sts, [dc2tog-blo over next 2 sts] 3 times (refer to stitch diagram A at right), dc in each of next 33 sts, do not join—84 sts. Work in a spiral, marking first st of rnd and moving marker up as work progresses.

RND 2: Dc in each of next 17 (18, 19, 20) sts, (dc, ch 2, dc) in next st, dc in next 6 (4, 2, 0) sts, (dc, ch 2, dc) in next st, dc in next 8 (9, 10, 11) sts, [dc2tog-blo over next 2 sts] 3 times, 2 dc-blo in each of next 6 sts, [dc2tog-blo over next 2 sts] 3 times, dc in each of next 8 (9, 10, 11) sts, (dc, ch 2, dc) in next st, dc in next 6 (4, 2, 0) sts, (dc, ch 2, dc) in next st, dc in next 17 (18, 19, 20) sts, do not join—88 sts. Pm in first and last st of center front 18 sts. Move marker up as work progresses.

RND 3: *Dc in each st to next ch-2 sp, (dc, ch 2, dc) in next ch-2 sp*, rep from * to * once, dc in each st to center front 18 sts, [dc2tog-blo over next 2 sts] 3 times, 2 dc-blo in each of next 6 sts, [dc2tog-blo over next 2 sts] 3 times, rep from * to * twice, dc in each st to end of rnd—96 sts.

RNDS 4–14: Rep Rnd 3—186 sts.

RND(S) 15 (15–18, 15–21, 15–24): *Dc in each st to next ch-2 sp, (dc, ch 2, dc) in next ch-2 sp*, rep from * to * 3 times, dc in each st to end of rnd—192 (216, 240, 264) sts at end of last rnd.

Body

Divide sts for Body and Sleeves.

RND 1: Dc in each of next 32 (36, 40, 44) sts, work 16 (20, 24, 28) fsc, skip next 32 (36, 40, 44) sts, dc in each of next 64 (72, 80, 88) sts, work 16 (20, 24, 28) fsc, skip next 32 (36, 40, 44) sts, dc in next 32 (36, 40, 44) sts—160 (184, 208, 232) sts.

RNDS 2–21: Dc in each st around. Pm in first st of rnd, moving marker up as work progresses.

Begin Side Gussets:
Refer to stitch diagram B for assistance.

RND 22: Dc in each of next 38 (44, 50, 56) sts, fpdc in each of next 4 sts, dc in each of next 76 (88, 100, 112) sts, fpdc in each of next 4 sts, dc in each of next 38 (44, 50, 56) sts—160 (184, 208, 232) sts.

RND 23: Dc in each of next 38 (44, 50, 56) sts, fpdc in each of next 2 sts, 2 dc in sp before next st, fpdc in each of next 2 sts, dc in each of next 76 (88, 100, 112) sts, fpdc in each of next 2 sts, 2 dc in sp before next st, fpdc in each of next 2 sts, dc in each of next 38 (44, 50, 56) sts—164 (188, 212, 236) sts.

RND 24: Dc in each of next 38 (44, 50, 56) sts, fpdc in each of next 2 sts, work 2 dc-blo in each of next 2 sts, fpdc in each of next 2 sts, dc in each of next 76 (88, 100, 112) sts, fpdc in each of next 2 sts, 2 dc-blo in each of next 2 sts, fpdc in each of next 2 sts, dc in each of next 38 (44, 50, 56) sts—168 (192, 216, 240) sts.

RND 25: Dc in each of next 38 (44, 50, 56) sts, fpdc in each of next 2 sts, 2 dc-blo in each of next 4 sts, fpdc in each of next 2 sts, dc in each of next 76 (88, 100, 112) sts, fpdc in each of next 2 sts, 2 dc-blo in each of next 4 sts, fpdc in each of next 2 sts, dc in each of next 38 (44, 50, 56) sts—176 (200, 224, 248) sts.

RND 26: Dc in each of next 38 (44, 50, 56) sts, fpdc in each of next 2 sts, dc-blo in each of next 2 sts, 2 dc-blo in each of next 4 sts, dc-blo in each of next 2 sts, fpdc in each of next 2 sts, dc in each of next 76 (88, 100, 112) sts, fpdc in each of next 2 sts, dc-blo in each of next 2 sts, 2 dc-blo in each of next 4 sts, dc-blo in each of next 2 sts, fpdc in each of next 2 sts, dc in each of next 38 (44, 50, 56) sts—184 (208, 232, 256) sts.

RND 27: Dc in each of next 38 (44, 50, 56) sts, fpdc in each of next 2 sts, dc-blo in each of next 3 sts, 2 dc-blo in each of next 6 sts, dc-blo in each of next 3 sts,

stitch diagram A

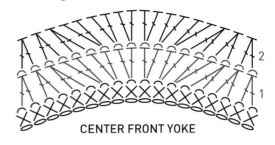

CENTER FRONT YOKE

stitch diagram B

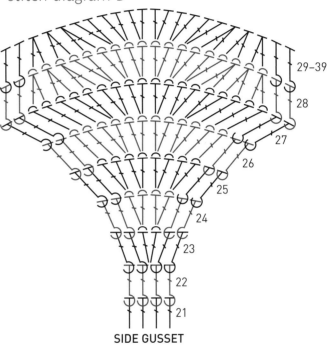

SIDE GUSSET

stitch key

◠ = chain (ch)

• = slip st (sl st)

✕ = foundation single crochet (fsc)

🇹 = double crochet (dc)

= Front Post dc (FPdc)

⋀ = dc2tog

⌢ = worked through back loop (blo)
⌣ = worked through front loop (flo)

fpdc in each of next 2 sts, dc in each of next 76 (88, 100, 112) sts, fpdc in each of next 2 sts, dc-blo in each of next 3 sts, 2 dc-blo in each of next 6 sts, dc-blo in each of next 3 sts, fpdc in each of next 2 sts, 1 dc in each of next 38 (44, 50, 56) sts—196 (220, 244, 268) sts.

RND 28: Dc in each of next 38 (44, 50, 56) sts, fpdc in each of next 2 sts, [dc2tog-blo over next 2 sts] 3 times, 2 dc-blo in each of next 6 sts, [dc2tog-blo over next 2 sts] 3 times, fpdc in each of next 2 sts, dc in each of next 76 (88, 100, 112) sts, fpdc in each of next 2 sts, [dc2tog-blo over next 2 sts] 3 times, 2 dc-blo in each of next 6 sts, [dc2tog-blo over next 2 sts] 3 times, fpdc in each of next 2 sts, dc in each of next 38 (44, 50, 56) sts—196 (220, 244, 268) sts.

RNDS 29–38: Rep Rnd 28.

RND 39: Dc in each of next 37 (43, 49, 55) sts, 2 dc in next st, fpdc in each of next 2 sts, [dc2tog-blo over next 2 sts] 3 times, 2 dc-blo in each of next 6 sts, [dc2tog-blo over next 2 sts] 3 times, fpdc in each of next 2 sts, 2 dc in next dc, dc in each of next 74 (86, 98, 110) sts, 2 dc in next dc, fpdc in each of next 2 sts, [dc2tog-blo over next 2 sts] 3 times, 2 dc-blo in each of next 6 sts, [dc2tog-blo over next 2 sts] 3 times, fpdc in each of next 2 sts, 2 dc in next dc, dc in each of next 37 (43, 49, 55) sts, sl st in next st to join—200 (224, 248, 272) sts. Fasten off.

Edging
Refer to stitch diagram C at right for assistance.

ROW 1: Ch 11, join with sl st to any st on last rnd of Body, ch 3, skip next st on Body, sl st to join to next st on body, turn, dc in 4th ch from hook, dc in each of next 4 ch, [ch 2, skip next 2 ch, dc in next ch] twice, turn.

ROW 2: Ch 8, dc in next ch-2 sp, ch 2, dc in next ch-2 sp, ch 6, dc in top of ch-3 at end of row, skip next Body st, sl st in next Body st.

ROW 3: Ch 3, skip next Body st, sl st in next Body st, turn, dc in each of next 5

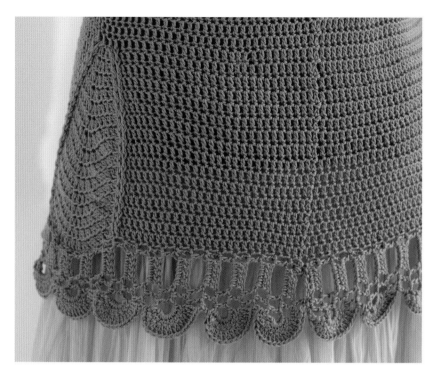

ch, ch 2, dc in next ch-2 sp, ch 2, 8 dc in next ch-8 sp.

ROW 4: Ch 3, sl st in last st on Row 1, turn, dc in same st as base of ch-3, 2 dc in each of next 7 sts, [ch 2, dc in next ch-2 sp] twice, ch 6, dc in top of ch-3 at end of row, skip next Body st, sl st in next Body st.

ROW 5: Ch 3, skip next Body st, sl st in next Body st, turn, dc in each of next 5 ch, [ch 2, dc in next ch-2 sp] twice, turn.

Rep Rows 2–5 until all Body sts are joined to Edging, ending with Row 4 of patt. Fasten off, leaving a long tail for sewing seam. Sew last row to foundation ch at base of Row 1.

Sleeves
RND 1: With RS facing, join yarn with sl st to 9th (11th, 13th, 15th) ch of underarm ch, ch 3 (counts as dc), dc in each of next 7 (9, 11, 13) ch, dc in each of next 32 (36, 40, 44) sts, dc in each of next 8 (10, 12, 14) ch, do not join—48 (56, 64, 72) sts. Work in a spiral as before, placing marker in first st of rnd, moving marker up as work progresses.

RNDS 2–25: Dc in each st around. At end of last rnd, sl st in next st to join. Fasten off.

Sleeve Edging
Refer to stitch diagram D at right for assistance.

ROW 1: Ch 27, join with sl st to any st on last rnd of Sleeve, ch 3, skip next st on Sleeve, sl st to next Sleeve st, turn, dc in 4th ch from hook, dc in each of next 20 ch, [ch 2, skip 2 ch, dc in next ch] twice, ch 2, turn.

ROW 2: Ch 8, dc in next ch-2 sp, ch 2, dc in next ch-2 sp, ch 22, dc in top of ch-3 at end of row, skip next Sleeve st, sl st in next Sleeve st.

ROW 3: Ch 3, skip next Sleeve st, sl st in next Sleeve st, turn, dc in each of next 21 ch, ch 2, dc in next ch-2 sp, ch 2, 8 dc in next ch-8 sp.

ROW 4: Ch 3, sl st in last st on Row 1, turn, dc in same st as base of ch-3, 2 dc in each of next 7 sts, [ch 2, dc in next ch-2 sp] twice, ch 22, dc in top of ch-3 at end of row, skip next Sleeve st, sl st in next Sleeve st.

stitch diagram C

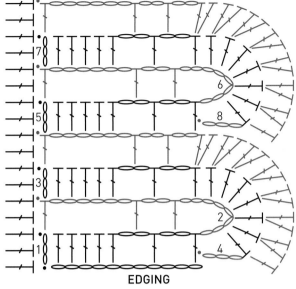

EDGING

stitch diagram D

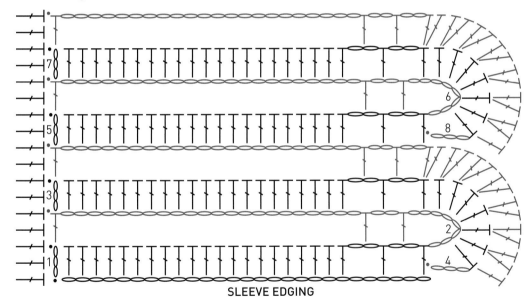

SLEEVE EDGING

stitch diagram E

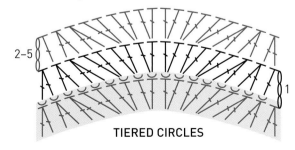

TIERED CIRCLES

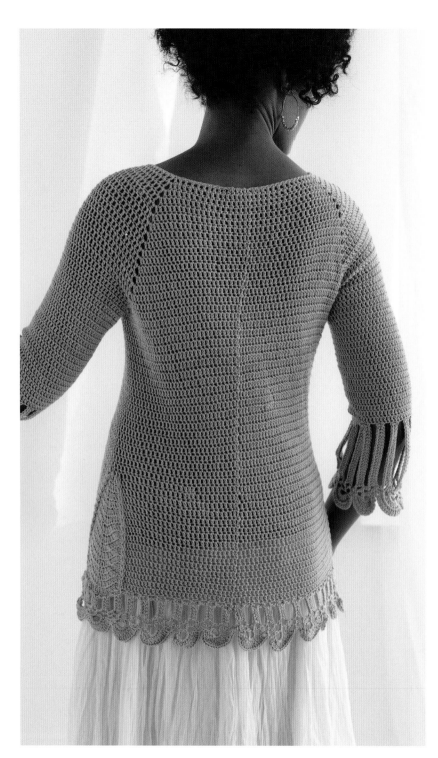

ROW 5: Ch 3, skip next Body st, sl st in next Body st, turn, dc in each of next 21 ch, [ch 2, dc in next ch-2 sp] twice, turn.

Rep Rows 2–5 until all Body sts are joined to Edging, ending with Row 4 of patt. Fasten off, leaving a long tail for sewing seam. Sew last row to foundation ch at base of Row 1.

Tiered Circles

Refer to stitch diagram E on p. 111 for assistance.

CIRCLE #1: Locate 18 center sts on Front of Body. With RS facing, join CC1 with sl st in rem front lp of first of center 18 sts on Rnd 1 of Body.

ROW 1: Ch 3 (counts as dc), dc in next st, [work dc2tog over next 2 sts] twice, 2 dc in each of next 6 sts, [dc2tog over next 2 sts] 3 times, turn.

ROWS 2–5: Rep Row 1. Fasten off.

CIRCLE #2: With RS facing, join CC2 with sl st in rem front loop of first of center 18 sts on Rnd 4 of Body. Rep Rows 1–5 of Circle #1.

CIRCLE #3: With RS facing, join CC1 with sl st in rem front loop of first of center 18 sts on Rnd 7 of Body. Rep Rows 1–5 of Circle #1.

CIRCLE #4: With RS facing, join CC2 with sl st in rem front loop of first of center 18 sts on Rnd 10 of Body. Rep Rows 1–5 of Circle #1.

CIRCLE #5: With RS facing, join CC1 with sl st in rem front loop of first of center 18 sts on Rnd 13 of Body. Rep Rows 1–5 of Circle #1.

Wet or steam block to finished measurments. Weave in loose ends with a tapestry needle.

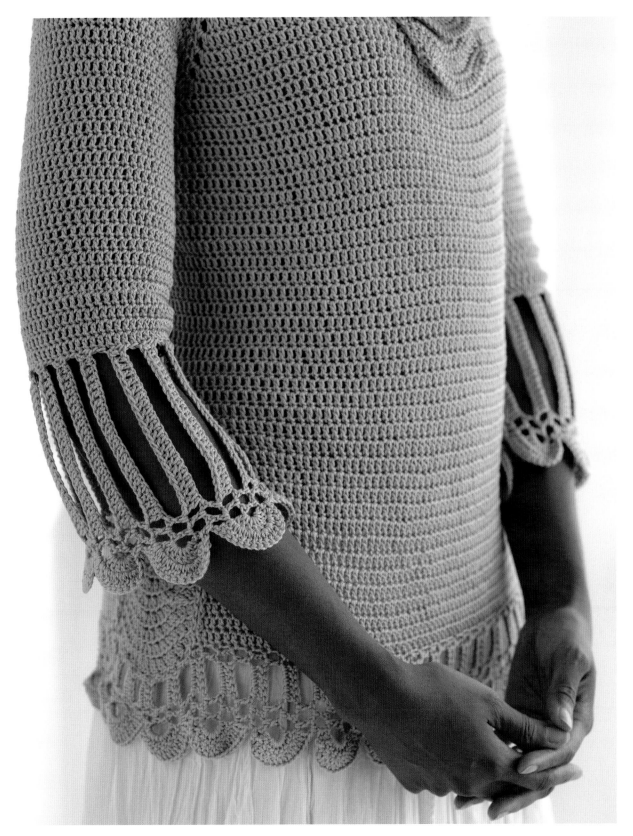

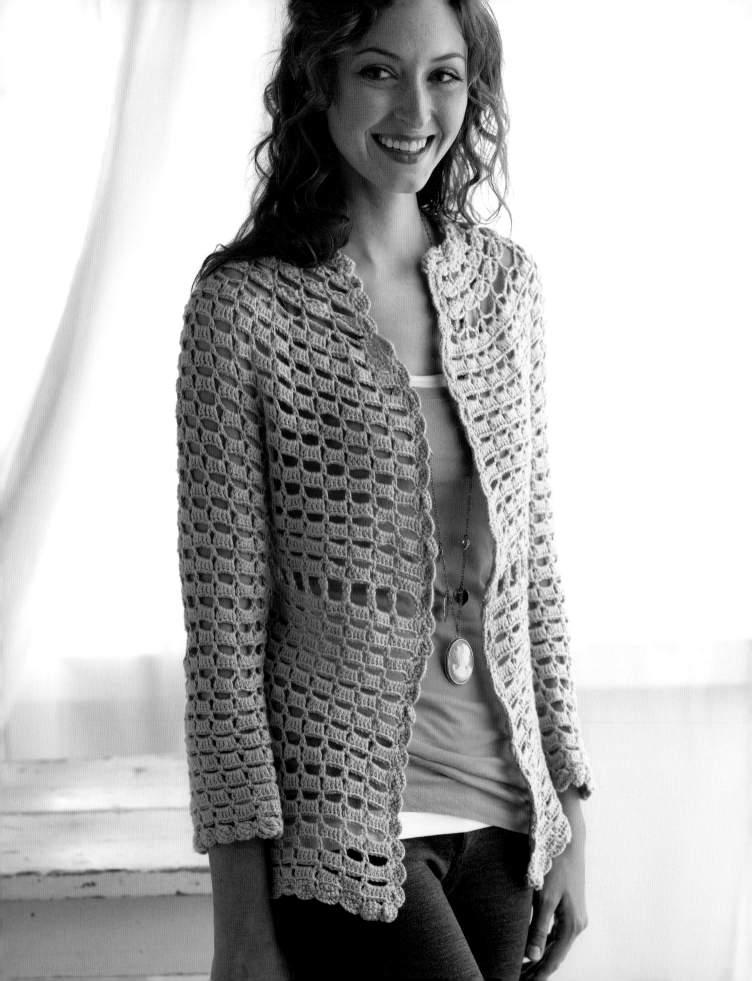

pearl's CARDIGAN

This cardigan is named after my great-grandmother, Pearl Svenson, a gorgeous Norwegian immigrant who aspired to be a 1920s Hollywood starlet. I imagine her wearing this classic cardigan with a crisp white blouse and perhaps cinching it around her famously tiny waist with a pretty scarf threaded through the belt holes. With a slightly vintage look, this is the perfect piece to accent a modern ensemble and add that touch of feminine flair. Whether it's worn loose or cinched at the waist, the easy fit and engaging stitch pattern make it a must-have for your closet.

YARN

DK weight (#3 Light); 1,095 (1,275 1,465, 1,665) yd (1,002 [1,166, 1,340, 1,523] m).

shown: Lion Brand Yarn, Microspun (100% microfiber acrylic; 168 yd [154 m]/2.5 oz [70 g]): #102 blush, 7 (8, 9, 10) balls.

HOOK

G/6 (4mm) or size needed to obtain gauge.

NOTIONS

Tapestry needle.

GAUGE

20 dc= 4" (10 cm); 10 rows in dc body patt = 4" (10 cm).

FINISHED SIZE

Size S (M, L, XL) fits 32 (36, 40, 42)" (81.5 [91.5, 101.5, 112] cm) bust circumference. Cardigan is 26 (26½, 27½, 28)" (66 [67.5, 70, 71] cm) long. Cardigan shown is a size L.

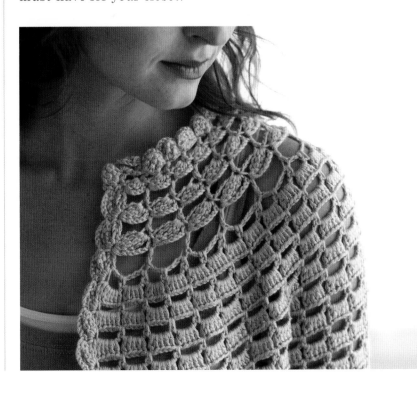

note

- The yarn featured here makes a fantastic transformation with steam blocking. The shine and drape are remarkably prettier after steaming.

special stitches

3 double crochet cluster (3-dc cl) p. 156.

3 treble crochet cluster (3-tr cl) p. 158.

2 double-treble crochet cluster (2-dtr cl) p. 157.

3 double-treble crochet cluster (3-dtr cl) p. 157.

10 (11½, 13½, 16)"
(25.5 [29, 34.5, 40.5] cm)

16" (40.5 cm)

9" (23 cm)

6 (6, 6½, 7)"
(15 [15, 16.5, 18] cm)

RIGHT FRONT

LEFT FRONT

17 (17½, 18½, 19)"
(43 [44.5, 47, 48.5] cm)

6" (15 cm)

16 (18, 20, 22)"
(40.5 [45.5, 51, 56] cm)

Pearl's Cardigan

Yoke

Refer to the stitch diagram at right for a reduced sample of Yoke patt.

Ch 84 (92, 104, 116).

ROW 1: Dc in 4th ch from hook, *ch 3, skip next 3 ch, dc in next ch, rep from * across, ending with 2 dc in last ch, turn—20 (22, 25, 28) ch-3 sps.

ROW 2: Ch 1, sc in first st, *ch 3, work 3-dc cl in last sc made, skip next ch-3 sp, sc in next dc, rep from * across, ending with last sc in top of ch-3 turning ch, turn—20 (22, 25, 28) cl.

ROW 3: Ch 3 (counts as dc), dc in first sc, *ch 4, skip next cl, dc in next sc, rep from * across, ending with 2 dc in last sc, turn—20 (22, 25, 28) ch-4 sps.

ROW 4: Ch 1, sc in first dc, *ch 4, work 3-tr cl in last sc made, skip next ch-4 sp, sc in next dc, rep from * across, ending with last sc in top of ch-3 tch, turn—20 (22, 25, 28) cl.

ROW 5: Ch 3 (counts as dc), dc in first sc, *ch 5, skip next cl, dc in next sc, rep from * across, ending with 2 dc in last sc, turn—20 (22, 25, 28) ch-5 sps.

ROW 6: Ch 1, sc in first dc, *ch 5, work 3-dtr cl in last sc made, skip next ch-5, sc in next dc, rep from * across, ending with last sc in top of ch-3 tch, turn—20 (22, 25, 28) cl.

ROW 7: Ch 3 (counts as dc), dc in first sc, *ch 6, skip next cl, dc in next sc, rep from * across, ending with 2 dc in last sc, turn—20 (22, 25, 28) ch-6 sps.

ROW 8: Ch 1, sc in first dc, *ch 5, sc in next ch-6 sp, ch 5, sc in next dc, rep from * across, ending with last sc in top of ch-3 tch, turn—40 (42, 50, 56) ch-5 sps.

ROW 9: Ch 3 (counts as dc), dc in first sc, 5 dc in each ch-5 sp across, 2 dc in last sc, turn—204 (214, 254, 284) dc.

ROW 10: Ch 1, sc in first dc, skip next dc, *ch 5, skip next 5 dc, sc in sp before next

dc, rep from * across to within last 7 sts, ch 5, skip next 6 dc, sc in top of ch-3 tch, turn—40 (42, 50, 56) ch-5 sps.

ROWS 11–14: Rep Rows 9–10 twice.

ROW 15: Ch 3 (counts as dc), dc in first sc, 5 dc in each of next 6 (7, 8, 9) ch-5 sps, 10 dc in next ch-5 sp (inc), 5 dc in each of next 6 (6, 7, 8) ch-5 sps, 10 dc in next ch-5 sp (inc), 5 dc in each of next 12 (14, 16, 18) ch-5 sps, 10 dc in next ch-5 sp (inc), 5 dc in each of next 6 (6, 7, 8) ch-5 sps, 10 dc in next ch-5 sp (inc), 5 dc in each of last 6 (7, 8, 9) ch-5 sps, 2 dc in last sc, turn—224 (234, 274, 304) dc.

ROW 16: Rep Row 10—44 (46, 54, 60) ch-5 sps.

ROW 17: Ch 3 (counts as dc), dc in first sc, 5 dc in each of next 7 (8, 9, 10) ch-5 sps, 10 dc in next ch-5 sp (inc), 5 dc in each of next 6 (6, 7, 8) ch-5 sps, 10 dc in next ch-5 sp (inc), 5 dc in each of next 14 (16, 18, 20) ch-5 sps, 10 dc in next ch-5 sp (inc), 5 dc in each of next 6 (6, 7, 8) ch-5 sps, 10 dc in next ch-5 sp (inc), 5 dc in each of last 7 (8, 9, 10) ch-5 sps, 2 dc in last sc, turn—244 (254, 294, 324) dc.

ROW 18: Rep Row 10—48 (50, 58, 64) ch-5 sps.

Cardigan Body
Divide for body and sleeves.

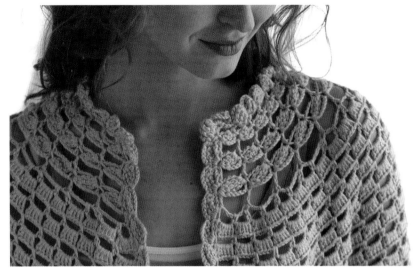

ROW 1: Ch 3 (counts as dc), dc in first sc, [5 dc in next ch-5 sp] 7 (8, 9, 10) times, ch 11 (for underarm), skip next 10 (10, 11, 12) ch-5 sps, [5 dc in next ch-5 sp] 14 (16, 18, 20) times, ch 11 (for underarm), skip next 10 (10, 11, 12) ch-5 sps, [5 dc in next ch-5 sp] 7 (8, 9, 10) times, 2 dc in last sc, turn—124 (144, 164, 204) dc, 2 ch-11 lps.

ROW 2: Ch 1, sc in first dc, [ch 5, skip next 5 dc, sc in sp before next dc] 6 (7, 8, 9) times, ch 5, skip next 5 dc, sc in next ch, [ch 5, skip next 4 ch, sc in next ch] twice, [ch 5, skip 5 dc, sc in sp before next dc] 13 (15, 17, 19) times, ch 5, skip

next 5 dc, sc in next ch, [ch 5, skip next 4 ch, sc in next ch] twice, [ch 5, skip 5 sts, sc in sp before next st] 6 (7, 8, 9) times, ch 5, skip next 6 dc, sc in top of ch-3 tch, turn

ROWS 3–13: Rep Rows 9–10 of Yoke 5 times, then Rep Row 9 once.

ROW 14: Ch 5, dtr in first dc, skip next dc, *ch 5, skip next 5 dc, 2-dtr cl in sp before next dc, rep from * across to within last 7 sts, ch 5, 2-dtr cl in top of ch-3 tch, turn.

ROWS 15–26 (28, 30, 32): Rep Rows 9–10 of Yoke 6 (7, 8, 9) times.

stitch diagram

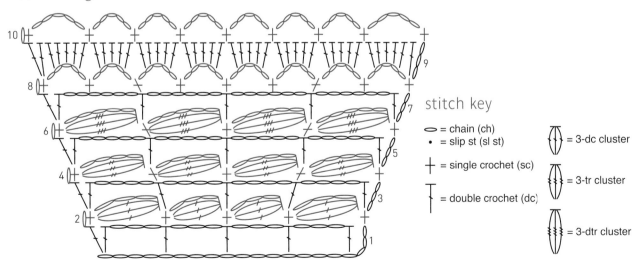

stitch key

○ = chain (ch)

• = slip st (sl st)

+ = single crochet (sc)

⊤ = double crochet (dc)

⦚ = 3-dc cluster

⦚ = 3-tr cluster

⦚ = 3-dtr cluster

Left Front

Divide for fronts and back, creating slits on the sides.

ROW 1: Ch 3 (counts as dc), dc in first sc, 5 dc in next 8 (9, 10, 11) ch-5 sps, 2 dc in next sc, turn, leaving rem sts unworked—44 (49, 54, 59) dc.

ROW 2: Ch 1, sc in first dc, skip next dc, *ch 5, skip next 5 dc, sc in sp before next dc, rep from * across to within last 7 sts, ch 5, skip next 6 dc, sc in top of ch-3 tch, turn—8 (9, 10, 11) ch-5 sps.

ROWS 3–12: Rep Rows 9–10 of Yoke 5 times.

Fasten off.

Back

ROW 1: With RS facing, join yarn in same sc holding last 2 dc on Row 1 of Left Front, ch 3 (counts as dc), dc in first sc, 5 dc in next 16 (18, 20, 22) ch-5 sps, 2 dc in next sc, turn, leaving rem sts unworked—84 (94, 104, 114) dc.

ROW 2: Ch 1, sc in first dc, skip next dc, *ch 5, skip next 5 dc, sc in sp before next dc, rep from * across to within last 7 sts, ch 5, skip next 6 dc, sc in top of ch-3 tch, turn—16 (18, 20, 22) ch-5 sps.

ROWS 3–14: Rep Rows 9–10 of Yoke 6 times.

Fasten off.

Right Front

ROW 1: With RS facing, join yarn in same sc holding last 2 dc on Row 1 of Left Front, ch 3 (counts as dc), dc in first sc, 5 dc in next 8 (9, 10, 11) ch-5 sps, 2 dc in next sc, turn, leaving rem sts unworked—44 (49, 54, 59) dc.

ROW 2: Ch 1, sc in first dc, skip next dc, *ch 5, skip next 5 dc, sc in sp before next dc, rep from * across to within last 7 sts, ch 5, skip next 6 dc, sc in top of ch-3 tch, turn—8 (9, 10, 11) ch-5 sps.

ROWS 3–14: Rep Rows 9–10 of Yoke 6 times.

Fasten off.

First Sleeve

ROW 1: With RS facing, attach yarn in center ch of underarm ch-11, ch 3 (counts a dc) 5 dc in next ch-4 sp of underarm, 5 dc in each of next 10 (10, 11, 12) ch-5 sps, 5 dc in next ch-4 sp of underarm, join with sl st in top of beg ch-3, turn—61 (61, 66, 71) dc.

ROW 2: Ch 1, sc in first st, [ch 5, skip next 5 dc, sc in sp before next dc] 11 (11, 12, 13) times, ch 5, skip 5 dc, join with sl st in first sc, turn—12 (12, 13, 14) ch-5 sps.

ROW 3: Ch 3 (counts as dc), 5 dc in each ch-5 sp around, join with sl st to top of beg ch-3, turn.

ROW 4: Rep Row 2.

Rep Rows 3–4 until Sleeve measures 15" (38 cm) or 1" (2.5 cm) less than desired length from underarm.

NEXT ROW: Ch 1, sc in first sc, *ch 5, work 3-dtr cl in last sc made, skip next ch-5 sp, sc in next sc, rep from * around, join with sl st in first sc.

Fasten off.

Second Sleeve

Rep First Sleeve in other armhole.

Sweater Edging

RND 1: With RS facing, attach yarn in first ch at beg of neck edge, ch 1, sc in first ch, *ch 3, work 3-dc cl in last sc made, skip next 3 ch, sc in next ch*, rep from * to * across neck edge, working across Left Front edge, **ch 4, work 3-tr cl in last sc made, skip next row**, rep from ** to ** across, ending with sc in bottom left corner, ***ch 5, 3-dtr cl in last sc made, skip next ch-5 sp, sc in next sc, rep from *** to *** across bottom edge of Left Front, rep from ** to ** up slit, ending with sc in center st of slit, rep from ** to ** down other side of slit, rep from *** to *** across bottom edge of Back, rep from ** to ** up slit, ending with sc in center st of slit, rep from ** to ** down other side of slit, rep from *** to *** across Right Front, rep from * to * across Right Front edge, join with sl st in first sc.

Fasten off.

Wet or steam block to finished measurements. Weave in loose ends with a tapestry needle.

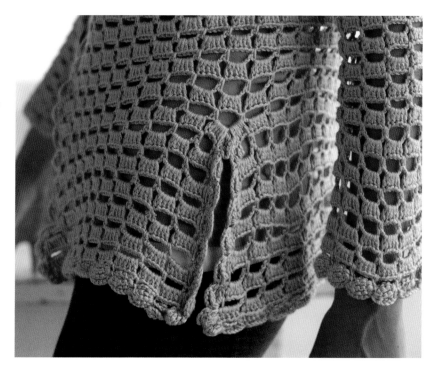

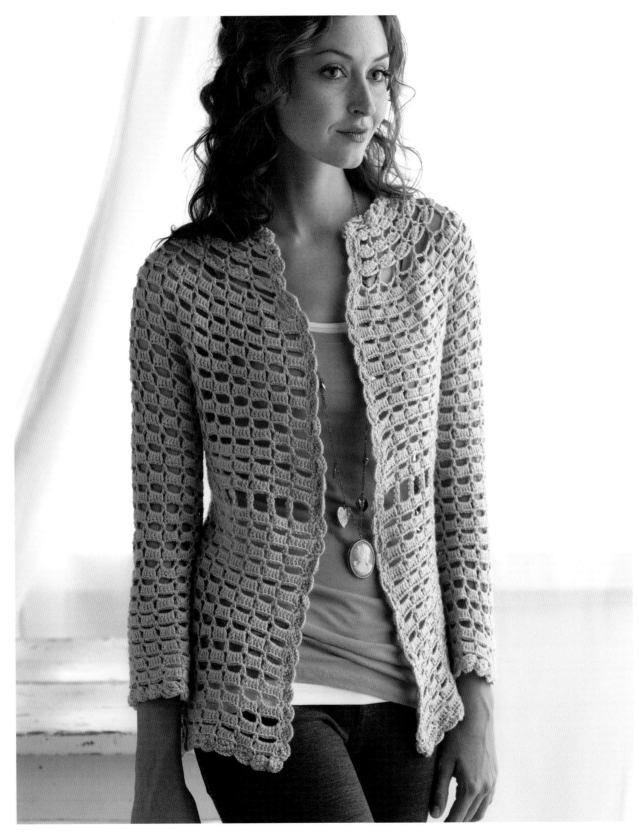

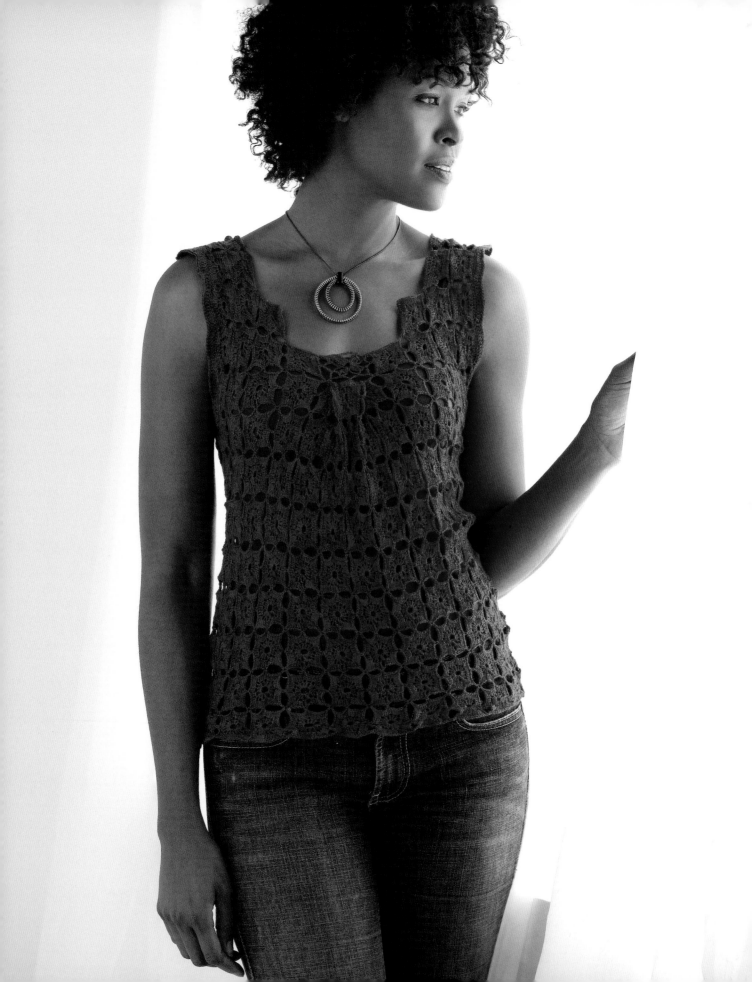

serene BOX PLEAT TOP

This sophistocated top flatters the figure with generous hip ease and clever yet simple shaping at the bust. Folding five motifs into a pretty box pleat at the bust creates a stunning visual effect that is further accentuated by the stepped neckline. A second motif used on the back creates an airy, openwork design.

YARN

Laceweight (#0 Lace); 950 (1,200, 1,525) yd (869 (1,097, 1,394.5) m).

shown: Lorna's Laces, Helen's Lace (50% silk/50% wool; 1,250 yd [1,143 m]/4 oz [113.4 g]): red rover, 1 (1, 2) skeins.

HOOK

C/2 (2.75mm) or size needed to obtain gauge.

NOTIONS

Tapestry needle.

GAUGE

Each motif is 2" (5 cm) square, after blocking.

FINISHED SIZE

Size S (M, L) fits 36 (42, 50)" (91.5 [106.5, 127] cm) bust circumference.

26 (28, 30)" (66 [71, 76] cm) total length. Top shown is a size S.

notes

- There are no seams to sew; the top is completely joined as you go.

- The last motif A (in the top center of the front) is not completed until the box pleat is formed.

- This design features two different motifs, but you could also make this sweater using only one or the other.

special stitches

3-tr cluster (3-tr cl) p. 158.

4-tr cluster (4-tr cl) p.158.

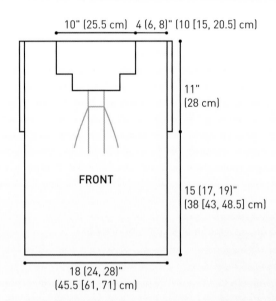

10" (25.5 cm) 4 (6, 8)" (10 [15, 20.5] cm)

11" (28 cm)

FRONT

15 (17, 19)" (38 [43, 48.5] cm)

18 (24, 28)" (45.5 [61, 71] cm)

Serene Box-Pleat Top

Motif A

Refer to stitch diagram A at right for assistance.

First Motif: Ch 5, join with sl st to form ring.

RND 1: [Ch 4, 3-tr cl in ring, ch 4, sl st in ring] 3 times, ch 4, 4-tr cl in ring, do not join.

RND 2: Ch 5, sc in next ch-4 sp, ch 7, sc in next ch-4 sp, *ch 5, sc in next ch-4 sp, ch 7, sc in next ch-4 sp, rep from *

twice, omitting last sc, join with sl st to first ch at beg of rnd. Fasten off.

One-Sided Join Motif: Rep Rnd 1 of First Motif.

RND 2: Ch 5, sc in next ch-4 sp, ch 3, sl st in corresponding ch-7 lp of adjacent motif, ch 3, sc in next ch-4 sp, ch 2, sl st in next ch-5 sp on adjacent motif, ch 2, sc in next ch-4 sp, ch 3, sl st in next ch-7 sp on adjacent motif, ch 3, sc in next ch-4 sp, *ch 5, sc in next ch-4 sp, ch 7*, sc in next ch-4 sp, rep from * to * once, join with sl st to first ch at beg of rnd. Fasten off.

Two-Sided Join Motif: Rep Rnd 1 of First Motif.

RND 2: Ch 5, sc in next ch-4 sp, ch 3, sl st in corresponding ch-7 lp of adjacent motif, ch 3, sc in next ch-4 sp, *ch 2, sl st in next ch-5 sp on adjacent motif, ch 2, sc in next ch-4 sp, ch 3, sl st in next ch-7 sp on adjacent motif, ch 3, sc in next ch-4 sp, rep from * once, ch 5, sc in next ch-4 sp, ch 7, join with sl st to first ch at beg of rnd. Fasten off.

Three-Sided Join Motif: Rep Rnd 1 of First Motif.

stitch diagram A

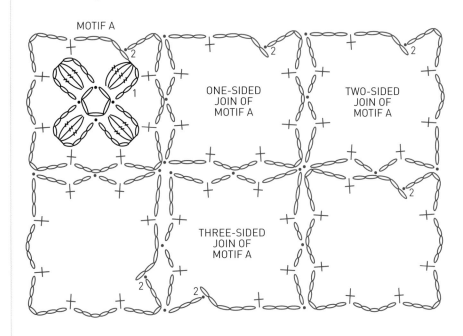

MOTIF A

ONE-SIDED
JOIN OF
MOTIF A

TWO-SIDED
JOIN OF
MOTIF A

THREE-SIDED
JOIN OF
MOTIF A

stitch diagram B

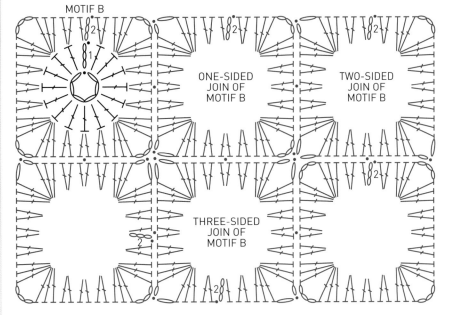

MOTIF B

ONE-SIDED
JOIN OF
MOTIF B

TWO-SIDED
JOIN OF
MOTIF B

THREE-SIDED
JOIN OF
MOTIF B

stitch key

⬭ = chain (ch)

• = slip st (sl st)

+ = single crochet (sc)

┼ = double crochet (dc)

= 3-tr cluster

= 4-tr cluster

RND 2: Ch 5, sc in next ch-4 sp, ch 3, sl st in corresponding ch-7 lp of adjacent motif, ch 3, sc in next ch-4 sp, *ch 2, sl st in next ch-5 sp on adjacent motif, ch 2, sc in next ch-4 sp, ch 3, sl st in next ch-7 sp on adjacent motif, ch 3, sc in next ch-4 sp, rep from * twice, omitting last sc, join with sl st to first ch at beg of rnd. Fasten off.

Motif B

Refer to stitch diagram B on p. 123 for assistance.

First Motif: Ch 6, join with sl st to form ring.

RND 1: Ch 3 (counts as dc), work 15 dc in ring, join with sl st to top of ch-3 at beg of rnd—16 sts.

RND 2: Ch 3 (counts as dc), dc in first st, 2 dc in next st, [3 dc, ch 3, 3 dc] in next st, *2 dc in each of next 3 sts, [3 dc, ch 3, 3 dc] in next st, rep from * twice, 2 dc in last st, join with sl st to top of ch-3 at beg of rnd. Fasten off.

One-Sided Join Motif: Rep Rnd 1 of First Motif.

RND 2: Ch 3 (counts as dc), dc in first st, 2 dc in next st, [3 dc, ch 1, sl st in corresponding ch-3 sp on adjacent motif, 3 dc] in next st, 2 dc in next st, [dc, sl st in corresponding sp on adjacent motif, dc] in next st, 2 dc in next st, [3 dc, ch 1, sl st in corresponding ch-3 sp on adjacent motif, 3 dc] in next st, *2 dc in each of next 3 sts, [3 dc, ch 3, 3 dc] in next st, rep from * once, 2 dc in last st, join with sl st to top of ch-3 at beg of rnd. Fasten off.

Two-Sided Join Motif: Rep Rnd 1 of First Motif.

RND 2: Ch 3 (counts as dc), dc in first st, 2 dc in next st, [3 dc, ch 1, sl st in corresponding ch-3 sp on adjacent motif, 3 dc] in next st, *2 dc in next st, [dc, sl st in corresponding sp on adjacent motif, dc] in next st, 2 dc in next st, [3 dc, ch 1, sl st in corresponding ch-3 sp on adjacent motif, 3 dc] in next st, rep from * once, 2 dc in each of next 3 sts, [3 dc, ch 3, 3 dc] in next st, 2 dc in last st, join

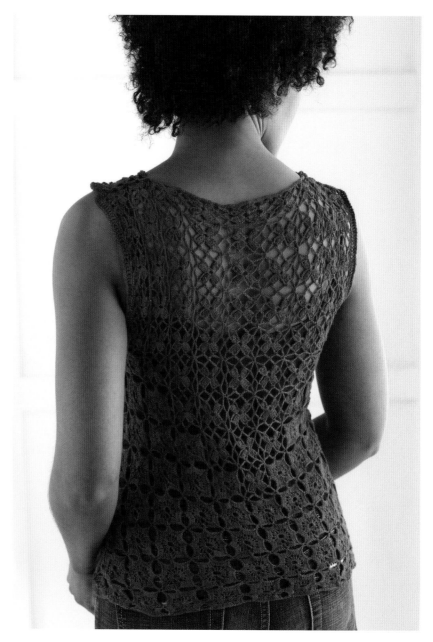

with sl st to top of ch-3 at beg of rnd. Fasten off.

Three-Sided Join Motif: Rep Rnd 1 of First Motif.

RND 2: Ch 3 (counts as dc), dc in first st, 2 dc in next st, [3 dc, ch 1, sl st in corresponding ch-3 sp on adjacent motif, 3 dc] in next st, *2 dc in next st, [dc, sl st in corresponding sp on adjacent motif, dc] in next st, 2 dc in next st, [3 dc, ch 1,

sl st in corresponding ch-3 sp on adjacent motif, 3 dc] in next st, rep from * twice, 2 dc in last st, join with sl st to top of ch-3 at beg of rnd. Fasten off.

Back

Following the back construction diagram, make and join 61 (69, 75) Motif A and 56 (85, 120) Motif B.

Front

Following the front construction diagram, make and join 139 (180, 225) Motif B, joining them to the Back as you go, leaving top 5½ motifs unjoined for armholes (red line on diagram).

Box pleat is worked with the top center 5 motifs of Front. Holding the center motif in front, fold the motifs on either side to the back of the center motif, layering the next motif on either side behind the center motif (see diagram C below). The box pleat will be 5 layers of motifs thick. Using a tapestry needle and long piece of MC yarn, sew through all 5 thicknesses to secure pleat. Once secure, crochet one more Motif A, joining it on 3 sides to top of pleat.

Armhole Opening

Join with sl st to any st in armhole opening, ch 3, dc in each st and ch around, join with sl st to top of ch-3 at beg of rnd.

RND 2: Ch 3, dc in each st around, join with sl st to top of ch-3 at beg of rnd. Fasten off.

Rep for 2nd armhole.

Wet or steam block to finished measurements. Weave in any loose ends with a tapestry needle.

back construction diagram

L/XL 2X | S/M ... S/M | L/XL 2X

A	A	A	A	A	A	A	A	A	A	A	A	A
A	A	A	A	A	A	A	A	A	A	A	A	A
A	A	A	A	A	A	A	A	A	A	A	A	A
B	A	A	A	A	A	A	A	A	A	A	A	B
B	B	A	A	A	A	A	A	A	A	A	B	B
B	B	B	A	A	A	A	A	A	A	B	B	B
B	B	B	B	A	A	A	A	A	B	B	B	B
B	B	B	B	B	A	A	A	B	B	B	B	B
B	B	B	B	B	B	A	B	B	B	B	B	B
B	B	B	B	B	B	B	B	B	B	B	B	B
B	B	B	B	B	B	B	B	B	B	B	B	B
B	B	B	B	B	B	B	B	B	B	B	B	B
B	B	B	B	B	B	B	B	B	B	B	B	B
B	B	B	B	B	B	B	B	B	B	B	B	B
B	B	B	B	B	B	B	B	B	B	B	B	B
B	B	B	B	B	B	B	B	B	B	B	B	B
B	B	B	B	B	B	B	B	B	B	B	B	B

front construction diagram

L/XL 2X | S/M ... S/M | L/XL 2X

SHADED AREA DETAILS ON CLOSE-UP

B	B	B	B								B	B	B	B
B	B	B	B								B	B	B	B
B	B	B	B	B						B	B	B	B	B
B	B	B	B	B	B		A		B	B	B	B	B	B
B	B	B	B	B	B	B	B	B	B	B	B	B	B	B
B	B	B	B	B	B	B	B	B	B	B	B	B	B	B
B	B	B	B	B	B	B	B	B	B	B	B	B	B	B
B	B	B	B	B	B	B	B	B	B	B	B	B	B	B
B	B	B	B	B	B	B	B	B	B	B	B	B	B	B
B	B	B	B	B	B	B	B	B	B	B	B	B	B	B
B	B	B	B	B	B	B	B	B	B	B	B	B	B	B
B	B	B	B	B	B	B	B	B	B	B	B	B	B	B
B	B	B	B	B	B	B	B	B	B	B	B	B	B	B
B	B	B	B	B	B	B	B	B	B	B	B	B	B	B
B	B	B	B	B	B	B	B	B	B	B	B	B	B	B

diagram c

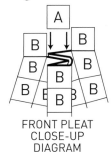

FRONT PLEAT CLOSE-UP DIAGRAM

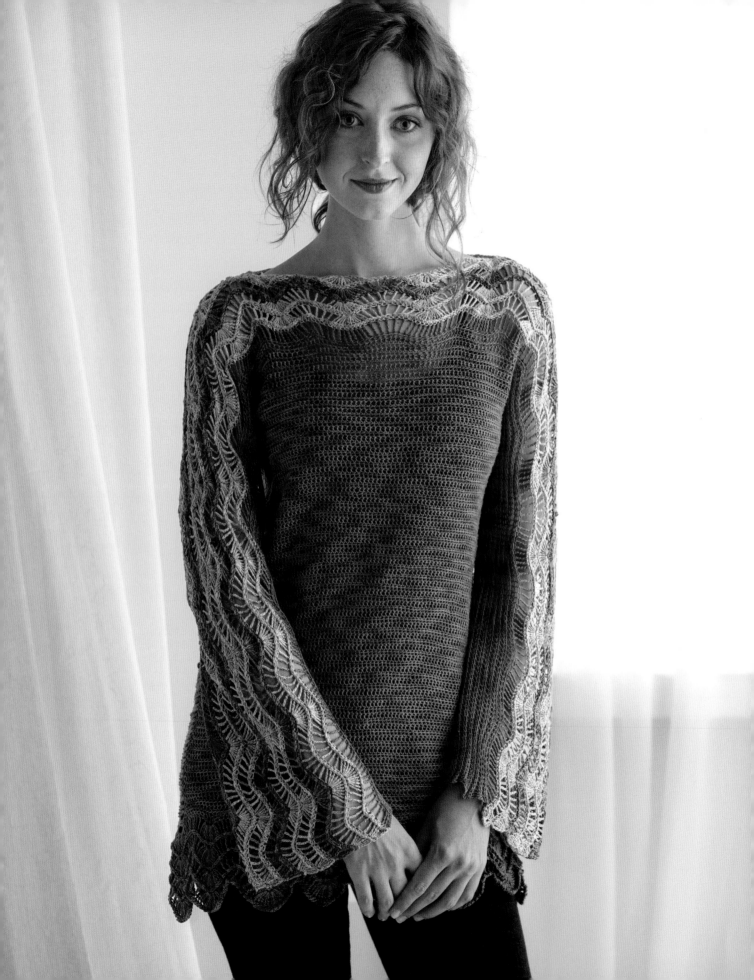

river TUNIC

Inspired by a meandering river with lush summer foliage spilling over the banks, this tunic looks lacy but is really just single crochet stitches manipulated to blossom into open stitchwork along the body and lower sleeves. The border at the hem reflects the lacy chevron sleeves, creating balance and drawing the eye downward for a flattering, lengthening effect. Extra ease is worked into the hips with chains that also create an unusual seaming technique. The result is a comfortable, versatile, and elegant tunic.

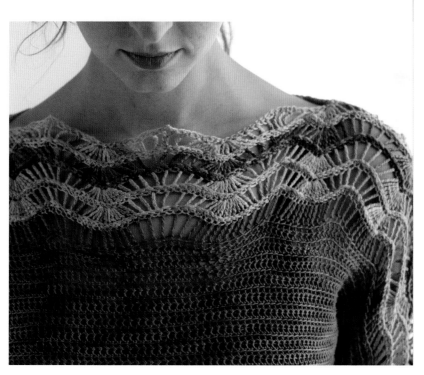

YARN

Laceweight (#0 Lace); 888 (1,160, 1,470, 1,815) yd (812 [1,061, 1,345, 1,660] m) MC, 95 yd (86.8 m) each of CC1–CC3—1,078 (1,350, 1,660, 2,005) yd (985.7 [1,234.4, 1,517.9, 1,833.4] m) total.

shown: Tilli Tomas, Voile de la Mer (70% silk/30% Seacell [natural kelp fiber]; 290 yd [265.2 m]/1.75 oz [50 g]): moss (MC), 4 (4, 6, 7) skeins; skydrop (CC1), 1 skein; parchment (CC2), 1 skein; eternal diva (CC3), 1 skein.

HOOK

C/3 (3.25mm) or size needed to obtain gauge.

NOTIONS

Split-ring stitch markers; tapestry needle.

GAUGE

18 sts x 16 rows = 4" (10 cm) in body pattern (after blocking).

FINISHED SIZE

Size S (M, L, XL) fits 31½ (36, 40½, 45)" (80 [91.5, 103, 114.5] cm) bust circumference. Tunic is 31 (31, 31½, 33½)" (79 [79, 80, 85] cm) long. Sleeves measure 19 (18, 16½, 15½) (48.5 [45.5, 42, 39.5] cm). Tunic shown is a size M.

notes

- There are a fair amount of ends to weave in on this project, but you can cut down on your finishing time by crocheting over ends (p. 156) as you go. The texture of the fiber in the yarn used for this project holds the tails firmly in place. If you still have some little ends poking out, you can trim them down after blocking.

- Body is worked in one piece from bottom front up to arms, bodice, and neck, and down to bottom of back. Sides are seamed separately with shaping chains.

- The stitch count is adjusted on the row before the wavy chevron lace pattern begins (across shoulders and along sleeves), so the width of the fabric remains constant.

special stitches

Foundation single crochet (fsc) p. 157.

2 treble crochet cluster (2-tr cl) p. 158.

Front Post Single Crochet (fpsc) p. 157.

Back Post Single Crochet (bpsc) p. 156.

Single crochet 2 together (sc2tog) p. 158.

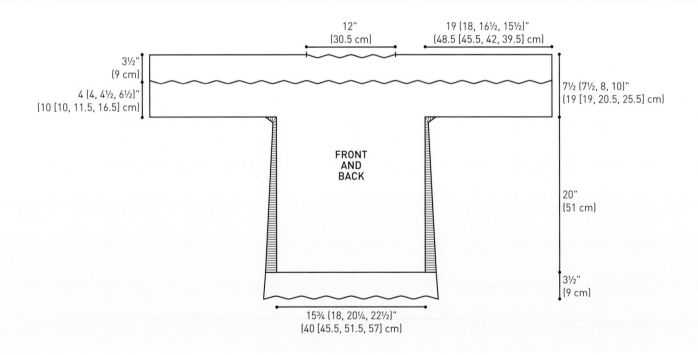

River Tunic

Front Body

Refer to stitch diagram A at right for a reduced sample of body (chevron) patt.

ROW 1 (RS): With MC, work 71 (81, 91, 101) fsc.

ROW 2: Ch 1, sc-flo in each st across, turn.

ROWS 3–80: Rep Row 2. Fasten off.

Front Yoke

ROW 81: Fsc 85 (80, 75, 70) sts, sc-flo in each st across last row, work 85 (80, 75, 70) fsc—241 sts.

ROWS 82–95 (95, 97, 105): Rep Row 2.

Note: On next row we will be adjusting the stitch count to accommodate a different gauge for the wavy lace stitch pattern.

ROW 96 (96, 98, 106): Ch 1, sc-flo in each st across, inc 6 sts evenly across, turn—247 sts.

Top Chevron Lace Edging

Refer to stitch diagram B at right for a reduced sample of chevron patt.

ROW 1: With MC, ch 5 (counts as dtr), 4 dtr in same st, skip next st, dtr in each of next 9 sts, skip next st, 5 dtr in next st, *5 dtr in next st, skip next st, dtr in each of next 9 sts, skip next st, 5 dtr in next st, rep from * across, turn—361 dtr, 19 chevrons.

ROW 2: Ch 1, fpsc in each st across, turn—361 sts. Fasten off.

ROW 3: With WS facing, join CC2 in first st, ch 5 (counts as dtr), 4 dtr in same st, [dtr in next st, skip next st] 8 times, dtr in next st, 5 dtr in next st, *work 5 dtr in next st, [dtr in next st, skip next st] 8 times, dtr in next st, 5 dtr in next st, rep from * across, turn. Fasten off.

ROW 4: Rep Row 2. Fasten off.

ROWS 5–6: With CC1, rep Rows 3–4. Fasten off.

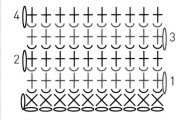

Reduced sample of body pattern

stitch key

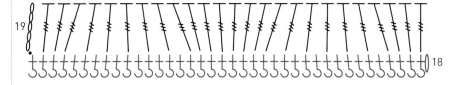 *(placed as stitch key)*

⊃ = chain (ch)

• = slip st (sl st)

✝ = single crochet (sc)

✕ = foundation sc (fsc)

✝ = Front Post sc (FPsc)

⫧ = double treble crochet (dtc)

‿ = worked in front loop only (flo)

stitch diagram B

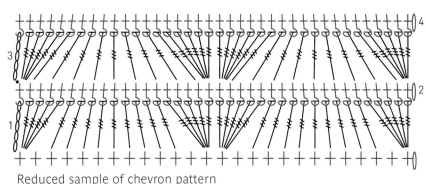

Reduced sample of chevron pattern

ROWS 7–8: With CC3, rep Rows 3–4. Fasten off.

ROWS 9–10: With CC2, rep Rows 3–4. Fasten off.

Mark center 58 sts.

With CC1, join with sl st to first marked st (134th st), work 56 fsc, skip next 56 sts, sl st in next st. This adds the neck opening and gives you sts to continuously work the next wavy row. Fasten off.

ROW 11: With CC1, rep Row 3.

ROW 12: Rep Row 2. Fasten off.

ROWS 13–14: With CC3, rep Rows 11–12. Fasten off.

ROWS 15–16: With CC2, rep Rows 11–12. Fasten off.

ROWS 17–18: With CC1, rep Rows 11–12. Fasten off.

ROW 19: With WS facing, join MC in first st, ch 5 (counts as dtr), skip 1st st, dtr

in each of next 3 sts, [skip next st, dtr in next st] 5 times, skip next st, dtr in each of next 4 sts, *dtr in each of next 4 sts, [skip next st, dtr in next st] 5 times, skip next st, dtr in each of next 4 sts, rep from * across, turn—247 sts.

ROW 20: Ch 1, sc-flo in each st across, dec 6 sts evenly across, turn—241 sts.

Note: The 6 decreases can each be worked as sc2tog over 2 stitches or by just skipping a stitch.

Back Yoke

ROWS 21–35 (35, 37, 45): Ch 1, sc-flo in each st across, turn. Fasten off.

Back Body

ROW 1: Skip first 85 (80, 75, 70) sts, join with sl st to next st, ch 1, sc-flo in same st and in next 70 (80, 90, 100) sts, turn, leaving rem sts unworked—71 (81, 91, 101) sts.

ROWS 2–80: Ch 1, sc-flo in each st across, turn—71 (81, 91, 101) sts.

Do not fasten off.

Seaming Sides and Sleeves

With MC, starting in back left bottom corner, ch 25 (28, 31, 34), sl st in end of Row 1 on left front bottom corner. Working upward, after each long chain, sl st into the next end of row, *ch 25 (28, 31, 34), sl st to end of next back row, ch 25 (28, 31, 34), sl st to end of next front row, rep from * for a total of 50 rows on each side. Continue to work ch lps in same manner, dec the ch by 1 every other lp until you have 7 ch sts. Cont to join sides with ch 7 until you reach the underarm. Turn and work along the sleeve seam, ch 6, sl st to front lower edge of sleeve, ch 5, sl st to next st on back lower edge of sleeve, ch 4, sl st to next st on front lower edge of sleeve, ch 3, sl st to next st on back lower edge of sleeve, ch 2, sl st to next st on front lower edge of sleeve, ch 1, sl st to next st of back. Fasten off, leaving very long tail. Sew remainder of sleeve seam together.

With MC, starting in front right bottom corner, rep from ** to ** for right side.

Bottom Lace Edging

RND 1: With MC, join with sl st to any st on bottom edge of sweater, ch 1, sc in each st and ch around, and inc 3 sts evenly spaced around, join with sl st to 1st sc at beg of rnd—195 (221, 247, 273) sts.

RND 2: Ch 5 (counts as dtr), 4 dtr in same st, skip next st, dtr in each of next 9 sts, skip next st, 5 dtr in next st, *5 dtr in next st, skip next st, dtr in each of next 9 sts, skip next st, 5 dtr in next st, rep from * around, join with sl st to 5th ch at beg of rnd—285 (323, 361, 399) sts.

RND 3: Ch 1, bpsc around post of each st around, join with sl st to first bpsc at beg of rnd.

RND 4: Ch 5 (counts as dtr), 4 dtr in same st, [dtr in next st, skip 1 st] 8 times, dtr in next st, 5 dtr in next st, *5 dtr in next st, [dtr in next st, skip next st] 8 times, dtr in next st, 5 dtr in next st, rep from * around, join with sl st to ch-5 at beg of rnd.

RNDS 5–8: Rep Rows 3–4 twice.

RND 9: Ch 1, [sl st, ch 1] in each st around, join with sl st to first sl st at beg of rnd. Fasten off.

Wet or steam block to finished measurements. Weave in loose ends with a tapestry needle.

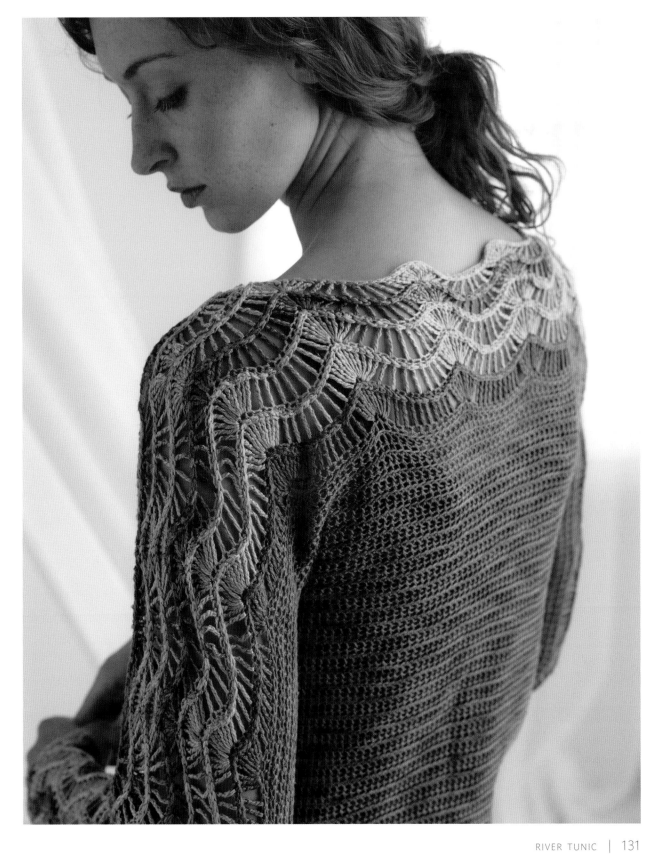

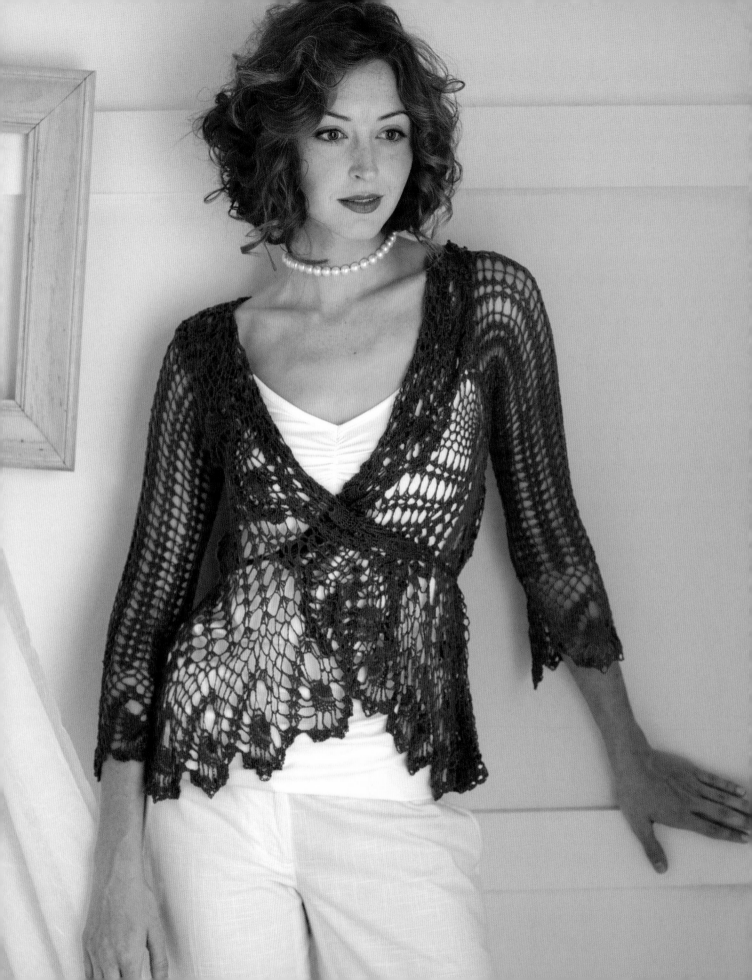

petals WRAP CARDIGAN

Geometry is often the inspiration for my crochet designs. In this sweater, it is twofold. First, I found a beautiful four-sided pineapple motif that I expanded into a six-sided design so that it would look like six petals of a flower. Second, I dissected the hexagon motif into two half hexagons to create the right and left fronts of the cardigan, with a full hexagon back. The resulting wraparound cardigan features a lacy six-petal flower motif across the back and a flower petal edging to mimic those of the central motif. The side ties are long enough to wrap around the waist and tie in the back.

YARN

Laceweight (#0 Lace [10/2]); 1,325 (1,655, 2,022, 2,425) yd (1,211 [1,513, 1,849, 2,217] m).

shown: Southwest Trading Company, Xie 10/2 (100% bamboo; 920 yd [841 m]/3.5 oz [100 g]): #471; 2 (2, 3, 3) cones.

HOOK

G/6 (4 mm) or size needed to obtain gauge.

GAUGE

First 3 rnds of Back = 3½" (9 cm) in diameter at widest point.

FINISHED SIZE

Size S (M, L, XL) fits 34 (38, 42, 46)" (86.5 (96.5, 106.5, 117) cm) bust circumference excluding the Side Edgings. 22 (24, 26, 28)" (56 (61, 66, 71) cm) long. Cardigan shown is a size M.

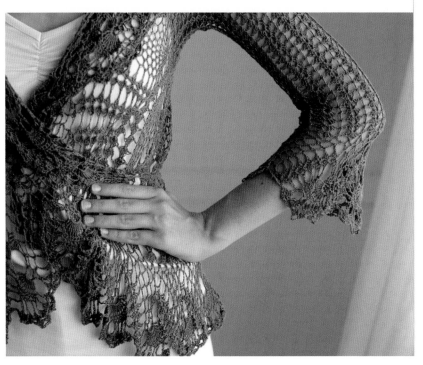

○ For edging, change ch 6 at beg of odd number rows to ch 3, sl st to body of jacket, ch 3.

Shell (3 dc, ch 2, 3 dc) in same st or sp.

Front post double crochet (fpdc) p. 157.

Single crochet 2 together (sc2tog) p. 158.

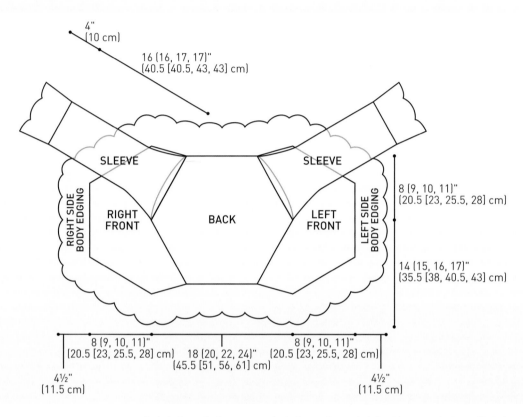

Petals Wrap Cardigan

Fronts (Make 2)

Refer to stitch diagram A at right for assistance.

Ch 4, join with sl st to form ring.

ROW 1: Ch 4, (counts as 1 dc and ch 1), [dc into ring, ch 1] 7 times, dc in ring, turn—9 dc, 8 ch-1 sps.

ROW 2: Ch 3 (counts as dc), 2 dc in first ch-1 sp, *ch 2, 3 dc in next ch-sp, ch 1, 3 dc in next ch-sp, rep from * twice, ch 2,

3 dc in last ch-1 sp, turn—4 ch-2 sps, 3 ch-1 sps.

ROW 3: Sl st to first ch-2 sp, ch 3 (counts as dc), (2 dc, ch 2, 3 dc) in first ch-2 sp, *ch 1, 1 sc in next ch-1 sp, ch 1, shell in next ch-2 sp, rep from * twice, turn—4 shells.

ROW 4: Sl st to first ch-2 sp, ch 3 (counts as dc), (2 dc, ch 2, 3 dc) in first ch-2 sp, *ch 1, (dc, ch 2, dc) in next sc, ch 1, shell in next ch-2 sp, rep from * twice, turn—4 shells.

ROW 5: Sl st to first ch-2 sp, ch 3 (counts as dc), (2 dc, ch 2, 3 dc) in first ch-2 sp,

*ch 2, skip next ch-1 sp, 10 dc in next ch-2 sp, ch 2, skip next ch-1 sp, shell in next ch-2 sp, rep from * twice, turn—3 groups of 10-dc to begin pineapples.

ROW 6: Sl st to first ch-2 sp, ch 3 (counts as dc), (2 dc, ch 2, 3 dc) in first ch-2 sp, *ch 2, (dc, ch 1) in each of next 9 dc, dc in next st, ch 2, skip next ch-1 sp, shell in next ch-2 sp, rep from * twice, turn.

ROW 7: Sl st to next ch-2 sp, ch 3 (counts as dc), (2 dc, ch 2, 3 dc, ch 2, 3 dc) in first ch-2 sp, *ch 2, skip next ch-2 sp, (sc, ch 3) in each of next 8 ch-1 sps, sc in next ch-1 sp, ch 2, skip next ch-2 sp,

stitch diagram A

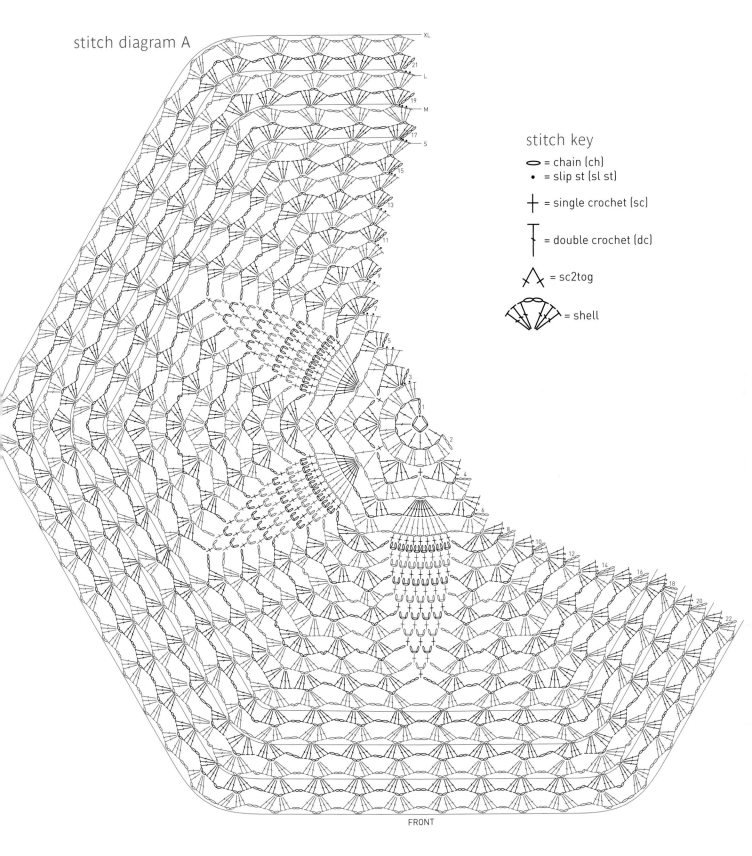

stitch key

\bigcirc = chain (ch)

• = slip st (sl st)

+ = single crochet (sc)

⊤ = double crochet (dc)

⋀ = sc2tog

⌢ = shell

FRONT

(3 dc, ch 2, 3 dc, ch 2, 3 dc) in next ch-2 sp, rep from * twice, turn.

ROW 8: Sl st to next ch-2 sp, ch 3 (counts as dc), (2 dc, ch 2, 3 dc) in first ch-2 sp, *ch 2, shell in next ch-2 sp, ch 2, skip next ch-2 sp, (sc, ch 3) in each of next 7 ch-1 sps, sc in next ch-3 sp, ch 2, skip next ch-2 sp, shell in next ch-2 sp, ch 2, shell in next ch-2 sp, rep from * twice, turn.

ROW 9: Sl st to next ch-2 sp, ch 3 (counts as dc), (2 dc, ch 3, 3 dc) in first ch-2 sp, shell in each of next 2 ch-2 sps, *ch 2, skip next ch-2 sp, (sc, ch 3) in each of next 6 ch-1 sps, sc in next ch-3 sp, ch 2, skip next ch-2 sp, shell in each of next 3 ch-2 sps, rep from * twice, turn.

ROW 10: Sl st to next ch-2 sp, ch 3 (counts as dc), (2 dc, ch 2, 3 dc) in first ch-2 sp, *ch 2, (3 dc, ch 2, 3 dc, ch 2, 3 dc) in next ch-2 sp, ch 2, shell in next ch-2 sp**, ch 2, skip next ch-2 sp, (sc, ch 3) in each of next 5 ch-1 sps, sc in next ch-3 sp, ch 2, skip next ch-2 sp, shell in next ch-2 sp, rep from * across, ending last rep at **, turn.

ROW 11: Sl st to next ch-2 sp, ch 3 (counts as dc), (2 dc, ch 2, 3 dc) in first ch-2 sp, *ch 2, skip next ch-2 sp, (shell, ch 2) in each of next 2 ch-2 sps, skip next ch-2 sp, shell in next ch-2 sp**, ch 2, skip next ch-2 sp, (sc, ch 3) in each of next 4 ch-1 sps, sc in next ch-3 sp, ch 2, skip next ch-2 sp, shell in next ch-2 sp, rep from * across, ending last rep at **, turn.

ROW 12: Sl st to next ch-2 sp, ch 3 (counts as dc), (2 dc, ch 2, 3 dc) in first ch-2 sp, *ch 2, skip next ch-2 sp, shell in each of next 3 ch-2 sps, ch 2, skip next ch-2 sp, shell in next ch-2 sp**, ch 2, skip next ch-2 sp, (sc, ch 3) in each of next 3 ch-1 sps, sc in next ch-3 sp, ch 2, skip next ch-2 sp, shell in next ch-2 sp, rep from * across, ending last rep at **, turn.

ROW 13: Sl st to next ch-2 sp, ch 3 (counts as dc), (2 dc, ch 2, 3 dc) in first ch-2 sp, *ch 2, skip next ch-2 sp, shell in next ch-2 sp, ch 2, (3 dc, ch 2, 3 dc, ch 2,

3 dc) in next ch-2 sp, ch 2, shell in next ch-2 sp, ch 2, skip next ch-2 sp, shell in next ch-2 sp**, ch 2, skip next ch-2 sp, (sc, ch 3) in each of next 2 ch-1 sps, sc in next ch-3 sp, ch 2, skip next ch-2 sp, shell in next ch-2 sp, rep from * across, ending last rep at **, turn.

ROW 14: Sl st to next ch-2 sp, ch 3 (counts as dc), (2 dc, ch 2, 3 dc) in first ch-2 sp, *[ch 2, skip next ch-2 sp, shell in next ch-2 sp] twice, (ch 2, shell) in each of next 2 ch-2 sps, [ch 2, skip next ch-2 sp, shell in next ch-2 sp] twice**, ch 2, skip next ch-2 sp, sc in next ch-3 sp, ch 3, sc in next ch-3 sp, ch 2, skip next ch-2 sp, shell in next ch-2 sp, rep from * across, ending last rep at **, turn.

ROW 15: Sl st to next ch-2 sp, ch 3 (counts as dc), (2 dc, ch 2, 3 dc) in first ch-2 sp, *[ch 2, skip next ch-2 sp, shell in next ch-2 sp] twice, shell in each of next 2 ch-2 sps, [ch 2, skip next ch-2 sp, shell in next ch-2 sp] twice**, ch 3, skip next ch-2 sp, sc in next ch-3 sp, ch 3, skip next ch-2 sp, shell in next ch-2 sp, rep from * across, ending last rep at **, turn.

ROW 16: Sl st to next ch-2 sp, ch 3 (counts as dc), (2 dc, ch 2, 3 dc) in first ch-2 sp, *[ch 2, skip next ch-2 sp, shell in next ch-2 sp] twice, ch 2, (3 dc, ch 2, 3 dc, ch 2, 3 dc) in next ch-2 sp, ch 2, [shell in next ch-2 sp, ch 2, skip next ch-sp] twice, shell in next ch-2 sp**, ch 2, skip next 2 ch-2 sps, shell in next ch-2 sp, rep from * across, ending last rep at **, turn. Fasten off size S only.

ROW 17 (SIZES M, L, XL ONLY): Sl st to next ch-2 sp, ch 3 (counts as dc), (2 dc, ch 2, 3 dc) in first ch-2 sp, [ch 2, skip next ch-2 sp, shell in next ch-2 sp] 3 times, *ch 2, shell in next ch-2 sp, [ch 2, skip next ch-2 sp, shell in next ch-2 sp] 7 times, rep from * twice, ch 2, shell in next ch-2 sp, [ch 2, skip next ch-2 sp, shell in next ch-2 sp] 3 times, turn.

ROW 18: Sl st to next ch-2 sp, ch 3 (counts as dc), (2 dc, ch 2, 3 dc) in first ch-2 sp, *(ch 2, skip next ch-2 sp, shell

in next ch-2 sp) across, turn. Fasten off size M only.

RND 19 (SIZES L, XL ONLY): Sl st to next ch-2 sp, ch 3 (counts as dc), (2 dc, ch 2, 3 dc) in first ch-2 sp, *[ch 2, skip next ch-2 sp, shell in next ch-2 sp] 3 times, shell in next ch-2 sp, shell in next ch-2 sp, [ch 2, skip next ch-2 sp, shell in next ch-2 sp] 3 times**, ch 2, skip next ch-2 sp, shell in next ch-2 sp, rep from * across, ending last rep at **.

RND 20: Sl st to next ch-2 sp, ch 3 (counts as dc), (2 dc, ch 2, 3 dc) in first ch-2 sp, *[ch 2, skip next ch-2 sp, shell in next ch-2 sp] 3 times, ch 2, (3 dc, ch 2, 3 dc, ch 2, 3 dc) in next ch-2 sp, [ch 2, skip next ch-2 sp, shell in next ch-2 sp] 4 times**, ch 2, skip next ch-2 sp, shell in next ch-2 sp, rep from * across, ending last rep at **. Fasten off size L only.

RND 21 (SIZE XL ONLY): Sl st to next ch-2 sp, ch 3 (counts as dc), (2 dc, ch 2, 3 dc) in first ch-2 sp, *[ch 2, skip next ch-2 sp, shell in next ch-2 sp] 4 times, ch 2, shell in next ch-2 sp, (ch 2, shell) in each of next 2 ch-2 sps, [ch 2, skip next ch-2 sp, shell in next ch-2 sp] 4 times**, ch 2, skip next ch-2 sp, shell in next ch-2 sp, rep from * across, ending last rep at **.

RND 22: Sl st to next ch-2 sp, ch 3 (counts as dc), (2 dc, ch 2, 3 dc) in first ch-2 sp, *(ch 2, skip next ch-2 sp, shell in next ch-2 sp) across. Fasten off size XL.

Back

Refer to stitch diagram B at right for assistance.

Ch 4, join with sl st to form ring.

RND 1: Ch 4 (counts as 1 dc and ch 1), [dc into ring, ch 1] 11 times, join with sl st in 3rd ch of ch-4 at beg of rnd—12 dc, 12 ch-1 sps.

RND 2: Sl st in next ch-1 sp, ch 3 (counts as dc), 2 dc in same sp, *ch 2, 3 dc in next ch-sp, ch 1**, 3 dc in next ch-1 sp, rep from * around, ending last rep at **, join with sl st to 3rd ch at beg of rnd—6 ch-2 sps, 6 ch-1 sps.

stitch diagram B

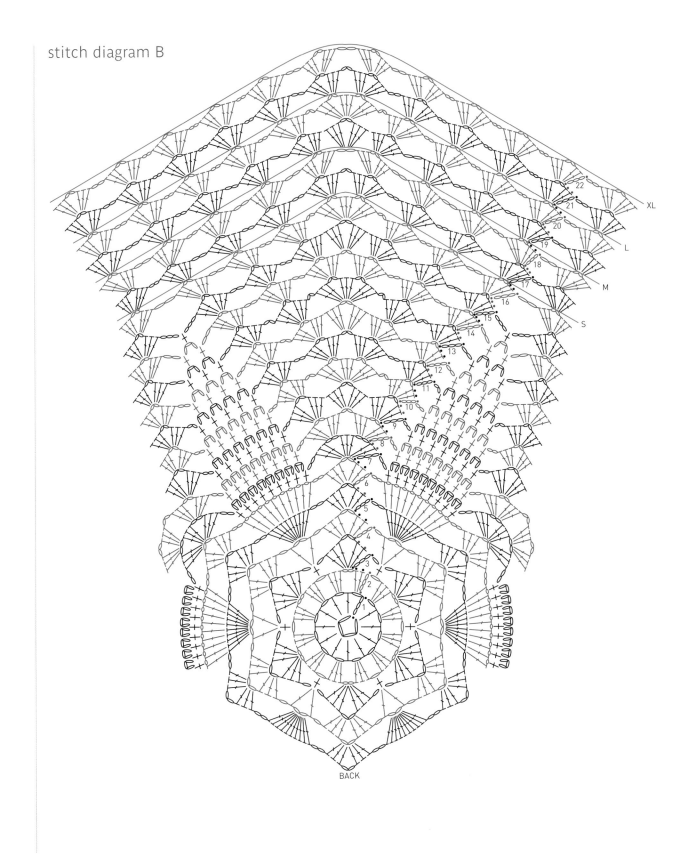

BACK

RND 3: Sl st in next ch-2 sp, ch 3 (counts as dc), (2 dc, ch 2, 3 dc) in first ch-2 sp, ch 1, sc in next ch-1 sp, ch 1, *shell in next ch-2 sp, ch 1, sc in next ch-1 sp, ch 1, rep from * around, join with sl st in top of ch-3 at beg of rnd—6 shells.

RND 4: Sl st to next ch-2 sp, ch 3 (counts as dc), (2 dc, ch 2, 3 dc) in first ch-2 sp, ch 1, (dc, ch 2 dc) in next sc, ch 1, *shell in next ch-2 sp, ch 1, (dc, ch 2, dc) in next sc, ch 1, rep from * around, join with sl st to top of ch-3 at beg of rnd—6 shells.

RND 5: Sl st to next ch-2 sp, ch 3 (counts as dc), (2 dc, ch 2, 3 dc) in first ch-2 sp, ch 2, 10 dc in next ch-2 sp, ch 2, *shell in next ch-2 sp, ch 2, 10 dc in next ch-2 sp, ch 2, rep from * around, join with sl st to top of ch-3 at beg of rnd—6 groups of 10-dc to begin pineapples.

RND 6: Sl st to next ch-2 sp, ch 3 (counts as dc), (2 dc, ch 2, 3 dc) in first ch-2 sp, ch 2, (dc, ch 1) in each of next 9 dc, dc in next dc, ch 2, skip next ch-2 sp, *shell in next ch-2 sp, (dc, ch 1) in each of next 9 dc, dc in next dc, ch 2, skip next ch-2 sp, rep from * around, join with sl st to top of ch-3 at beg of rnd.

RND 7: Sl st to next ch-2 sp, ch 3 (counts as dc), (2 dc, ch 2, 3 dc, ch 2, 3 dc) in first ch-2 sp, ch 2, (sc, ch 3) in each of next 8 ch-1 sps, sc in next ch-1 sp, ch 2, skip next ch-2 sp, *(3 dc, ch 2, 3 dc, ch 2, 3 dc) in next ch-2 sp, (sc, ch 3) in each of next 8 ch-1 sps, sc in next ch-1 sp, ch 2, skip next ch-2 sp, rep from * around, join with sl st to top of ch-3 at beg of rnd.

RND 8: Sl st to next ch-2 sp, ch 3 (counts as dc), (2 dc, ch 2, 3 dc) in first ch-2 sp, ch 2, shell in next ch-2 sp, ch 2, skip next ch-2 sp, (sc, ch 3) in each of next 7 ch-1 sps, sc in next ch-3 sp, ch 2, skip next ch-2 sp, *(shell, ch 2) in each of next 2 ch-2 sps, (sc, ch 3) in each of next 7 ch-1 sps, sc in next ch-3 sp, ch 2, rep from * around, join with sl st to top of ch-3 at beg of rnd.

RND 9: Sl st to next ch-2 sp, ch 3 (counts as dc), (2 dc, ch 3, 3 dc) in first ch-2 sp,

*shell in each of next 2 next ch-2 sps, ch 2, skip next ch-2 sp, (sc, ch 3) in each of next 6 ch-1 sps, sc in next ch-3 sp, ch 2, skip next ch-2 sp**, shell in next ch-2 sp, rep from * around, ending with last rep at **, join with sl st to top of ch-3 at beg of rnd.

RND 10: Sl st to next ch-2 sp, ch 3 (counts as dc), (2 dc, ch 2, 3 dc) in first ch-2 sp, *ch 2, (3 dc, ch 2, 3 dc, ch 2, 3 dc) in next ch-2 sp, ch 2, shell in next ch-2 sp, ch 2, skip next ch-2 sp, (sc, ch 3) in each of next 5 ch-1 sps, sc in next ch-3 sp, ch 2, skip next ch-2 sp**, shell in next ch-2 sp, rep from * around, ending last rep at **, join with sl st to top of ch-3 at beg of rnd.

RND 11: Sl st to next ch-2 sp, ch 3 (counts as dc), (2 dc, ch 2, 3 dc) in first ch-2 sp, *ch 2, skip next ch-2 sp, (shell, ch 2) in each of next 2 ch-2 sps, skip next ch-2 sp, shell in next ch-2 sp, ch 2, skip next ch-2 sp, (sc, ch 3) in each of next 4 ch-1 sps, sc in next ch-3 sp, ch 2, skip next ch-2 sp**, shell in next ch-2 sp, rep from * around, ending last rep at **, join with sl st to top of ch 3 at beg of rnd.

RND 12: Sl st to next ch-2 sp, ch 3 (counts as dc), (2 dc, ch 2, 3 dc) in first ch-2 sp, *ch 2, skip next ch-2 sp, shell in each of next 3 ch-2 sps, ch 2, skip next ch-2 sp, shell in next ch-2 sp, ch 2, skip next ch-2 sp, (sc, ch 3) in each of next 3 ch-1 sps, sc in next ch-3 sp, ch 2, skip next ch-2 sp**, shell in next ch-2 sp, rep from * around, join with sl st to top of ch-3 at beg of rnd.

RND 13: Sl st to next ch-2 sp, ch 3 (counts as dc), (2 dc, ch 2, 3 dc) in first ch-2 sp, *ch 2, skip next ch-2 sp, shell in next ch-2 sp, ch 2, (3 dc, ch 2, 3 dc, ch 2, 3 dc) in next ch-2 sp, ch 2, shell in next ch-2 sp, ch 2, skip next ch-2 sp, shell in next ch-2 sp, ch 2, skip next ch-2 sp, (sc, ch 3) in each of next 2 ch-1 sps, sc in next ch-3 sp, ch 2, skip next ch-2 sp**, shell in next ch-2 sp, rep from * around, ending last rep at **, join with sl st to top of ch-3 at beg of rnd.

RND 14: Sl st to next ch-2 sp, ch 3 (counts as dc), (2 dc, ch 2, 3 dc) in first

ch-2 sp, *[ch 2, skip next ch-2 sp, shell in next ch-2 sp], twice, ch 2, [shell in next ch-2 sp, ch 2, skip next ch-2 sp] 3 times, sc in next ch-3 sp, ch 3, sc in next ch-3 sp, ch 2**, shell in next ch-2 sp, rep from * around, ending last rep at **, join with sl st to top of ch-3 at beg of rnd.

RND 15: Sl st to next ch-2 sp, ch 3 (counts as dc), (2 dc, ch 2, 3 dc) in first ch-2 sp, *[ch 2, skip next ch-2 sp, shell in next ch-2 sp] twice, shell in each of next 2 ch-2 sps, [ch 2, skip next ch-2 sp, shell in next ch-2 sp] twice, ch 3, skip next ch-2 sp, sc in next ch-3 sp, ch 3**, shell in next ch-2 sp, rep from * around, ending last rep at **, join with sl st to top of ch-3 at beg of rnd.

(SIZE S ONLY) RND 16 (JOINING RND): Sl st to next ch-2 sp, ch 3 (counts as dc), (2 dc, ch 2, 3 dc) in first ch-2 sp, [ch 2, skip next ch-2 sp, shell in next ch-2 sp] twice, ch 2, (3 dc, ch 1, sl st in first row-end st of first row of Right Front, ch 1, 3 dc, ch 2, 3 dc) in next ch-2 sp of Back, *[ch 2, skip next ch-2 sp, shell in next ch-2 sp] 3 times, ch 2, skip next 2 ch-2 sps, shell in next ch-2 sp, [ch 2, skip next ch-2 sp, shell in next ch-2 sp] twice*, (3 dc, ch 2, 3 dc, ch 1, sl st in last row-end st of last row of Left Front, ch 1, 3 dc) in next ch-2 sp of Back, rep from * to * once, (3 dc, ch 2, 3 dc, ch 1, sl st in center ring of Left Front, ch 1, 3 dc) in next ch-2 sp of Back, [ch 2, skip next ch-2 sp on Back, skip next 2 rows on Front, (3 dc, ch 1, sl st in next row-end st, ch 1, 3 dc) in next ch-2 sp] twice, [ch 2, skip next ch-2 sp on Back, skip next row on Front, (3 dc, ch 1, sl st in next row-end st, ch 1, 3 dc) in next ch-2 sp] 4 times, ch 2, skip next row on Front, (3 dc, ch 1, sl st in next row-end st, ch 1, 3 dc, ch 2, 3 dc) in next ch-2 sp, rep from * to * once, ch 2, (3 dc, ch 2, 3 dc, ch 1, sl st in last row-end st in last row of Right Front, ch 1, 3 dc) in next ch-2 sp of Back, [ch 2, skip next ch-2 sp on Back, skip next row on Front, (3 dc, ch 1, sl st in next row-end st, ch 1, 3 dc) in next ch-2 sp] 5 times, ch 2, skip next ch-2 sp on Back, skip next 2 rows on Front, (3 dc,

ch 1, sl st in next row-end st, ch 1, 3 dc) in next ch-2 sp, ch 2, skip next 2 rows on Front, (3 dc, ch 1, sl st in center ring on Front, ch 1, 3 dc, ch 2, 3 dc) in next ch-2 sp, [ch 2, skip next ch-2 sp, shell in next ch-2 sp] 3 times, ch 2, skip next 2 ch-2 sps, join with sl st to top of ch-3 at beg of rnd. Fasten off Size S only.

(SIZES M, L, XL ONLY) RND 16: Sl st to next ch-2 sp, ch 3 (counts as dc), (2 dc, ch 2, 3 dc) in first ch-2 sp, *[ch 2, skip next ch-2 sp, shell in next ch-2 sp] twice, ch 2, (3 dc, ch 2, 3 dc, ch 2, 3 dc) in next ch-2 sp, [ch 2, skip next ch-2 sp, shell in next ch-2 sp] 3 times, ch 2, skip next 2 ch-2 sps**, shell in next ch-2 sp, rep from * around, ending last rep at **, join with sl st to top of ch-3 at beg of rnd.

RND 17: Sl st to next ch-2 sp, ch 3 (counts as dc), (2 dc, ch 2, 3 dc) in first ch-2 sp, *[ch 2, skip next ch-2 sp, shell in next ch-2 sp] 3 times, ch 2, shell in next ch-2 sp, [ch 2, skip next ch-2 sp, shell in next ch-2 sp] 3 times, ch 2, skip next ch-2 sp**, shell in next ch-2 sp, rep from * around, ending last rep at **, join with sl st to top of ch-3 at beg of rnd.

(SIZE M ONLY) RND 18 (JOINING RND): Sl st to next ch-2 sp, ch 3 (counts as dc), (2 dc, ch 2, 3 dc) in first ch-2 sp, [ch 2, skip next ch-2 sp, shell in next ch-2 sp] twice, (3 dc, ch 1, sl st in first row-end st in first row of Right Front, ch 1, 3 dc) in next ch-2 sp on Back, *[ch 2, skip next ch-2 sp, shell in next ch-2 sp] 8 times*, (3 dc, ch 1, sl st in last row-end st in last row of Left Front, ch 1, 3 dc) in next ch-2 sp on Back, rep from * to * once, ch 2, skip next ch-2 sp on Back, (3 dc, ch 1, sl st in center ring on Front, ch 1, 3 dc) in next ch-2 sp on Back, [ch 2, skip next ch-2 sp on Back, skip next 2 rows on Front, (3 dc, ch 1, sl st in next row-end st, ch 1, 3 dc) in next ch-2 sp] twice, ch 2, [skip next row on Front, (3 dc, ch 1, sl st in next row-end st, ch 1, 3 dc in next ch-2 sp] 6 times, ch 2, skip next row on Front, (3 dc, ch 1, sl st in next row-end st, ch 1, 3 dc) in next ch-2 sp, rep from * to * once, ch 2, skip next ch-2 sp on

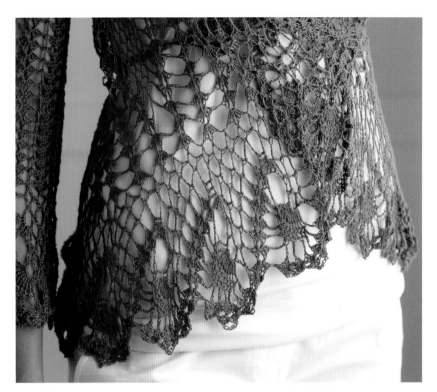

Back, (3 dc, ch 1, sl st in last row-end st in last row of Left Front, ch 1, 3 dc) in next ch-2 sp on Back, ch 2, [skip next row on Front, (3 dc, ch 1, sl st in next row-end st, ch 1, 3 dc, ch 2, 3 dc) in next ch-2 sp] 6 times, ch 2, skip next ch-2 sp on Back, skip next 2 rows on Front, (3 dc, ch 1, sl st in next row-end st, ch 1, 3 dc) in next ch-2 sp, ch 2, skip next ch-2 sp on Back, skip next 2 rows on Front, (3 dc, ch 1, sl st in center ring on Front, ch 1, 3 dc) in next ch-2 sp, [ch 2, skip next ch-2 sp, shell in next ch-2 sp] 4 times, ch 2, skip next ch-2 sp, join with sl st to top of ch-3 at beg of rnd. Fasten off.

(SIZES L, XL ONLY) RND 18: Sl st to next ch-2 sp, ch 3 (counts as dc), (2 dc, ch 2, 3 dc) in first ch-2 sp, *(ch 2, skip next ch-2 sp, shell in next ch-2 sp] around, ch 2, skip next ch-2 sp, join with sl st to top of ch-3 at beg of rnd.

RND 19: Sl st to next ch-2 sp, ch 3 (counts as dc), (2 dc, ch 2, 3 dc) in first ch-2 sp, *[ch 2, skip next ch-2 sp, shell in next ch-2 sp] 3 times, shell in each of next 2 ch-2 sps, [ch 2, skip next ch-2 sp, shell in next ch-2 sp] 3 times, ch 2, skip

next ch-2 sp**, shell in next ch-2 sp, rep from * around, ending last rep at **, join with sl st to top of ch-3 at beg of rnd.

(SIZE L ONLY) RND 20 (JOINING RND): Sl st to next ch-2 sp, ch 3 (counts as dc), (2 dc, ch 2, 3 dc) in first ch-2 sp, [ch 2, skip next ch-2 sp, shell in next ch-2 sp] 3 times, [3 dc, ch 1 sl st in first row-end st of first row of Right Front, ch 1, 3 dc, ch 2, 3 dc] in next ch-2 sp of Back, *[ch 2, skip next ch-2 sp, shell in next ch-2 sp] 8 times*, (3 dc, ch 2, 3 dc, ch 1 sl st in last row-end st of last row of Left Front, ch 1, 3 dc) in next ch-2 sp of Back, rep from * to * once, (3 dc, ch 2, 3 dc, ch 1, sl st in center ring of Left Front, ch 1, 3 dc) in next ch-2 sp of Back, [ch 2, skip next ch-2 sp on Back, skip next 2 rows on Front, (3 dc, ch 1, sl st in next row-end st, ch 1, 3 dc) in next ch-2 sp] twice, [ch 2, skip next ch-2 sp on Back, skip next row on Front, (3 dc, ch 1, sl st in next row-end st, ch 1, 3 dc) in next ch-2 sp] 7 times, ch 2, skip next row on Front, (3 dc, ch 1, sl st in next row-end st, ch 1, 3 dc, ch 2, 3 dc) in next ch-2 sp, rep from * to * once, ch 2, (3 dc, ch 2, 3 dc, ch 1, sl st in last row-end st in last row of Right

Front, ch 1, 3 dc) in next ch-2 sp of Back, [ch 2, skip next ch-2 sp on Back, skip next row on Front, (3 dc, ch 1, sl st in next row-end st, ch 1, 3 dc) in next ch-2 sp] 7 times, ch 2, skip next ch-2 sp on Back, skip next 2 rows on Front, (3 dc, ch 1, sl st in next row-end st, ch 1, 3 dc) in next ch-2 sp, ch 2, skip next 2 rows on Front, (3 dc, ch 1, sl st in center ring on Front, ch 1, 3 dc, ch 2, 3 dc) in next ch-2 sp, [ch 2, skip next ch-2 sp, shell in next ch-2 sp] 4 times, ch 2, skip next ch-2 sp, join with sl st to top of ch-3 at beg of rnd. Fasten off Size L only.

(SIZE XL ONLY) RND 20: Sl st to next ch-2 sp, ch 3 (counts as dc), (2 dc, ch 2, 3 dc) in first ch-2 sp, *[ch 2, skip next ch-2 sp, shell in next ch-2 sp] 3 times, ch 2, (3 dc, ch 2, 3 dc, ch 2, 3 dc) in next ch-2 sp, ch 2, shell in next ch-2 sp, [ch 2, skip next ch-2 sp, shell in next ch-2 sp] 3 times, ch 2, skip next ch-2 sp**, shell in next ch-2 sp, rep from * around, ending last rep at **, join with sl st to top of ch-3 at beg of rnd.

RND 21: Sl st to next ch-2 sp, ch 3 (counts as dc), (2 dc, ch 2, 3 dc) in first ch-2 sp, *[ch 2, skip next ch-2 sp, shell in next ch-2 sp] 4 times, (ch 2, shell) in each of next 2 ch-2 sps, [ch 2, skip next ch-2 sp, shell in next ch-2 sp] 4 times, ch 2, skip next ch-2 sp**, shell in next ch-2 sp, rep from * around, ending last rep at **, join with sl st to top of ch-3 at beg of rnd.

RND 22: Sl st to next ch-2 sp, ch 3 (counts as dc), (2 dc, ch 2, 3 dc) in first ch-2 sp, [ch 2, skip next ch-2 sp, shell in next ch-2 sp] 3 times, (3 dc, ch 1, sl st in first row-end st in first row of Right Front, ch 1, 3 dc) in next ch-2 sp on Back, *[ch 2, skip next ch-2 sp, shell in next ch-2 sp] 10 times*, (3 dc, ch 1, sl st in last row-end st in last row of Left Front, ch 1, 3 dc) in next ch-2 sp on Back, rep from * to * once, ch 2, skip next ch-2 sp on Back, (3 dc, ch 1, sl st in center ring on Front, ch 1, 3 dc) in next ch-2 sp on Back, [ch 2, skip next ch-2 sp on Back, skip next 2 rows on Front, (3 dc, ch 1, sl st in next row-end st, ch 1, 3 dc)

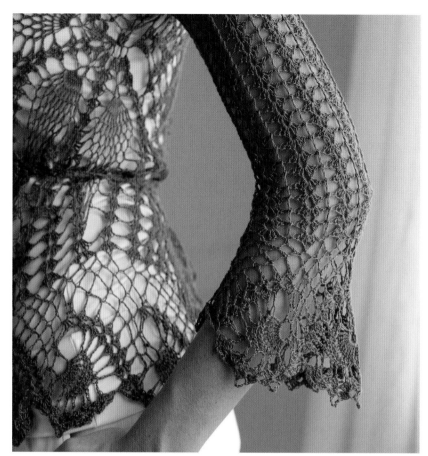

in next ch-2 sp] 4 times, ch 2, [skip next row on Front, (3 dc, ch 1, sl st in next row-end st, ch 1, 3 dc) in next ch-2 sp] 5 times, ch 2, skip next row (3 dc, ch 1, sl st in next row-end st, ch 1, 3 dc) in next ch-2 sp, rep from * to * once, ch 2, skip next ch-2 sp on Back, (3 dc, ch 1, sl st in last row-end st in last row of Left Front, ch 1, 3 dc) in next ch-2 sp on Back, ch 2, [skip next row on Front, (3 dc, ch 1, sl st in next row-end st, ch 1, 3 dc, ch 2, 3 dc) in next ch-2 sp] 5 times, [ch 2, skip next ch-2 sp on Back, skip next 2 rows on Front, (3 dc, ch 1, sl st in next row-end st, ch 1, 3 dc) in next ch-2 sp] 3 times, ch 2, skip next ch-2 sp on Back, skip next 2 rows on Front, (3 dc, ch 1, sl st in center ring on Front, ch 1, 3 dc) in next ch-2 sp, [ch 2, skip next ch-2 sp, shell in next ch-2 sp] 5 times, ch 2, skip next ch-2 sp, join with sl st to top of ch-3 at beg of rnd. Fasten off size XL.

Sleeve (Make 2)
Refer to stitch diagram C at right for assistance.

RND 1: With RS facing, join with sl st to top row-end st in on front edge of right armhole opening, ch 3 (counts as dc), *skip next 1 (2, 1, 2) rows, [3 dc, ch 3, 3 dc] in next row-end st, skip next row, dc in next row-end st, [3 dc, ch 3, 3 dc] in next row-end st, skip next row, dc in next row-end st, skip next 1 (2, 1, 2) rows, [3 dc, ch 3, 3 dc] in next row-end st, *skip next row, dc in next row-end st, skip next row, [3 dc, ch 3, 3 dc] in next row-end st, rep from * 0 (0, 1, 1) time, dc in next 1 (0, 1, 0) row-end st, working across back of armhole, dc in next 0 (1, 0, 1) ch-2 sp of next shell, skip next ch-2 sp, **[3 dc, ch 3, 3 dc] in ch-2 sp of next shell, skip next ch-2 sp, dc in ch-2 sp of next shell, skip next ch-2 sp, [3 dc, ch 3, 3 dc] in ch-2 sp of next shell, rep from ** 3 times, join

with sl st to top of ch-3 at beg of rnd—8 (8, 10, 10) shells.

RND 2: Ch 3, fpdc around the post of ch-3 in last rnd, (3 dc, ch 3, 3 dc) in next ch-3 sp, *fpdc around the post of next dc, (3 dc, ch 3, 3 dc) in next ch-3 sp, rep from * around, join with sl st to top of ch-3 at beg of rnd.

RND 3: Ch 3, fpdc around ch-3 and fpdc in last rnd, (3 dc, ch 3, 3 dc) in next ch-3 sp, *fpdc around the post of next dc, (3 dc, ch 3, 3 dc) in next ch-3 sp, rep from * around, join with sl st to top of ch-3 at beg of rnd.

Rep Rnd 3 until sleeve measures 16 (16, 17, 17)" (40½ [40½, 43, 43] cm) from beg.

Right Side Body Edging

Refer to stitch diagram D at right for assistance.

Ch 22.

ROW 1: With RS facing, sl st in center ch-2 sp on Back neck edge, ch 3, sk next 5 ch, sc in next ch, [ch 6, skip next 3 ch, sc in next ch] 3 times, ch 4, skip next 3 ch, shell in last ch, turn.

ROW 2: Ch 6, shell in next ch-2 sp, ch 2, sc in next ch-4 sp, ch 2, (dc, ch 5, dc) in next ch-5 sp, ch 2, sc in next ch-5 sp, ch 2, shell in next ch-5 sp, ch 5, sc in last ch-3 sp.

ROW 3: Ch 3, sl st in next ch-2 sp on body, turn, ch 3, sc in next ch-5 sp, ch 5, shell in next ch-2 sp, ch 3, skip next 2 ch-2 sps, 10 tr in next ch-5 sp, ch 3, skip next 2 ch-2 sps, shell in next ch-2 sp, turn.

ROW 4: Ch 6, shell in next ch-2 sp, ch 3, skip next ch-3 sp, sc in each of next 10 tr, ch 3, skip next ch-3 sp, shell in next ch-2 sp, (ch 5, sc) in each of next 2 ch-sps, turn.

ROW 5: Ch 3, sl st in next ch-2 sp on body, turn, ch 3, (sc, ch 5) in each of next 2 ch-5 sps, shell in next ch-2 sp, ch 3, skip next sc, sc in each of next 8 sc, skip next sc, ch 3, skip next ch-3 sp, shell in next ch-2 sp, turn.

stitch diagram C

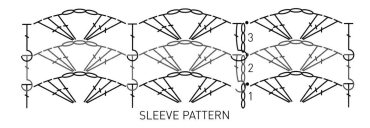

SLEEVE PATTERN

stitch diagram D

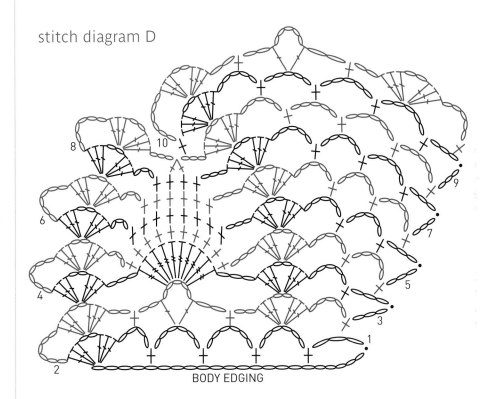

BODY EDGING

ROW 6: Ch 6, shell in next ch-2 sp, ch 3, skip next sc, sc in each of next 6 sc, skip last sc, ch 3, skip next ch-3, shell in next ch-2 sp, (ch 5, sc) in each of next 3 ch-sps.

ROW 7: Ch 3, sl st in next ch-2 sp on body, turn, ch 3, (sc, ch 5) in each of next 3 ch-5 sps, shell in next ch-2 sp, ch 3, skip next sc, sc in each of next 4 sc, skip last sc, ch 3, skip next ch-3 sp, shell in next ch-2 sp, turn.

ROW 8: Ch 6, shell in next ch-2 sp, ch 3, skip next sc, work sc2tog over next 2 sc, skip next sc, ch 3, skip next ch-3 sp, shell in next ch-2 sp, (ch 5, sc) in each of next 4 ch-sps.

ROW 9: Ch 3, sl st in next ch-2 sp on body, turn, ch 3, (sc, ch 5) in each of next 4 ch-5 sps, shell in next ch-2 sp, sc in next ch-2 sp, turn.

ROW 10: Ch 6, shell in next ch-2 sp, ch 2, sc in next ch-5 sp, ch 2, (dc, ch 5, dc) in next ch-5 sp, ch 2, sc in next ch-5 sp, ch 2, shell in next ch-5 sp, ch 5, sc in next ch-3 sp, turn.

Rep Rows 3–10 across neck edge of Back, around Left Front edge, across bottom edge of Back to center ch-2 sp on bottom edge of Back, ending with Row 9. Fasten off.

Left Side Body Edging

ROW 1: With RS facing, sl st in center ch-2 sp on Back neck edge, ch 3, skip next 5 ch of foundation ch of Right Side Body Edging, sc in next ch, [ch 6, skip next 3 ch, sc in next ch] 3 times, ch 4, skip next 3 ch, shell in last ch, turn.

Work same as Right Side Body Edging, joining to left side of body, ending 1 ch-2 sp prior to center ch-2 sp on bottom edge of Back, ending with Row 8.

LAST ROW: Ch 3, sl st in next ch-2 sp on body, turn, ch 3, (sc, ch 2, sl st in corresponding ch-5 sp on Right Side Body Edging, ch 2) in each of next 4 ch-5 sps, (3 dc, ch 1, sl st in corresponding ch-2 sp on Right Side Body Edging, ch 1, 3 dc) in next ch-2 sp, sc in next ch-2 sp. Fasten off.

Sleeve Edging
Ch 22.

ROW 1: With RS facing, sl st in ch-3 sp on cuff edge of Sleeve at underside of wrist, ch 3, turn, sk next 5 ch, sc in next ch, [ch 6, skip next 3 ch, sc in next ch] 3 times, ch 4, skip next 3 ch, shell in last ch, turn.

ROWS 2–10: Work same as Rows 2–10 of Right Side Body Edging, joining with sl st to each fpdc and each ch-2 sp.

ROWS 11–31 (31, 39, 39): Rep Rows 3–10 two (two, three, three) times, rep Rows 3–7.

ROW 32 (32, 40, 40): Ch 6, shell in next ch-2 sp, ch 3, skip next sc, work sc2tog over next 2 sc, skip next sc, ch 3, skip next ch-3 sp, shell in next ch-2 sp, (ch 2, sl st in corresponding ch-sp on foundation ch of cuff, ch 2, sc) in each of next 4 ch-sps. Fasten off.

First Tie

ROW 1: Join with sl st in ch-6 sp in Row 54 of Right Side Body Edging, ch 4 (counts as tr), 3 tr in same st, turn.

ROW 2: Sl st into sp bet 2nd and 3rd tr, ch 4 (counts as tr), work 3 tr in same sp, turn.
Rep Row 2 until tie measures 40" (101.5 cm) from beg. Fasten off.

Second Tie
Starting in corresponding ch-6 sp on Left Side Body Edging, rep First Tie on opposite side.

Wet or steam block to finished measurements. Weave in loose ends with a tapestry needle.

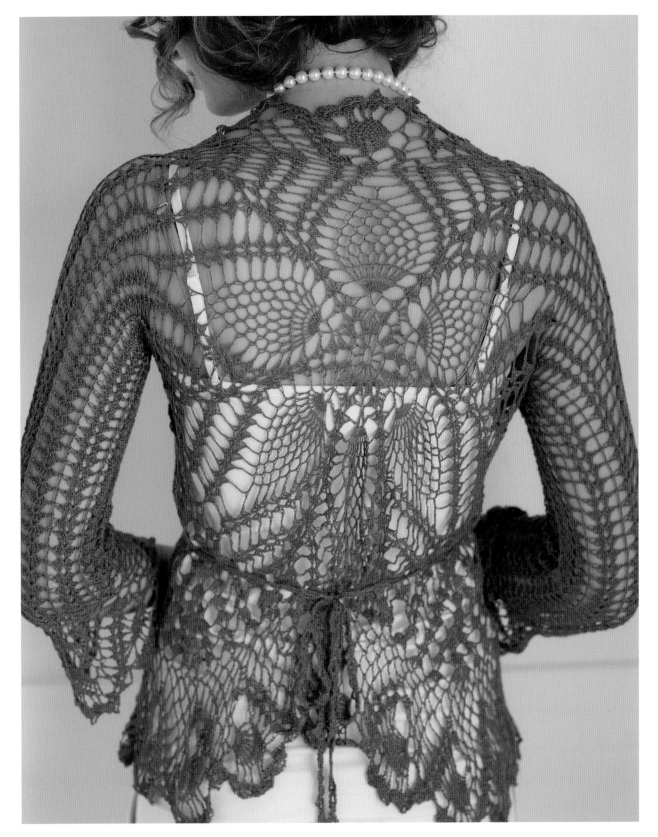

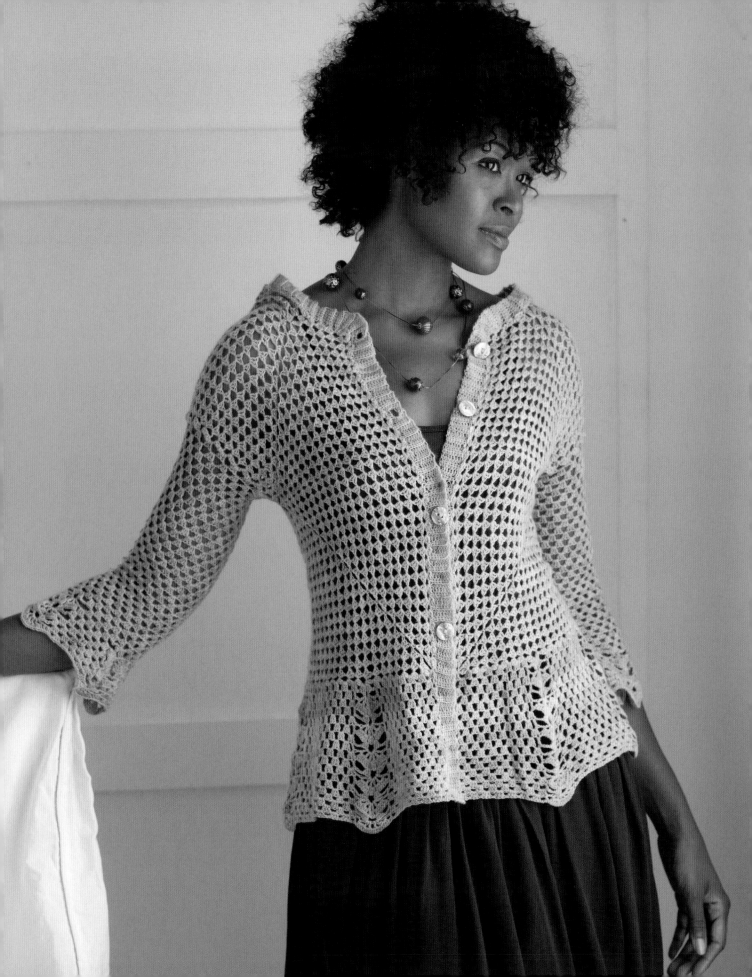

enigma HOODED CARDIGAN

The ubiquitous granny square is one of the first things a cro-
cheter learns and is possibly the easiest skill to teach a begin-
ner. I wanted to figure out a way to create a granny-inspired
motif that would be each section of a sweater. Encouraged by
the fact that triangles can be joined together to make squares,
and squares can be joined together to make sweaters, I cre-
ated this cardigan with only a few motifs. With an edging of
pretty lace columns that are repeated in the sleeve cuffs, and
the addition of a hood, this sweater is a stylish addition to any
wardrobe.

YARN

Laceweight (#0 Lace); 1,400 (1,750,
2,140, 2,570) yd (1,280 (1,600, 1,957,
2,350) m).

shown: Malabrigo Yarn, Lace
(100% Baby Merino Wool; 470 yd
[155.4 m]/1.75 oz [50 g]): #34 orchid,
3 (4, 5, 6) skeins

NOTIONS

4 buttons, ¾" (19 mm) in diameter
(shown: JHB #2188); tapestry needle.

HOOK

D/4 (3.5 mm) or size needed to obtain
gauge.

GAUGE

18 sts x 6 rows in dc pattern = 2" (5
cm); First 4 rnds of Back = 3" (7.5 cm)
square.

FINISHED SIZE

Size S (M, L, XL) 35 (39, 42, 46)" (89
[99, 106.5, 117] cm) bust circumfer-
ence and 47 (48½, 50, 51½)" (119.5
[123, 127, 131] cm) hip circumference.
21½ (23½, 25, 27)" (54.5 [59.5, 63.5,
68.5] cm) long. Cardigan shown is a
size S.

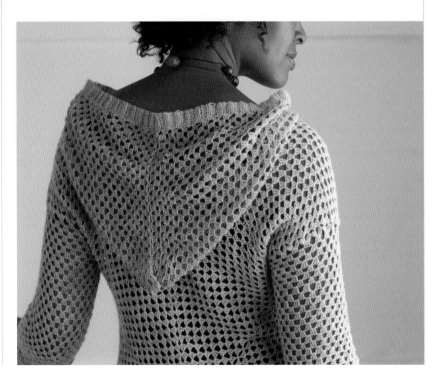

- The Back is begun by working in the round, but will switch to working back and forth in rows. To maintain the same look of alternating right side and wrong side facing, turn work at the end of each round.

- The Hood is worked in rows, worked right onto the neck edge.

- The Front Bands are worked in one piece up and around, including the hood edge.

Shell (3 dc, ch 3, 3 dc) in same st or sp.

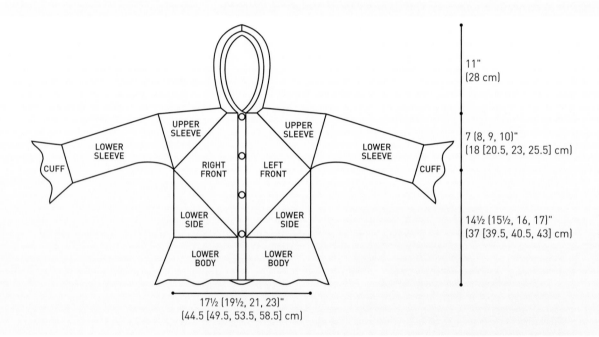

11"
(28 cm)

7 (8, 9, 10)"
(18 [20.5, 23, 25.5] cm)

14½ (15½, 16, 17)"
(37 [39.5, 40.5, 43] cm)

17½ (19½, 21, 23)"
(44.5 [49.5, 53.5, 58.5] cm)

Enigma
Hooded Cardigan

Back

Refer to stitch diagram A at right for assistance.

Ch 5, join with sl st to form ring.

RND 1: Ch 3 (counts as dc), 2 dc in ring, ch 3, [3 dc, ch 3] 3 times in ring, join with sl st to top of ch-3 at beg of rnd, turn.

RND 2: Sl st in first ch-3 sp, ch 3 (counts as dc), [2 dc, ch 3, 3 dc] in first ch-3 sp, ch 1, *shell in next ch-3 sp, ch 1, rep from * twice, join with sl st to top of ch-3 at beg of rnd, turn.

RND 3: Sl st in first ch-1 sp, ch 3 (counts as dc), 2 dc in first ch-1 sp, ch 1, *[3 dc, ch 3, 3 dc, ch 1] in next ch-3 sp**, 3 dc in next ch-1 sp, ch 1, rep from * around, ending last rep at **, join with sl st to top of ch-3 at beg of rnd, turn.

RND 4: Sl st in first ch-1 sp, ch 3 (counts as dc), 2 dc in same ch-1 sp, ch 1, *[3 dc, ch 3, 3 dc, ch 1] in next ch-3 sp**, [3 dc, ch 1] in each of next 2 next ch-1 sps, rep from * around, ending last rep at **, 3 dc, in next ch-1 sp, ch 1, join with sl st to top of ch-3 at beg of rnd, turn.

RND 5: Sl st in first ch-1 sp, ch 3 (counts as dc), 2 dc in same ch-1 sp, ch 1, [3 dc, ch 1] in each ch-1 sp across to next corner, *[3 dc, ch 3, 3 dc, ch 1] in next ch-3 sp**, [3 dc, ch 1] in each ch-1 sp across to next corner, rep from * around, ending last rep at **, [3 dc, ch 1] in each

ch-1 sp across to beg, join with sl st to top of ch-3 at beg of rnd, turn.

RNDS 6–15 (17, 19, 21): Rep Rnd 5, working 1 more 3-dc rep on each side. Fasten off.

Shape Top Edge

Note: Work now progresses in rows.

ROW 1: Turn, with WS facing, join with sl st in first ch-1 space to left of any corner, ch 3 (counts as dc), 2 dc in first ch-1 sp, *(ch 1, 3 dc) in each ch-1 sp across to next corner**, (ch 1, 3 dc, ch 3, 3 dc) in next ch-3 sp, rep from * around, ending last rep at ** in ch-1 sp before last corner sp, turn.

ROW 2: Sl st in first ch-1 sp, ch 3, 2 dc in first ch-1 sp, *(ch 1, 3 dc) in each ch-1 sp across to next corner, (ch 1, 3 dc, ch 3, 3 dc) in next ch-3 sp, rep from * once, (ch 1, 3 dc) in each ch-1 sp across to last ch-1 sp, turn, leaving rem sts unworked.

ROW 3: Rep Row 2. Fasten off.

Front (Make 2)

Note: Right and Left Fronts are identical.

Refer to stitch diagram B for assistance.

Ch 5, join with sl st to form ring.

ROW 1: Ch 3, (counts as dc), 2 dc in ring, [ch 3, 3 dc] 3 times in ring, turn.

ROW 2: Sl st in first ch-3 sp, ch 3 (counts as dc), (2 dc, ch 3, 3 dc) in first ch-3 sp, *ch 1, shell in next ch-3 sp, rep from * once, turn.

ROW 3: Sl st to first ch-3 sp, ch 3 (counts as dc), (2 dc, ch 3, 3 dc) in first ch-3 sp, *ch 1, 3 dc) in next ch-1 sp, ch 1, (3 dc, ch 3, 3 dc) in next ch-3 sp, rep from * once, turn.

ROW 4: Sl st to first ch-3 sp, ch 3 (counts as dc), (2 dc, ch 3, 3 dc) in first ch-3 sp, *ch 1, (3 dc, ch 1) in each of next 2 ch-1 sps, (3 dc, ch 3, 3 dc) in next ch-3 sp, rep from * once, turn.

ROW 5: Sl st to first ch-3 sp, ch 3 (counts as dc), (2 dc, ch 3, 3 dc) in first ch-3 sp, *ch 1, (3 dc, ch 1) in each ch-1 sp across to next corner, shell in next ch-3 sp, rep from * once, turn.

stitch diagram A

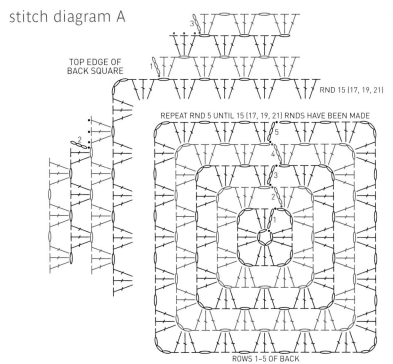

TOP EDGE OF BACK SQUARE

RND 15 (17, 19, 21)

REPEAT RND 5 UNTIL 15 (17, 19, 21) RNDS HAVE BEEN MADE

ROWS 1–5 OF BACK

stitch diagram B

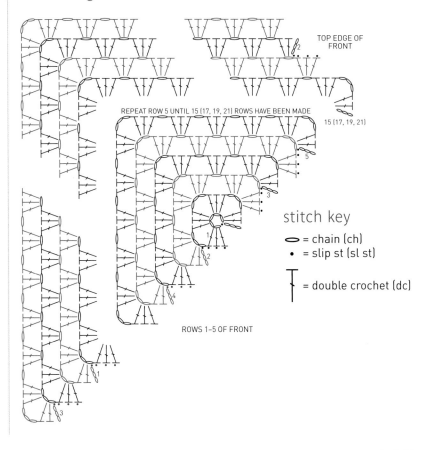

TOP EDGE OF FRONT

REPEAT ROW 5 UNTIL 15 (17, 19, 21) ROWS HAVE BEEN MADE

15 (17, 19, 21)

ROWS 1–5 OF FRONT

stitch key

⬯ = chain (ch)

• = slip st (sl st)

T = double crochet (dc)

stitch diagram C

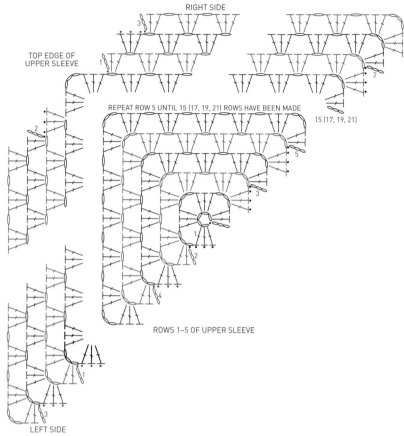

RIGHT SIDE

TOP EDGE OF
UPPER SLEEVE

REPEAT ROW 5 UNTIL 15 (17, 19, 21) ROWS HAVE BEEN MADE

15 (17, 19, 21)

ROWS 1–5 OF UPPER SLEEVE

LEFT SIDE

stitch diagram D

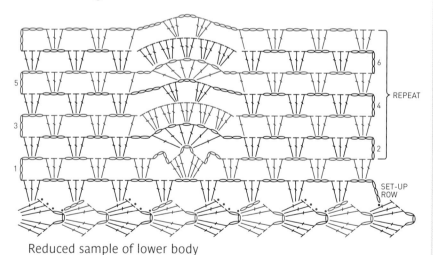

REPEAT

SET-UP
ROW

Reduced sample of lower body

ROWS 6–15 (17, 19, 21): Rep Row 5, working 1 more 3-dc rep on each side. Do not fasten off.

Shape Top Edge

ROW 1: Sl st to first ch-3 sp, ch 3 (counts as dc), (2 dc, ch 3, 3 dc) in first ch-3 sp, *(ch 1, 3 dc) in each ch-1 sp across to next corner*, (ch 1, 3 dc, ch 3, 3 dc) in next ch-3 sp, rep from * to * once, turn, leaving rem sts unworked.

ROW 2: Sl st to first ch-1 sp, ch 3 (counts as dc), 2 dc in first ch-1 sp, *ch 1, (3 dc, ch 1) in each ch-1 sp across to next corner, shell in next ch-3 sp, rep from * once, turn.

ROW 3: Sl st to first ch-3 sp, ch 3 (counts as dc), (2 dc, ch 3, 3 dc) in first ch-3 sp, *(ch 1, 3 dc) in each ch-1 sp across* to next corner, (ch 1, 3 dc, ch 3, 3 dc) in next ch-3 sp, rep from * to * once, turn, leaving rem sts unworked. Fasten off.

Right and Left Front Lower Sides (Make 2)

Work same as Front through Row 5.

ROWS 6–18 (20, 22, 23): Rep Row 5 of Front, working 1 more 3-dc rep on each side. Fasten off.

Upper Sleeve (Make 2)

Refer to stitch diagram C for assistance.

Work same as Front through Row 15 (17, 19, 21).

Note: Starting on next row, the sides are worked separately because the center corner will be skipped.

Left Side

ROW 1: Sl st in first ch-3 sp, ch 3 (counts as dc), (2 dc, ch 3, 3 dc) in first ch-3 sp, (ch-1, 3 dc) in each ch-1 sp across to next corner, turn, leaving rem sts unworked.

ROW 2: Sl st to first ch-1 sp, ch 3 (counts as dc), 2 dc in first ch-1 sp, (ch 1, 3 dc) in each ch-1 sp across to next corner, (ch 1, 3 dc, ch 3, 3 dc) in next ch-3 sp, turn.

ROW 3: Sl st in first ch-3 sp, ch 3 (counts as dc), (2 dc, ch 3, 3 dc) in first ch-3 sp,

ch-1, (3 dc, ch 1) in each ch-1 sp across. Fasten off.

Right Side
ROW 1: With WS facing, join with sl st in first ch-1 space to left of next corner, ch 3 (counts as dc), 2 dc in first ch-1 sp, *(ch 1, 3 dc) in each ch-1 sp across to next corner**, (ch 1, 3 dc, ch 3, 3 dc) in next ch-3 sp, turn.

ROW 2: Sl st in first ch-3 sp, ch 3 (counts as dc), (2 dc, ch 3, 3 dc) in first ch-3 sp, (ch-1, 3 dc) in each ch-1 sp across, turn.

ROW 3: Sl st to first ch-1 sp, ch 3 (counts as dc), 2 dc in first ch-1 sp, (ch 1, 3 dc) in each ch-1 sp across to next corner, (ch 1, 3 dc, ch 3, 3 dc) in next ch-3 sp. Fasten off.

Assembly
Sew Fronts, Back, Lower Sides, and Upper Sleeves together with a whipstitch, following Construction Diagram.

Lower Body
Refer to stitch diagram D at left for assistance.

SET-UP ROW: With RS facing, join with sl st to first row-end st at lower corner of Left Front, ch 6 (counts as dc, ch 3), (3 dc, ch 3) in each row-end st acoss bottom edge of assembled body, working 3 dc in last st on corner of lower Right Front—71 (79, 87, 95) shells.

ROW 1: Ch 6 (counts as dc, ch 3), (3 dc, ch 3) in each of next 8 (9, 10, 11) ch-3 sps, ch 4, shell in next ch-3 sp, ch 4, *(3 dc, ch 3) in each of next 8 (9, 10, 11) ch-3 sps ch 4, shell in next ch-3 sp, ch 4, rep from * 5 times, (3 dc, ch 3) in each of next 7 (8, 9, 10) ch-3 sps, 3 dc in last ch-3 sp, turn—7 shells.

ROW 2: Ch 6 (counts as dc, ch 3), 3 dc in next ch-3 sp, (ch 3, 3 dc) in each of next 6 (7, 8, 9) ch-3 sps, ch 2, skip next ch-4 sp, *([dc, ch 1] 5 times, dc) in next ch-3 sp, ch 2, skip next ch-4 sp, (3 dc, ch 3) in each of next 6 (7, 8, 9) ch-3 sps, 3 dc in next ch-3 sp, rep from * across, turn.

ROW 3: Ch 6 (counts as dc, ch 3), 3 dc

in next ch-3 sp, (ch 3, 3 dc) in each of next 6 (7, 8, 9) ch-3 sps, *ch 3, skip next 2 dc, dc in next dc, skip next ch-2 sp, 3 dc in each of next 5 ch-1 sps, skip next ch-2 sp, dc in next dc, ch 3, (ch 3, 3 dc) in each of next 6 (7, 8, 9) ch-3 sps, rep from * across, ch 3, 3 dc in last ch-3 sps, turn.

ROW 4: Ch 6 (counts as dc, ch 3), (3 dc, ch 3) in each of next 6 (7, 8, 9) ch-3 sps, *3 dc in next ch-3 sp, ch 4, skip next 7 dc, 3 dc in sp before next dc, ch 3, skip next 3 dc, 3 dc in sp before next dc, ch 4, (3 dc, ch 3) in each of next 7 (8, 9, 10) ch-3 sps, rep from * across, 3 dc in last ch-3 sp, turn.

ROW 5: Ch 6 (counts as dc, ch 3), 3 dc in next ch-3 sp, (ch 3, 3 dc) in each of next 6 (7, 8, 9) ch-3 sps, *ch 3, skip next 2 dc, dc in next dc, ch 2, skip next ch-4 sp, ([dc, ch 1] 5 times, dc) in next ch-3 sp, ch 2, skip next ch-4 sp, dc in next dc, (ch 3, 3 dc) in each of next 6 (7, 8, 9) ch-3 sps, rep from * across, ch 3, 3 dc in last ch-3 sp, turn.

ROW 6: Ch 6 (counts as dc, ch 3), 3 dc in next ch-3 sp, (ch 3, 3 dc) in each of next 6 (7, 8, 9) ch-3 sps, *skip next ch-2 sp, 3 dc in each of next 5 ch-1 sps, skip next ch-2 sp, 3 dc in next ch-3 sp, (ch 3, 3 dc)

in each of next 6 (7, 8, 9) ch-3 sps, rep from * across, ch 3, 3 dc in last ch-3 sp, turn.

ROW 7: Ch 6 (counts as dc, ch 3), (3 dc, ch 3) in each of next 7 (8, 9, 10) ch-3 sps, *ch 3, skip next 2 dc, dc in next dc, ch 4, skip next 6 dc, 3 dc in sp before next dc, ch 3, skip next 3 dc, 3 dc in sp before next dc, ch 4, skip next 6 dc, dc in next dc, (ch 3, 3 dc) in each of next 6 (7, 8, 9) ch-3 sps, rep from * across, ch 3, 3 dc in last ch-3 sp, turn.

ROWS 8–24: Rep Rows 2–7 twice, then rep Rows 2–6 once. Fasten off.

Lower Sleeve (Make 2)
Note: Lower Sleeves are worked in rnds. Turn at the end of each rnd so the RS and WS rows are facing alternately.

RND 1: With RS facing, join with sl st to any end of row of Upper Sleeve, ch 3 (counts as dc), 2 dc in first sp, (ch 3, 3 dc) in next 3 (0, 3, 0) row-end sts, *skip next row, (ch 3, 3 dc) in next row-end st, rep from * around armhole, ch 3, join with sl st to top of ch-3 at beg of rnd, turn—20 (20, 24, 24) shells.

RND 2: Sl st in next ch-3 sp, ch 3 (counts as dc), 2 dc in first ch-3 sp, (ch 3, 3 dc) in each ch-3 sp around, ch 1, join with sl st

construction diagram

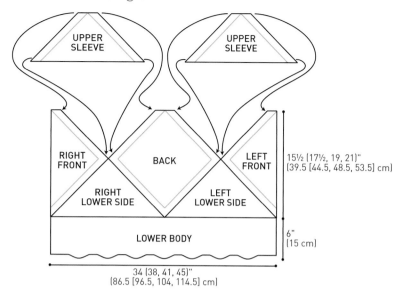

UPPER SLEEVE

UPPER SLEEVE

RIGHT FRONT

BACK

LEFT FRONT

RIGHT LOWER SIDE

LEFT LOWER SIDE

15½ (17½, 19, 21)" (39.5 [44.5, 48.5, 53.5] cm)

LOWER BODY

6" (15 cm)

34 (38, 41, 45)" (86.5 [96.5, 104, 114.5] cm)

to top of ch-3 at beg of rnd, turn.

Rep Rnd 2 until Sleeve measures 13" (33 cm) long.

Cuff

Refer to stitch diagram E for assistance.

RND 1: Sl st in next ch-3 sp, ch 3 (counts as dc), 2 dc in first ch-3 sp, (ch 3, 3 dc) in each of next 1 (1, 2, 2) ch-3 sps, *ch 4, shell in next ch-3 sp, ch 4**, (3 dc, ch 3) in each of next 3 (3, 4, 4) ch-3 sps, 3 dc in next ch-3 sp, rep from * around, ending last rep at **, (3 dc, ch 3) in each of next 2 ch-3 sps, join with sl st in ch-3 at beg of rnd, turn—4 shells.

RND 2: Sl st in next ch-3 sp, ch 3 (counts as dc), 2 dc in first ch-3 sp, ch 3, 3 dc in next ch-3 sp, ch 4, skip next ch-4 sp, *([dc, ch 1] 5 times, dc) in next ch-3 sp, ch 4, skip next ch-4 sp**, (3 dc, ch 3) in each of next 2 (2, 3) ch-3 sps, 3 dc in next ch-3 sp, rep from * around, ending last rep at **, (3 dc, ch 3) in each of next 1 (1, 2, 2) ch-3 sps, join with sl st in ch-3 at beg of rnd, turn.

RND 3: Sl st in next ch-3 sp, ch 3 (counts as dc), 2 dc in first ch-3 sp, (ch 3, 3 dc)

in each of next 1 (1, 2, 2) ch-sps, *3 dc in each of next 5 ch-1 sps, 3 dc in next ch-4 sp**, (ch 3, 3 dc) in each of next 3 (3, 4, 4) ch-sps, rep from * around, ending last rep at **, ch 3, 3 dc in next ch-3 sp, ch 3, join with sl st in ch-3 at beg of rnd, turn.

RND 4: Sl st in next ch-3 sp, ch 3 (counts as dc), 2 dc in first ch-3 sp, ch 3, 3 dc in next ch-3 sp, *ch 3, skip next 3 dc, 3 dc in sp before next dc, skip next 6 dc, 3 dc in sp before next st, ch 3, skip next 3 dc, 3 dc in sp before next dc, skip next 6 dc, 3 dc in sp before next dc**, (ch 3, 3 dc) in each of next 3 (3, 4, 4) ch-3 sps, rep from * around, ending last rep at **, (ch 3, 3 dc) in each of next 1 (1, 2, 2) ch-3 sps, ch 3, join with sl st in ch-3 at beg of rnd, turn.

RND 5: Sl st in next ch-3 sp, ch 3 (counts as dc), 2 dc in first ch-3 sp, (ch 3, 3 dc) in each of next 1 (1, 2, 2) ch-3 sps, *ch 3, skip next ch-4 sp, ([dc, ch 1] 5 times, dc) in next ch-3 sp, skip next ch-4 sp**, (ch 3, 3 dc) in each of next 4 (4, 5, 5) ch-3 sps, rep from * around, ending last rep at **, (ch 3, 3 dc) in each of next 2 ch-3

sps, ch 3, join with sl st in ch-3 at beg of rnd, turn.

RND 6: Sl st in next ch-3 sp, ch 3 (counts as dc), 2 dc in first ch-3 sp, (ch 3, 3 dc) in each of next 2 ch-3 sps, *3 dc in each of next 5 ch-1 sps, 3 dc in next ch-3 sp**, (ch 3, 3 dc) in each of next 4 (4, 5, 5) ch-3 sps, rep from * around, ending last rep at **, (ch 3, 3 dc) in each of next 1 (1, 2, 2) ch-3 sps, ch 3, join with sl st in ch-3 at beg of rnd, turn.

RND 7: Sl st in next ch-3 sp, ch 3 (counts as dc), 2 dc in first ch-3 sp, (ch 3, 3 dc) in each of next 1 (1, 2, 2) ch-3 sps, *ch 3, skip next 3 dc, 3 dc in sp before next dc, ch 4, skip next 6 dc, 3 dc in sp before next dc, ch 3, skip next 3 dc, 3 dc in sp before next dc, ch 4, skip next 6 dc, 3 dc in sp before next dc**, (ch 3, 3 dc) in each of next 4 (4, 5, 5) ch-3 sps, rep from * around, ending last rep at **, (ch 3, 3 dc) in each of next 2 ch-3 sps, ch 3, join with sl st in ch-3 at beg of rnd, turn.

RND 8: Sl st in next ch-3 sp, ch 3 (counts as dc), 2 dc in first ch-3 sp, (ch 3, 3 dc) in each of next 2 ch-sps, *ch 4, skip next ch-4 sp, ([dc, ch 1] 5 times, dc) in next

stitch diagram E

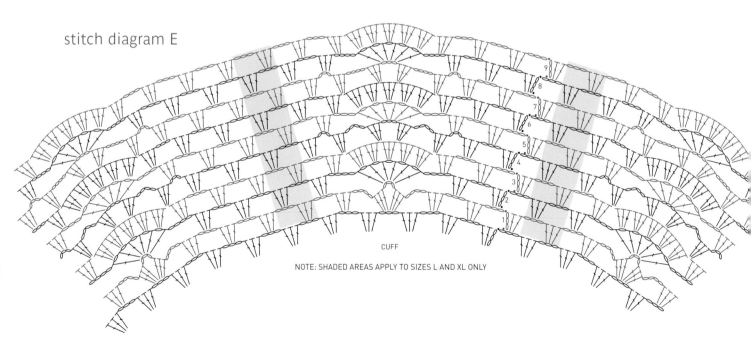

CUFF

NOTE: SHADED AREAS APPLY TO SIZES L AND XL ONLY

ch-3 sp, ch 4, skip next ch-4 sp**, (3 dc, ch 3) in each of next 4 (4, 5, 5) ch-3 sps, 3 dc in next ch-3 sp, rep from * around, ending last rep at **, (3 dc, ch 3) in each of next 2 (2, 3, 3) ch-3 sps, join with sl st in ch-3 at beg of rnd, turn.

RND 9: Sl st in next ch-3 sp, ch 3 (counts as dc), 2 dc in first ch-3 sp, (ch 3, 3 dc) in each of next 2 (2, 3, 3) ch-sps, *3 dc in each of next 5 ch-1 sps, 3 dc in next ch-4 sp**, [ch 3, 3 dc] in each of next 5 (5, 6, 6) ch-sps, rep from * around, ending last rep at **, (ch 3, 3 dc) in each of next 2 ch-sps, ch 3, join with sl st in ch-3 at beg of rnd, turn. Fasten off.

Hood

Note: Rows 1–4 are decreasing rows to create some shaping around face.

ROW 1: With RS facing, join with sl st to top right corner of neck edge, ch 3, 2 dc in first sp, *skip next row, (ch 3, 3 dc) in next row-end st, rep from * across to top left corner of neck edge, turn.

ROW 2: Sl st into first ch-3 sp, ch 3, 2 dc in first sp, (ch 3, 3 dc) in each ch-3 sp across, turn, leaving rem sts unworked.

ROW 3–4: Rep Row 2.

ROW 5: Ch 6 (counts as dc, ch 3), (3 dc, ch 3) in each ch-3 sp across, dc in 3rd ch of tch, turn.

ROW 6: Sl st in first ch-3 sp, ch 3, 2 dc in same sp, (ch 3, 3 dc) in each ch-3 sp across.

Rep Rows 5–6 until Hood measures 11" (28 cm) from beg.

Fold last row in half, and sew beg and end of last row together for top seam, using a whipstitch.

Finishing
Buttonhole Band
Place 4 markers on right front edge, placing bottom marker at bottom corner of Right Front, top marker at top corner of Right Front and 2 markers evenly spaced bet.

With RS facing, join yarn in bottom right-hand corner of Right Front edge, work 7 fsc, turn.

***ROW 1:** Ch 2, hdc-blo in each st across, sl st in end of next two rows on body, turn—7 sts.

ROW 2: Skip last 2 sl sts, hdc-blo in each st across, hdc in top of tch, turn—7 sts.

Rep Rows 1–2 to next marker.

Buttonhole Row A: Ch 2, hdc-blo in next st, ch 2, skip next 3 sts, hdc-blo in next 2 sts, sl st in end of next two rows on body, turn—7 sts.

Buttonhole Row B: Skip last 2 sl sts, hdc-blo in next st, 3 hdc in next ch-2 sp, hdc-blo in next st, hdc in top of ch-2 tch, turn.*

Rep from * to * across Right Front edge to last buttonhole at last marker, rep

Rows 1–2 across front edge of Hood, down front edge of Left Front to bottom left-hand corner. Fasten off. Sew buttons to Left Front Band, opposite buttonholes.

Wet or steam block to finished measurements. Weave in loose ends with a tapestry needle.

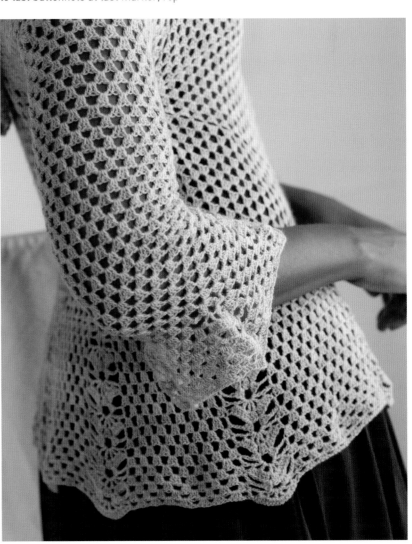

Glossary

Abbreviations

beg	beginning	L-	linked crochet
bet	between	lp(s)	loops(s)
blo	back loop(s) only	m	meter(s)
bp	back post	patt	pattern(s)
bp-cl	back post cluster	pm	place marker
ch	chain	rem	remain(s); remaining
ch-	chain or space previously made	rnd	round
cl	cluster	rep	repeat; repeating
cm	centimeter(s)	RS	right side(s)
dc	double crochet	sc	single crochet
dec	decrease; decreases; decreasing	sl st	slip stitch
dtr	double treble crochet	sp	space(s)
Edc	extended double crochet	st(s)	stitch(es)
Esc	extended single crochet	tch	turning chain
fdc	foundation double crochet	tog	together
flo	front loop(s) only	tr	treble crochet
foll	follow/ follows/ following	WS	wrong side(s)
fp	front post	yd	yard(s)
fp-cl	front post cluster	yo	yarnover
fdc	foundation double crochet	*	repeat instructions following asterisk as directed
fsc	foundation single crochet	**	repeat instructions between asterisks as directed
g	gram(s)	()	alternate measure- ments or instructions
hdc	half double crochet	[]	work bracketed instruc- tions specified number of times
inc	increase; increases; increasing		

Terms

Gauge

The quickest way to check gauge is to make a square of fabric about 4" (10 cm) wide by 4" (10 cm) tall (or motif indicated in pattern for gauge) with the suggested hook size and in the indicated stitch. If your measurements match the measurements of the pattern's gauge, congratulations! If you have too many stitches, try going down a hook size, if you have too few stitches, try going up a hook size. Crochet another swatch with the new hook until your gauge matches what is indicated in the pattern.

If the gauge has been measured after blocking, be sure to wet your swatch and block it before taking measurements to check gauge. Wet blocking drastically effects the gauge measurement, especially in lace stitch work.

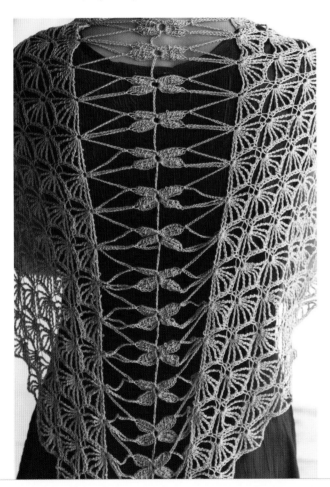

Blocking

Blocking allows the fabric to relax and ensures proper shape, measurements, and drape of the fabric. After time and wear, you will still want to block your garment after washings to bring it back to the original shape. Remember to treat wool fibers carefully when wetting or washing to block. Avoid felting by staying away from hot water and agitation (from a washing machine or water removal by hand). Also remember to keep synthetic fibers (i.e., acrylic) away from high heat.

Wet blocking

Gently submerge the fabric in lukewarm water with a bit of mild, wool-sensitive wash. Don't agitate. Let it soak for 20 minutes or longer, to allow the liquid to absorb into the fibers well. Drain the water and gently expel the water from the fabric (pressing between two layers of towels) but do not wring or twist. Lay the fabric out over a fresh dry towel and roll it up to expel even more water. Pin the piece out to the specified dimensions on a blocking board, carpeted flooring, or a bed (if you are using a carpeted floor or a bed, be sure to cover the surface with towels first). Allow to dry.

Steam Blocking

Steam relaxes fibers gently and more subtly than the wet-blocking method. It is very effective on synthetics and silks—the steaming creates lovely drape, even in the roughest acrylics! Follow the directions for pinning under Wet Blocking (above). Then use a steamer or an iron on the steam setting to steam the entire piece. Be sure to keep the steamer or iron a few inches away from the surface of the garment to avoid damaging the fibers. Allow to dry.

Crochet Stitches and Techniques

Crochet Chain (ch)

Make a slipknot on hook. Yarn over hook and draw it through loop of slipknot. Repeat, drawing yarn through the last loop formed.

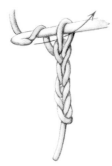

Single Crochet (sc)

Insert hook into a stitch, yarn over hook and draw a loop through stitch (Figure 1), yarn over hook and draw it through both loops on hook (Figure 2).

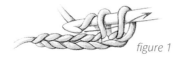

figure 1

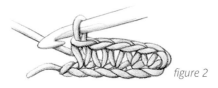

figure 2

Slip Stitch (sl st)

*Insert hook into stitch, yarn over hook and draw loop through stitch and loop on hook. Repeat from *.

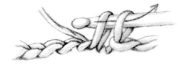

Half Double Crochet (hdc)

*Yarn over hook, insert hook into a stitch, yarn over hook and draw a loop through stitch (3 loops on hook), yarn over hook (Figure 1) and draw it through all the loops on the hook (Figure 2). Repeat from *.

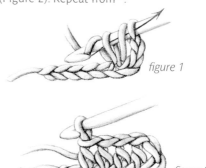

figure 1

figure 2

Double Crochet (dc)

*Yarn over hook, insert hook into a stitch, yarn over hook and draw up a loop through stitch (3 loops on hook; Figure 1), yarn over hook and draw it through 2 loops (Figure 2), yarn over hook and draw it through the remaining 2 loops (Figure 3). Repeat from *.

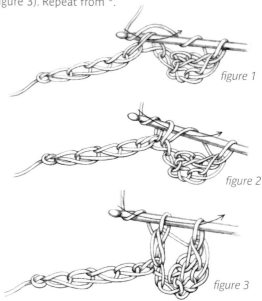

figure 1

figure 2

figure 3

Double Crochet 2 Together (dc2tog)

[Yarn over hook, insert hook in next stitch, yarn over hook and draw up a loop, yarn over hook and draw through 2 loops] twice (3 loops on hook). Yarn over hook, pull though all remaining loops on hook—1 decrease made.

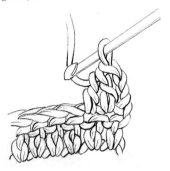

Double-Treble Crochet (dtr)

*Wrap yarn around hook three times, insert hook into a stitch. [Yarn over hook and draw it through 2 loops] 4 times. Repeat from *.

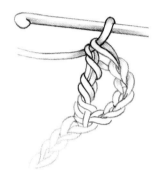

Treble Crochet (tr)

*Wrap yarn around hook twice, insert hook into next stitch, yarn over hook and draw a loop (4 loops on hook; Figure 1), yarn over hook and draw it through 2 loops (Figure 2), yarn over hook and draw it through the next 2 loops (Figure 3), yarn over hook and draw it through the remaining 2 loops. Repeat from *.

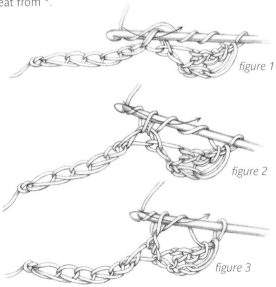

figure 1

figure 2

figure 3

Whipstitch Seam

With right side of work facing and working through edge stitches, bring threaded needle out from back to front, along edge of piece.

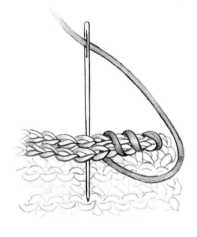

Switching Yarns and Crocheting Over Ends

When you switch yarns, add the new yarn by using it as the last loop of the last stitch completed with the previous yarn (see Figure 1, sample shown in single crochet).

Hold the tails of both the previous and new yarns together along the top of the stitches of the previous row (Figure 1); you will be crocheting around the tails. Insert your hook into the next stitch (under the tails), yarn over hook and draw up a loop. Complete the stitch normally, around the tails; as shown here (single crochet), yarn over hook, ensuring the hook is above the tails, draw the yarn through both loops on hook. The tails are being hidden inside the stitches (Figure 2). Continue crocheting around the tails in this manner until they are completely covered (Figure 3).

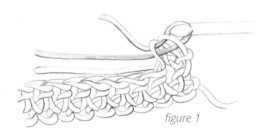

figure 1

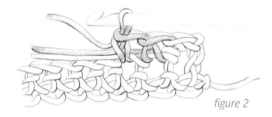

figure 2

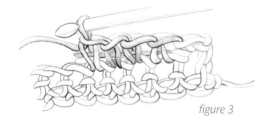

figure 3

Back Post Cluster (bp-cl)

*Yarn over hook, insert hook from back to front around post of next stitch, yarn over hook and pull up a loop, yarn over hook and draw through 2 loops on hook; rep from * once more, yarn over hook and draw through all 3 loops on hook.

Back Post Double Crochet (bpdc)

Yarn over hook, insert hook from back to front, to back again around the post of next stitch, yarn over hook, draw yarn through stitch, [yarn over hook, draw yarn through 2 loops on hook] twice.

Back Post Double Crochet 2 Together (bpdc2tog)

[Yarn over hook, insert hook from back to front, to back again around the post of next stitch, yarn over, draw yarn through stitch, yarn over, draw yarn through 2 loops on hook] twice, yarn over hook, draw yarn through 3 loops on hook.

Back Post Single Crochet (bpsc)

Insert hook from back to front, right to left, around the post of the specified stitch, yarn over hook, pull through work only, yarn over hook, pull through both loops on hook—1 bpsc made.

Bobble

[Yarn over hook, insert hook in next stitch, yarn over hook, draw yarn through stitch and draw up to level of work] 3 times, yarn over hook, draw yarn through 7 loops on hook.

3 Double Crochet Cluster (3-dc cl)

[Yarn over hook, insert hook in next stitch, yarn over hook, draw yarn through stitch, yarn over hook, draw yarn through 2 loops on hook] 3 times in same stitch, yarn over hook, draw yarn through 4 loops on hook.

Double Crochet 2 Together Through Back Loop Only (dc2tog-blo)

Work as dc2tog, but working through the back loop only of indicated stitches.

2 Double-Treble Crochet Cluster (2-dtr cl)

[Yarn over hook 3 times, insert hook in next stitch, yarn over hook, draw yarn through stitch, (yarn over hook, draw yarn through 2 loops on hook) 3 times] twice in same stitch, yarn over hook, draw yarn through 3 loops on hook.

3 Double-Treble Crochet Cluster (3-dtr cl)

[Yarn over hook 3 times, insert hook in next stitch, yarn over hook, draw yarn through stitch, (yarn over hook, draw yarn through 2 loops on hook) 3 times] 3 times in same stitch, yarn over hook, draw yarn through 4 loops on hook.

4 Double-Treble Crochet Cluster (4-dtr cl)

 [Yarn over hook 3 times, insert hook in next stitch, yarn over hook, draw yarn through stitch, (yarn over hook, draw yarn through 2 loops on hook) 3 times] 4 times in same stitch, yarn over hook, draw yarn through 5 loops on hook.

Extended Double Crochet (Edc)

Yarn over hook, insert hook in next stitch, yarn over hook, draw yarn through stitch, yarn over hook, draw through 1 loop on hook, [yarn over hook, draw through 2 loops on hook] twice—1 Edc made.

Extended Single Crochet (Esc)

Insert hook in next stitch, yarn over hook, draw up a loop (2 loops on hook), yarn over hook and draw through first loop on hook, yarn over hook and draw through both loops on hook—1 esc made.

Foundation Single Crochet (fsc)

Ch 2, insert hook in 2nd ch from hook, yarn over hook and draw up a loop (2 loops on hook), yarn over hook, draw yarn through first loop on hook, yarn over hook and draw through 2 loops on hook—1 fsc made.

*Insert hook under 2 loops of ch made at base of previous stitch, yarn over hook and draw up a loop (2 loops on hook), yarn over hook and draw through first loop on hook, yarn over hook and draw through 2 loops on hook. Rep from * for length of foundation.

Foundation Double Crochet (fdc)

Ch 3, yarn over hook, insert hook in 3rd ch from hook, yarn over hook and draw up a loop (3 loops on hook), yarn over hook, draw yarn through first loop on hook, [yarn over hook and draw through 2 loops] twice—1 fdc made.

*Yarn over hook, insert hook under both loops of ch just made. Yarn over hook and draw up a loop (3 loops on hook), yarn over hook and draw through 1 loop, [yarn over hook and draw through 2 loops] twice. Rep from * for length of foundation.

Front Post Double Crochet (fpdc)

Yarn over hook, insert hook from front to back to front again around post of stitch indicated, yarn over hook and pull up a loop (3 loops on hook), [yarn over hook and draw through 2 loops on hook] twice—1 fpdc made.

Front Post Single Crochet (fpsc)

Insert hook from front to back, right to left, around the post (or stem) of the specified stitch, yarn over hook, pull through work only, yarn over hook, pull through both loops on hook—1 fpsc made.

Front Post Treble Crochet (fptr)

Yarn over hook twice, insert hook in specified stitch from front to back, right to left, around the post (or stem). Yarn over hook, pull through work only, *yarn over hook, pull through 2 loops on hook. Rep from * twice—1 fptr made.

Beg Linked Double Treble Crochet (beg L-dtr)

Ch 5, insert hook and pull up a loop in 2nd ch from hook, and each of next 2 stitches (4 loops on hook), insert hook in next stitch on last round, pull up a loop. *Yarn over hook, pull through 2 loops. Repeat from * 4 times—1 beg L-dtr made.

Linked Double-Treble Crochet (L-dtr)

*Insert hook in closest horizontal loop, pull up a loop. Repeat from * in each of next 2 horizontal loops (4 loops on hook). Insert hook into next stitch on last round, pull up a

loop. **Yarn over hook, pull through 2 loops. Repeat from ** 4 times—1 L-dtr made.

Note: Each following linked stitch is worked in the starting ch in the first stitch, instead of the horizontal loops of the previous stitch—1 beg L-dtr made.

Joining/Last Linked Stitch

Insert hook through all horizontal loops of last st and into the next st in the round below, insert hook in st at base of beg linked st, yarn over, draw through 2 loops on hook, insert hook in bottom horizontal loop on beg linked st, yarn over, draw through 3 loops on hook, [insert hook in next horizontal loop up on beg linked st, yarn over, draw through 3 loops on hook] for each loop of beg linked st, insert hook in both loops at top of beg linked st, yarn over, draw through last 3 loops on hook.

Picot

Ch 3, sl st in 3rd ch from hook.

Single Crochet Through Back Loop Only (sc-blo)

Work as sc, but working through the back loop only of specified stitch.

Single Crochet Through Front Loop Only (sc-flo)

Work as sc, but working through the front loop only of specified stitch.

Single Crochet 2 Together (sc2tog)

Insert hook into stitch and draw up a loop. Insert hook into next stitch and draw up a loop. Yarn over hook, draw through all 3 loops on hook.

Single Crochet 3 Together Through Back Loop Only (sc3tog-blo)

[Insert hook into back loop only of next stitch and draw up a loop] 3 times (4 loops on hook). Yarn over hook, pull through all loops on hook.

Triple Treble Crochet (ttr)

Yarn over hook 4 times, insert hook in next stitch, yarn over hook, draw up a loop (6 loops on hook), [yarn over hook, draw yarn through 2 loops on hook] 5 times.

2 Treble Crochet Cluster (2-tr cl)

[Yarn over hook twice, insert hook in next stitch or space, yarn over hook, draw yarn through stitch or space, (yarn over hook, draw yarn through 2 loops on hook) twice] twice in same stitch or space, yarn over hook, draw yarn through all 3 loops on hook.

3 Treble Crochet Cluster (3-tr cl)

[Yarn over hook twice, insert hook in next stitch, yarn over hook, draw yarn through stitch, (yarn over hook, draw yarn through 2 loops on hook) twice] 3 times in same stitch, yarn over hook, draw yarn through 4 loops on hook.

Beg 3-Treble Crochet Cluster (3-tr cl)

Ch 4 (counts as tr), work 2-tr cl in specified sp.

4 Treble Crochet Cluster (4-tr cl)

[Yarn over hook twice, insert hook in next stitch, yarn over hook, draw yarn through stitch, (yarn over hook, draw yarn through 2 loops on hook) twice] 4 times in same stitch, yarn over hook, draw yarn through 5 loops on hook.

Resources

Thank you to all these generous suppliers of yarn. Your support is greatly appreciated!

The Alpaca Yarn Company
(866) 440-7222
144 Roosevelt Ave. Bay #1
York, PA 17401
thealpacayarnco.com
Halo
Glimmer

Bijou Basin Ranch
(303) 601-7544
PO Box 154
Elbert, CO 80106
bijoubasinranch.com
50/50 Yak/Cormo wool blend

Buffalo Gold
(817) 905-4584
PO Box 516
11316 CR 604
Burleson, TX 76097
buffalogold.net
#12 Lux

Coats & Clark
(800) 648-1479
Consumer Services
PO Box 12229
Greenville, SC 29612-0229
coatsandclark.com
Aunt Lydia's Classic Crochet Thread

Lion Brand Yarn
(800) 258-9276
135 Kero Rd.
Carlstadt, NJ 07072
lionbrand.com
Microspun

Lorna's Laces
(773) 935-3803
4229 North Honore St.
Chicago, IL 60613
lornaslaces.net
Helen's Lace

Louet North America
(800) 897-6444
3425 Hands Rd.
Prescott, ON
Canada K0E 1T0
louet.com
Euroflax Sportweight

Malabrigo Yarn Company
(786) 866-6187
malabrigoyarn.com
Lace

Patons Yarn
(888) 368-8401
320 Livingstone Ave. S.
Listowel, ON
Canada N4W 3H3
patonsyarns.com
Grace

Southwest Trading Company
(866) 794-1818
soysilk.com
Xie 10/2

Stitch Diva Studios
PO Box 1701
Fremont, CA 94538
stitchdiva.com
Studio Silk

Tahki Stacy Charles Inc.
(800) 338-9276
70-30 80th St., Bldg. 36
Ridgewood, NY 11385
tahkistacycharles.com
S. Charles Collezione, Sahara
Filatura di Crosa, Superior
Tahki, Cotton Classic Lite

Tilli Tomas
(617) 524-3330
tillitomas.com
Sequin Lace
Symphony
Voile de la Mer

Valley Yarns
WEBS-America's Yarn Store
(800) 367-9327
75 Service Center Rd.
Northampton, MA 01060
yarn.com
2/14 Alpaca Silk

Special thanks to Lantern Moon, for supplying all of the crochet hooks.

Lantern Moon
(800) 530-4170
7911 N.E. 33rd Dr., Ste. 140
Portland, OR 97211
lanternmoon.com

For more information, visit my website, styledbykristin.com.

Index